£-22-75

LIGHTING TECHNIQUES

FOR VIDEO PRODUCTION

THE ART OF CASTING SHADOWS

by Tom LeTourneau

Paddington Green
London W2 1NB

Knowledge Industry Publications, Inc. White Plains, NY and London

Video Bookshelf

Lighting Techniques for Video Production: The Art of Casting Shadows

Library of Congress Cataloging-in-Publication Data

LeTourneau, Tom.

Lighting techniques for video production.

Bibliography: p.
Includes index.
1. Television-Lighting. I. Title.
TK6643.L45 1986 778.5'343 86-27224
ISBN 0-86729-129-X
ISBN 0-86729-130-3 (pbk.)

Illustrations by Kathleen Joanne Jordan

Printed in the United States of America

Copyright © 1987 by Knowledge Industry Publications, Inc., 701 Westchester Ave., White Plains, NY 10604. Not to be reproduced in any form whatever without written permission from the publisher.

10 9 8 7 6 5 4 3

Contents

List of Tables and Figures	vi
Preface	ii
1. The Physics of Light: Starting on the Right Wavelength	1
2. Meters, Monitors and Scopes: Looks Good Here!	.7
3. Lamps, Reflectors and Lighting Instruments: What Is the Difference? 4	.3
4. Video Contrast Ratios: Help, They Don't Match!	3
5. Instrument Functions: What Do They Do?	1
6. Terms and Tips: Control Yourself8	9
7. Basic Lighting Setups: Where Do They Go?	9
8. Avoiding Problems: Be Prepared	7
9. Location Lighting: Battling the Elements	5
10. Studio Lighting: The Good Life	9
11. Future Directions: Watts New?	9
Appendix: Resources for the Lighting Professional	1
Recommended Readings	
Index	
About the Author	

List of Tables and Figures

Figure 1.1	The Spectral Colors	. 2
Figure 1.2	Electromagnetic Spectrum and Approximate Wavelengths in	
	Nanometers	. 3
Figure 1.3	Internal Optical System for Color Camera	
Figure 1.4	White Balance Without Black Balance	
Figure 1.5	White Balance with Black Balance	
Figure 1.6	Effect of Atmosphere on Color Temperature	
Figure 1.7	A Vectorscope Display	
Table 1.1	Common Light Sources and Their Approximate Color Temperatures.	
Figure 1.8	A Radiating Point Source	
Figure 1.9	Typical Lamps Effects on Light Rays	
	Lighting Intensity Falloff Outdoors in Sunlight	
Figure 1.10	Lighting Intensity Falloff Indoors in Artificial Light	23
Figure 1.11		
Figure 1.12	Lighting Intensity Falloff	23
		20
Figure 2.1	Spot Meter	
Figure 2.2	Incident Meter	
Figure 2.3	Color Temperature Meter	
Figure 2.4	Image from a Cross-Pulse Monitor and Blanking Information	
Figure 2.5	EIA Full-Field Color Bars (RS-189)	
Figure 2.6	EIA Split-Field Color Bars (RS-189-A)	
Figure 2.7	SMPTE Color Bars	37
Figure 2.8	Waveform Monitor	39
Figure 2.9	Vectorscope Display Parameters	41
Figure 3.1	Butterflys in Use	
Figure 3.2	Photo Lamp	45
Figure 3.3	Photoflood Lamp with Barndoor	
Figure 3.4	Quartz-Halogen Lamps	
Figure 3.5	Tubular Quartz Lamp	
Figure 3.6	PAR Lamp with Available Lenses · · · · · · · · · · · · · · · · · ·	49
Figure 3.7	MR-16 Lamp	50
Figure 3.8	HMI Discharge Lamp	52
Figure 3.9	Specular Reflection	53
Figure 3.10	An Example of Tenting	
Figure 3.11	Diffuse Reflection	
Figure 3.12	Reflector Shapes	
Figure 3.13	Inky	
Figure 3.14		
Figure 3.15	Scoop	
Figure 3.16	Softlight	
Figure 3.17	Portable Softlight	
Figure 3.17	Umbrella Lighting	
Figure 3.18	Softlight Cluster	
Figure 3.19 Figure 3.20	Nine-light Molefay	
rigule 5.20	Nine-light Wolciay	UJ

Figure 3.21 Figure 3.22 Figure 3.23 Figure 3.24 Figure 3.25 Figure 3.26 Figure 3.27 Figure 3.28	PAR Can 6 Plano Convex Lens 6 Stepped Lens 6 Fresnel Lens 6 The Spot and Flood Focus of a Fresnel 6 Fresnel Instrument 6 Older Form of Leko 7 Newer Form of Axial Leko with Multifaceted Reflector 7	57 58 58 58 58 70
Table 4.1 Figure 4.1	Contrast to f-stop Conversion	79
Figure 6.1 Figure 6.2 Figure 6.3 Figure 6.4 Figure 6.5 Figure 6.6 Figure 6.7 Figure 6.9 Figure 6.10 Figure 6.11 Figure 6.12 Figure 6.13 Figure 6.14 Figure 6.15 Figure 6.16	Baby Combo Barndoors on a Lowel Omni Color Frame Cucoloris Cyc Light Strip with Stage Paddles Cyclorama Dimmer Dots Ellipsoidal French Flag Frezzi Gaffer Grip Inky Sliding Rod with Grip Head Tener Zip 10	95 95 96 96 97 98 99 99 99 90 00
Figure 7.1 Figure 7.2 Figure 7.3 Figure 7.4 Figure 7.5	Head-On Lighting Setup11Near-Side Lighting Setup11Far-Side Lighting Setup11Sidelighting Setup12Cross-Key Lighting Setup11	12 13 15
Table 8.1 Table 8.2	Watts vs. Voltages	
Figure 9.1 Figure 9.2 Figure 9.3	A Combination of Reflectors	30
Figure 10.1 Figure 10.2 Figure 10.3	Basic Cyc Shapes 14 Basic Cyc Designs 14 Trench Cyc 14	41
Figure 11.1 Figure 11.2 Figure 11.3 Figure 11.4 Figure 11.5 Figure 11.6 Figure 11.7 Figure 11.8	Micro-Set Lighting System 15 HMI Lampwith Attachments 15 Cinepar 575 15 Mini-Cool 15 Mighty-Lite 15 Ministrips 15 Mini-Fresnel 15 Photo Dimmer 15	52 53 54 55 56 57

ACKNOWLEDGMENTS

I am grateful to many who assisted in the preparation of this text for their contribution of information, expertise and reviews. Some granted interviews that provided greater insight into certain concepts. Others were ready sources of facts and figures. And one was ruthless with the red pencil to bring order to the chaos. Special thanks to Marlene Board, Roger Claman, Dr. Raoul Johnson, Kathy Zukasky, George Panagiotou, Paul Vlahos, Victor En Yu Tan and the many manufacturers who granted permission to reproduce photos of their products.

And a special thanks to my wife and daughter for not complaining about all the times I said, "Not now, I'm working on the book."

DEDICATION

In everyone's life there are events that are firmly etched in memory. One such event in my life stemmed from an over-active discussion period in a college speech class. Near the end of that class I was ''invited'' by Dr. Manion to "See me in my office after class''. The tone of the ''invite'' led me to believe me that I would not be receiving an award during the encounter.

I arrived at the office moments before he did and seated myself in the wooden chair just inside the door. Doc, a man of normally genial disposition, stormed in and with a gesture more dramatic than convincing, slammed the door. Though stunned, I could not help but wonder why the large glass panel in the top of the door had not shattered. My concern for the welfare of the door soon turned inward as he shouted in a fit of pique, "Damn it, LeTourneau, you're suffering from an actue case of oral diarrhea."

Despite the recent diagnosis I was unable to muster any reply and sat there as he continued to berate me for constantly interrupting his lecture with questions. And then he demanded to know, "Have you no respect?" Rodney Dangerfield would have loved to have been there, but I didn't. I did have respect, but at that moment I was unable to do any convincing.

My disease would seem to be incurable, for I'm still asking questions of everyone and find it an effective method of learning. Hopefully today I'm more skilled in timing my queries.

Some months after my explosive encounter, I was surprised to find a letter in my mailbox from Dr. Manion congratulating me on my performance in a production of "Ghosts." The letter, which is framed on my office wall, begins, "Although I am regrettably late in commending you…"

Well Doc, although I am regrettably late in responding to a 24-year-old question, "Yes, I do have respect." And I hope this dedication will prove the fact. It's for all the times you weren't diagnosing my behavior problems, but trying patiently to instill some communication skills.

Preface

Who said, "Hold it, I think you're going to like this picture?" If you know the answer, you will probably want to pour yourself a cup of warm Ovaltine, shuffle off to your study and settle your head on the antimacassar of your favorite wing chair to read this.

That bit of trivia dates me, but then, the first television station I ever worked at used an iconoscope in one of the film chains. Maybe that is what makes me an iconoclast.

If you have just waded through the first two paragraphs and have no idea what I am talking about, take heart. I am not the fossil you think I am. I did not chisel the manuscript for this epic on stone, nor did I scratch it on sheets of papyrus with a reed dipped in ox blood.

I booted my ROM, or was it my RAM? (At any rate, it always sounds painful.) And with the appearance of the command prompt, I used my ASCII code alphanumeric keyboard to enter the proper commands, bringing my word-processing program on line. As the text appeared on the CRT, I took advantage of block moves, global searches and spelling checkers to rearrange and correct the content.

If that last paragraph made more sense to you than the others did, you may wish to pour yourself a can of a cold soft drink, jog into your media room, use your wireless remote control to turn off your projection TV and read on.

The point is that there have been myriad changes in the past 25 years. While we have progressed from iconoscopes to CCDs, the days of fluorescent banks and shadowless lighting are gone. Lighting techniques of television have been more aligned with those employed by the film industry.

Hence the subtitle of this lighting text is, *The Art of Casting Shadows*. It is based on the premise that you place your key and fill instruments in positions that produce the most effective shadow patterns. Shadow patterns are created in order to establish mood

and location, provide concealment, establish flattering portraiture, accentuate texture and create interesting composition.

Most people confuse the term "illumination" with "lighting." However, a scene may be illuminated, yet far from lit. You will understand the distinction before reaching the last chapter.

Now then, what else can you expect from this book? You can expect to be more aware of the tricks and equipment used by the professionals. When you have finished reading, you will not be an expert lighting designer; that will not happen until you light many sets under a variety of trying circumstances. However, learning about the special accessories and methods I am about to describe will make your work easier and your results more professional.

If you were raised as I was, you believe that federal marshals will storm your home and arrest you for removing the tag from new pillows. After all, the ominous warning reads, "Do not remove under penalty of law." Well, I have come to the point in life where I rip them off and cry, "Come and get me."

I was also raised to believe it is a crime to write in books. But I am going to request that you throw caution to the wind and write in this one. Trust me. Your mother will not punish you, and I need your cooperation in order to make an important point about the intentions and methods of this text.

In Diagram 1 you will find a jumble of numbers. Get a pencil and give yourself 30 seconds to draw a continuous line from number 1 to number 2 to number 3, etc. At the end of 30 seconds stop and make a note of the number you last connected to the series. Got everything you need? Pencil poised? (The truly brave may use a pen.) Stop watch set? OK! Ready...begin.

How did you do? Now we will see if we can improve your score. In Diagram 2 you will see the same jumble of numbers. Notice that there are four small dots located around the edge of the jumble on this page. Draw a vertical line from the dot in the center at the top to the dot in the center at the bottom of the jumble. Now draw a horizontal line connecting the two dots on the left and right sides of the jumble.

Now the jumble is divided into quadrants. Starting at the top left quadrant of the jumble, write number 1. Put number 2 at the top right corner, number 3 at the bottom right corner and number 4 at the bottom left corner.

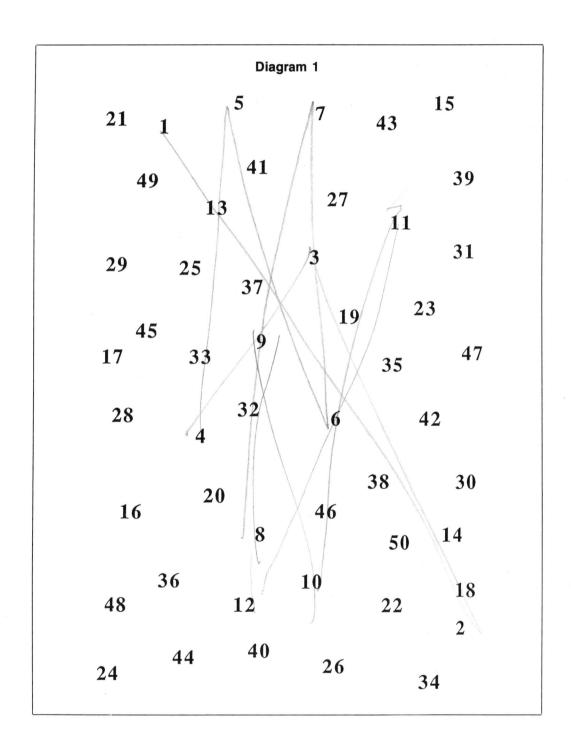

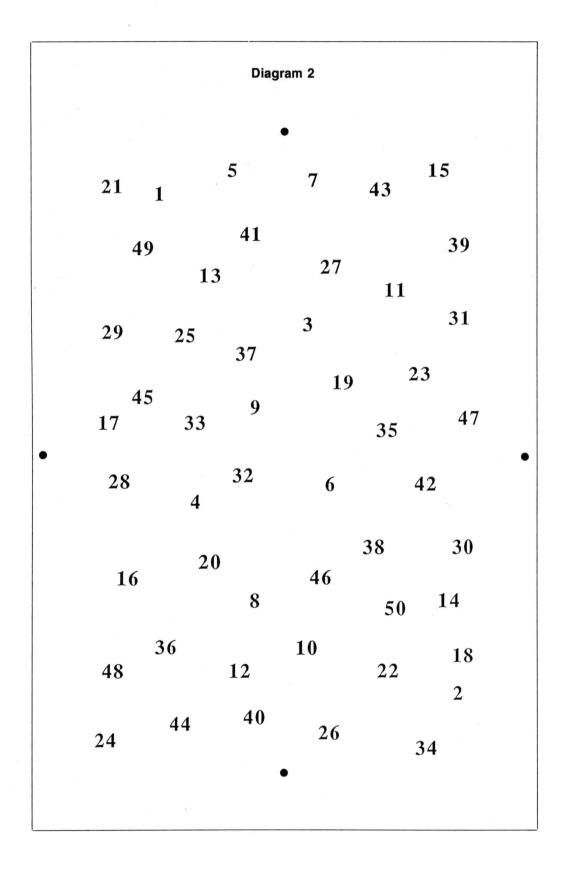

I'll also point out that the numbers are arranged so that the first numeral ir of four numbers is found in the first quadrant. The next number is located in quadrant. The following number will be in the second quadrant, and the next in will be located in the fourth quadrant. Then the pattern starts over again. In order, the numbers are found first in quadrant 1, then in quadrants 3 and 2 and finally in quadrant 4. Got it? Good! Now give yourself another 30 seconds and try again.

Armed with that new information you reached a much higher number this second time around, I am sure. While there has been no improvement in your IQ, there has been quite an improvement in your ability to complete the specific task.

In a way, that is what this book will do for your lighting skills. It will not improve your IQ, but it will make it easier and more enjoyable for you to light sets. The book is designed to encourage you to go out and try new things—to experiment and to be creative. After all, like the producers of *The Outer Limits*, you have total control over what the viewers see and how they perceive it.

A lone lighting instrument is a pretty poor lighting tool. This is especially true of the open-faced instruments that are commonly used for location lighting. The creative control of light is the result of using the various accessories available. You will read about many of them, look at photos of them and learn the roles they play in the control of light. Some uses will be suggested for each item, but do not limit yourself to the examples given. Try other applications. Controlling the placement of shadows and spill is what good lighting is all about, so there is a heavy accent on the use of accessories. You may already know about some of these; others may be completely new to you. Some are nice to have. Others are a must.

You must light to accommodate the limited capabilities of an electronic system. It is essential that you understand how that system reacts to light; you must also know a bit about the physical properties of light itself. I am the first to admit that I am not an electronics expert or a physicist, and you do not need to be one either to acquire a basic understanding of these disciplines as they relate to your work with lights. Before you learned some inside information about the number jumble earlier, you wasted time looking all around for your next selection. You are just as likely to waste time lighting a set without some inside information about the properties of light and the way the television system is designed to react to those properties. You will make a series of uninformed decisions about instrument selection and placement. Often you may be working against your intended goals.

I begin with some painless lessons in physics and electronics. Every effort has been made to keep explanations nontechnical. A clear understanding of the first three chapters is essential groundwork for the remainder of the text. There are many authoritative books that deal in greater detail with the subjects of the first three chapters; they are listed in the Appendix at the end of the book. So read on, enjoy and experiment. And learn to view the art of lighting as an opportunity to create and to make a great contribution to each scene. Remember, viewers can see only what you let them see. Your task is to place

the correct amount of light where it is needed and to keep it off areas where it is a distraction. You should provide no more, no less.

I do not believe it is possible for any book to teach you how to light every conceivable situation; every lighting setup is different from every other one. What this book will do is provide the facts necessary for you to make informed decisions regarding instrument selection and placement to meet the challenges faced on location. You will learn to analyze a scene in terms of how lighting can assist with mood, indicate time and control space. You will learn to analyze and emulate nature, to make the best use of existing light. You will learn to be a watt miser and to use fewer instruments and accessories to light a scene. You will learn to control and create shadows that enhance and clarify the intention of a scene. In other words, you will learn the art of lighting.

The Physics of Light: Starting on the Right Wavelength

Light is a particular range of electromagnetic radiation that stimulates the optic receptors and makes it possible for the eye to determine the color and form of our surroundings.

Light has three properties that contribute to our perception of the things it illuminates:

- color
- quality
- intensity

Lighting directors must have a basic understanding of all three properties, from a scientific point of view, in order to make an artistic contribution to the productions they are lighting. In Chapter 1 we will deal with the aspects of color and quality; in Chapter 3 we will discuss the quality of light provided by various lamp and reflector types: and in Chapter 4 we will discuss aspects of intensity.

COLOR

We know that the light of the sun or of an electric lamp can be broken down into the colors of the rainbow. The common method for dispersing white light is by using a prism. As a young science student you may have learned the memory crutch Roy G. Biv to help you remember the colors and the order they fall in when white light passes through a prism and is projected on a white surface.

Primary Colors

Light has two components: luminance information and chrominance information. The luminance information deals with the amount of light in lumens and is measured in footcandles. Chrominance information is subdivided into two factors: hue or tint, and saturation.

Hue defines color with respect to its placement within the spectral range shown in Figure 1.1. It is the basic color of the light. The term tint is often used interchangeably with hue in defining chrominance and in labeling the monitor control that adjusts that aspect of color.

Saturation is the property of light that determines the difference from white at a given hue. In other words, heavily saturated red might be described as fire-engine red. A poorly saturated red is closer to white in value and may be called pale pink. Unfortunately, most monitors label the saturation control as color.

To understand saturation, think of color as a specific hue that gradually increases in intensity along a straight line from white at the left end to the pure color on the right. The pure color—for example, red—is said to be saturated, while its unsaturated hue is called pink. Adjusting the color control of a monitor or television affects the degree of color saturation in the scene.

Light source

Prism

Red
Orange
Yellow
Green
Blue
Indigo
Violet

Cool colors

Figure 1.1: The Spectral Colors

Figure 1.1 shows that white light consists of at least seven distinct colors, known as the spectral colors. We know from observation that there are a great many other colors in the world around us. In the great scheme of things, these seven colors are of no particular importance except to illustrate the concept of refraction and that white light has distinct component parts—parts that can be measured. There are three colors, however, that are extremely important in understanding the physics of light and the transmission of color pictures by the television system. These colors, the capital letters of the name Roy G. Biv, are red, blue and green. They are the primary colors of light. Various combinations of these three colors make it possible to reproduce all the other colors in the visible spectrum. Since this is true, we need only evaluate everything we see in terms of how much red, green and blue light it reflects in order to reproduce its actual color. That is why the television camera has three pickup tubes, each one reacting to the percentage of a

particular primary color reflected by the subject. The display screen, a cathode ray tube (CRT), contains red, green and blue phosphors that glow with an intensity relative to the signal generated by the corresponding pickup tubes in the camera.

While the knowledge that white light could be broken down into seven colors in a particular order may have gotten us through our science test, we need to understand the color aspects of light in greater detail in order to understand how it affects the television camera (see Figure 1.2). Red has the longest wavelength of visible light. The farther you

Figure 1.2: Electromagnetic Spectrum and Approximate Wavelengths in Nanometers

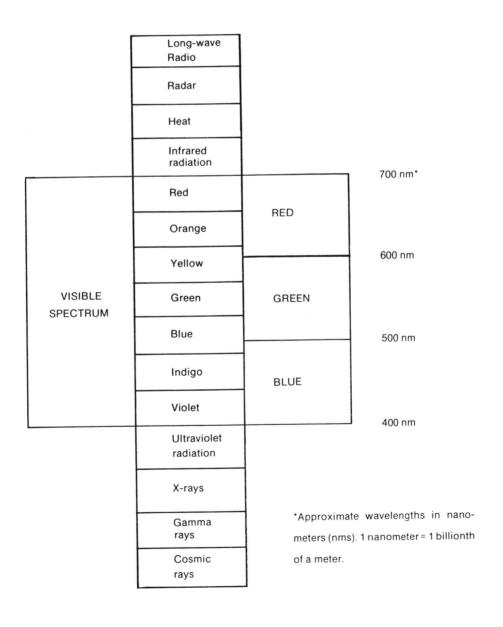

4 LIGHTING TECHNIQUES FOR VIDEO PRODUCTION

proceed toward the violet, or opposite, end of the spectrum, the shorter the wavelengths become. People commonly use the term "warm" to identify light in the red-orange portion of the spectrum and "cool" to describe light in the blue-violet end of it. These terms are subjective evaluations that relate to the perceived or psychological effect of these colors on the viewer. These terms should not be confused with the objective measurement of the actual spectral composition of a light source known as the color temperature, discussed in the next section.

Color Temperature

The *color temperature* of a light source is determined by the wavelengths of light it emits. That is, how much red light, how much green light, how much blue light, etc. We know that as an object is heated it will first glow with a reddish color. If we continue to apply heat, it will give off a yellow light and change to blue and then violet as additional heat is applied. Because, due to their differing chemical compositions, different substances emit different wavelengths of light when heated to identical temperatures, a specific substance must be used to establish standards.

Such a standard is called a "blackbody." This mythical body, or substance, is said to be composed of a material that neither emits nor reflects any light whatsoever. When it is heated to a specific temperature, it gives off a specific combination of wavelengths that are consistent and predictable. The temperature scale used is Kelvin (K), in which -273° Celsius is absolute zero. In theory, when we heat this body to a temperature of 3200°K, it will emit a certain combination of wavelengths through the yellow end of the spectrum. It is classified as white light because it contains sufficient wavelengths of all the colors of the visible spectrum which, when added together, form white. If we continue heating the body to a temperature of 5600°K, it will emit additional wavelengths nearer the violet end of the spectrum.

The important part of this definition is that the light emitted during the heating process progresses at a gradually increasing rate from the longer red wavelengths to the shorter wavelengths in the blue-violet end of the spectrum. This phenomenon occurs only when a tungsten filament is heated by passing a current through it. Incandescent lamps produce this gradual, predictable increase when current is applied to their filament.

For reasons both scientific and economic, tungsten is the metal of choice for manufacturers of lamp filaments. Since the melting point of tungsten is 3800 °K, a working temperature of 3200 °K has been chosen as the standard for tungsten lighting. At an operating temperature of 3200 °K, a tungsten filament will have a relatively long life span and still produce a desirable spectrum. The tungsten lamps that are designed to burn at 3400 °K for special photographic applications have greatly reduced life spans due to higher operating temperatures. The closer you operate a filament to its boiling point, the shorter its life.

Some tungsten-halogen lamps are rated at 5600 °K, or "daylight." Since the filament will vaporize at 3800 °K, how can a color temperature of 5600 °K be achieved? The answer

is the application of dichroic filters. These are special optical coatings applied to the front of daylight lamps that reduce the colors complementary to blue and produce a pseudo daylight spectrum. Most daylight sources, like the halogen metal iodine (HMI) lamps, are the result of specially designed discharge lamps that generate the higher color temperature without the need for special dichroic coatings that reduce output and lamp efficiency. No true blackbody source can produce the daylight spectrum, since no metal filament can be heated to 5600 °K or higher, without melting.

Fluorescent lamps, on the other hand, do not produce light as the result of passing current through a filament. Instead, an arc of current passes through a combination of gases, excites them and causes a phosphor coating inside the lamp to glow. Such light sources do not produce a continuous spectrum and are very difficult to correct and balance with standard light sources. Sometimes you may see a correlated color temperature listed for some fluorescent lamps. Generally such a listing will rate a cool white lamp at 4200 °K and a warm white fluorescent lamp at 2900 °K. Do not be misled by such ratings, however: they are not really scientific and do not provide satisfactory results when you add filters based on those temperatures to such a source. It merely means that a certain number of people have looked at this light source and agreed that it appears to the human eye to produce a blackbody color temperature that correlates with 2900 °K or 4200 °K. It is not actually 2900 °K or 4200 °K. No light source, other than incandescent lamps, are true blackbody sources, measurable in degrees Kelvin.

Fluorescent lights, mercury vapor lamps, sodium vapor lamps and various other multivapor discharge sources all produce a very erratic spectrum and cannot be rated in degrees Kelvin as blackbody sources can. The actual wavelengths produced depend on the composition of gases and the coatings on the interior of the lamps. The spectrum they produce does not provide a true white light containing known wavelengths from the red end of the spectrum to the violet end. Since they do not produce a true white light, they are very difficult to color correct with filtration media. (See the section later on in this chapter, "Working with Sources of Mixed Color Temperature.")

Color Rendering Index (CRI)

A more scientific approach to the classification of the apparent color temperature of fluorescent and other discharge lamps is recommended by the International Commission of Illumination (CIE). That method is the Color Rendering Index (CRI) in which eight standard pastel colors are viewed under the light source being rated and under a blackbody source of known color temperature. The color index ranges from below zero to 100. A number on that scale is assigned to the rated source light based on how accurately it renders the pastel colors compared to the same swatches viewed under the blackbody source. The closer they come to matching the look of samples under the blackbody source, the higher the index number assigned to the source being tested. Cool white fluorescent lamps are given a CRI of 68. Warm white fluorescent lamps have a CRI of 56. Daylite fluorescent lamps have a CRI of 75. A special fluorescent lamp called the Vita-lite has a CRI of 91 and comes as close as possible to a natural or daylight source.

Light radiates from the source in waves. The length of these waves, when measured from peak to peak, varies with the color involved. As mentioned earlier, the longer wavelengths are near the red end of the spectrum. These are perceived as being warm in color. The shorter wavelengths, near the violet end of the spectrum, are perceived as being cool in color.

While the human eye is capable of adapting to a wide range of color temperatures and interpreting color correctly, the pickup tubes of the television camera cannot. Television cameras are designed to produce accurate color when the scene is illuminated with light at 3200 °K. Within a given range the camera circuits can compensate for slight deviation from the ideal 3200 °K color temperature. (See the next section, "Auto White Balance.") This color temperature is often referred to as "tungsten" light. The other general color temperature classification is "daylight." It ranges anywhere from 5400 °K to 6800 °K. These color temperatures are usually found when shooting in sunlight or under specially balanced or color-corrected studio lights.

CAMERA OPERATION

Before plunging into a technical explanation of camera operation or, later on, proper setup techniques for a color monitor, let me say a word about why such topics are covered in a text about lighting.

In order to make valid judgments about your lighting efforts you must be able to view the results through the system. A number of texts dealing with TV lighting state that your monitor should be properly adjusted before you can make a valid assessment of the scene. They do not, however, tell you how to adjust it properly. Understanding proper adjustment methods is important for both the independent video producer who must know some basic aspects of lighting and for lighting designers who work with monitors daily.

In Figure 1.3 we see that the light that passes through the lens is split up by the prism block into its three primary colors. Each pickup tube then produces a voltage signal that is relative to the amount of that particular color present in the image at any given location. For example, if we were shooting a primary red art card, the red tube would produce the entire signal, and the green and blue tubes would produce no signal at all.

According to the National Television Systems Committee (NTSC) standards for American television, the camera should be set up to produce a 1-volt signal, from peak to peak, when it is properly adjusted. In the case of shooting the red art card mentioned above, that entire signal would be produced by the red tube. However, we rarely shoot a subject that contains a single primary color, so all pictures will be composed of varying voltages from each of the three pickup tubes. Since white contains all the colors of the visible spectrum, we can reason that if we reproduce white accurately, we will automatically reproduce individual colors accurately. When white is reproduced on television there is a definite ratio among the three primary colors. In that ratio red is 30% of the total signal, blue is 11% and green is 59%.

Figure 1.3: Internal Optical System for a Color Camera

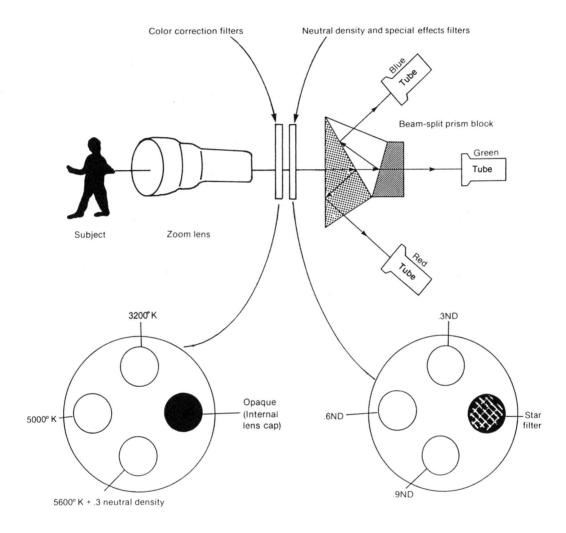

Color correction filter wheel

Neutral density and special effects filter wheel

Auto White Balance

In order to achieve the ratio for proper reproduction of white, and subsequently colors, the modern camera is designed with auto white balance circuits. These circuits are able to make adjustments in the output voltages of the three pickup tubes so that their combined

outputs form a 1-volt signal from peak to peak. The red signal will be .30 volt. The blue signal will be .11 volt, and the green signal will be .59 volt when the camera is aimed at a white card lit by 3200 °K light. When this occurs on an indoor location and the operator pushes the auto white button, you can see the image on the monitor change from off-white to white as the three voltages are adjusted to the established ratio.

From a strictly technical standpoint this voltage ratio does not directly determine the color information for the encoded signal. It represents the quantity of each of the three primary colors, but there is a far more complicated method of establishing the actual chrominance information of the NTSC signal. Since our purpose is not technical in nature, that information will not be covered here, but many excellent books on the subject are listed in the Appendix. The important concept for the lighting director to remember about color temperature is the ratio of the primary colors and how the camera is designed to establish them.

If white balance is achieved at the start of a shoot with proper voltage applied to the lamps and a voltage drop occurs later on, the camera will then produce pictures that are warmer in color. This is due to a decrease in the blue-violet spectrum that occurs because the filaments are not as hot as they were during the white balance procedure. It is not due to an increase or abundance of red in the spectrum. The lamp filaments, operating at lower voltage, will burn cooler and produce less light in the higher end of the 3200 °K spectrum, resulting in warmer colors. Note that the actual temperature at which the filament burns, based on the voltage applied, has an inverse effect on the color temperature. (For example, reduced voltage to a 3200 °K lamp will cause the filament to run cooler. The cooler filament produces fewer wavelengths from the upper end of the spectrum, resulting in a warmer or more reddish tone to the scene being shot.) The actual amount of light in the red spectrum does not increase, but the reduction of wavelengths in the blue end of the spectrum causes an apparent increase in red. It is possible to calculate the color temperature by measuring the voltage at the lamps and using certain formulas. From a practical standpoint there is not time to do that, and there is no need to under studio lighting, since the camera is capable of auto white balance anyway. A color temperature meter may also be used to make quantitative measurements of the red, blue and green light present from any source. In fact, use of such a meter is required when trying to determine the proper filter material to use to make color correction of discharge sources having unknown spectrums.

Black Balance

Before continuing our discussion about white balance, a brief explanation about the black balance function of the camera is suitable. Whether the function is automatic with your camera or must be set by a technician, the black balance is usually done *before* you white balance, but some manufacturers recommend that you do it *after* you white balance. Naturally you should follow the recommended procedures for your particular camera.

The reason for this seeming contradiction has to do with the design differences in the black balance circuits. More recent auto black circuits are able to modify the starting point of white balance voltages without changing their overall waveform, something earlier circuits could not do. It is generally best to cap the camera when making a black balance adjustment, though many cameras automatically do this for you. The diagrams in Figures 1.4 and 1.5 should help to illustrate the effect of and need for black balance.

Figure 1.4: White Balance Without Black Balance

Figure 1.5: White Balance with Black Balance

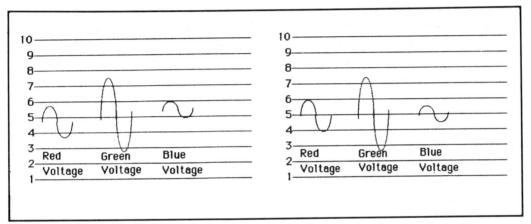

In Figure 1.4, the camera has been white balanced and the circuits are producing the proper voltage from each tube. The output of the red channel is .30 volt. The green channel output is .59 volt, and the blue channel is producing .11 volt. The problem is that each measurement does not start at the same base line, resulting in "black" that is tinted.

In Figure 1.5, the camera has been black balanced and the three voltage measurements start at the same base line. In this case the blacks will be a true TV black without any shift toward a color.

Selecting the Correct Camera Filter Wheel Position

As good as white balance circuits are, they have a limited correction range. To make it possible to achieve correction over a greater range of color temperature differences, cameras have filter wheels built into the optical path just behind the rear lens element. (See Figure 1.3.) Most cameras have only four filter positions on a single wheel. There is usually a studio or tungsten filter, two daylight filters and a fourth position that is not a filter but a cap to prevent any light from reaching the pickup tubes. This position may be used for black balance procedure and should always be used when changing from one lens to another, removing a lens for shipment or when shipping the camera. It is also a good idea to cap the camera when moving it from one position on set to another. Often you will end up shooting a backlight or some bright area of the set and, depending on the type of tube, you may burn an image on the face of the tube before you discover your error.

Since cameras are designed to operate under 3200 °K lighting, the tungsten position of the filter wheel is really nothing more than a piece of optically clear glass. The two daylight positions filter out the blue-violet wavelengths that are in excess of those found in 3200 °K light sources. Typically they will be rated around 5000 °K and 6500 °K.

Some manufacturers assume that when the 6500 °K filter is necessary, the scene will be so bright that you have to stop down to your smallest f-stop. For this reason they combine the 6500 °K setting with a .3 neutral density (ND) filter to reduce your depth of field somewhat. Neutral density filters are designed to equally reduce the amount of light in the red, blue and green spectrum. They do not affect the color temperature. A .3 neutral density filter reduces light by one stop. It is a nice touch, but it generally does not provide adequate control over your depth of field. For greater control you should have a set of neutral density filters that can be placed in front of your lens to cut back the incoming light. The normal complement of such a filter pack is .3ND, .6ND and .9ND, which reduces the light by one, two and three stops, respectively. The filters may be used in any combination to give even greater latitude of control. They permit you to work with larger f-stops so not everything is in focus from 3 feet in front of the camera to the horizon. (Two sources for screw-on neutral density filters are Belden Communications, Inc. and Tiffen [see the Appendix]. They also make a variety of other effects filters that will be discussed later.)

A few cameras have two filter wheels, like the one illustrated in Figure 1.3. One wheel is for color correction filters only and one wheel for a complete set of ND filters and possibly some special effects filter, such as a star filter, diffusion or low-contrast filter. Naturally this makes it easier and faster to tailor the f-stop to your requirements. Not having filters built into your camera does not restrict you from using external filters to gain control of your f-stop setting. The end result will be no different if the filters are internal or external. The external filter pack can be rented for a few dollars a day.

If the camera is white balanced in the studio under 3200 °K lights with the tungsten (3200 °K) filter in position, you will not be able to achieve white balance if you move outdoors and attempt white balance without changing the filter. The camera will not be able to bring the signals within the required ratios. That is because the color temperature of the light is probably above 5000 °K and contains a great deal more blue light than the circuits are able to compensate for. It will be necessary to change the filter wheel to one of the daylight settings to remove the excess blue light before it reaches the prism block. If the color temperature is even higher, near 6500 °K, as it would be under a blue sky on a sunny day, then it may be necessary to change to a second daylight filter position to remove the excess blue light present before the camera will white balance properly.

OUTDOOR COLOR BALANCE

The sun's color temperature changes throughout the day, so when shooting outdoors you should white balance the camera often (as often as every five minutes when shooting early or late in the day). That way shot 39, made at 11:00 a.m., will match shot 40 made

at 3:00 p.m. The change in color temperature is caused by the different wavelengths of each color and the filtration effect of dust particles in the atmosphere. The dust, moisture droplets and pollution in the atmosphere act as a great filter and diffuser. These particles break up and absorb the shorter wavelengths near the blue end of the spectrum. The blue wavelengths that are diffused among these particles account for the blue color in the sky. The longer red wavelengths are affected less by the atmosphere and pass through it with greater freedom. It is this factor that accounts for the warm or yellow-orange look of the sun near sunrise and sunset. At these times, when the sun is low in the sky, its rays strike the earth obliquely. At an oblique angle they pass through more of the atmosphere than they do at noon, when they are at right angles to the earth's surface. The additional atmosphere filters out the shorter wavelength, cooler colors while permitting the warmer, longer wavelengths to pass through more readily. The greater the dust and moisture content of the atmosphere, the more spectacular the effect. Clear, cloudless days do not yield beautiful sunsets. Since the earth is constantly rotating, in effect changing the filter pack on the sun's rays, the amount of blue light decreases and causes "warmer" pictures (see Figure 1.6). After noon, density of the atmosphere increases with the passage of time due to the increasing distance between the sun and the subject. As the angle becomes more oblique, it travels through a greater portion of the earth's atmosphere. To compensate for this ever-changing condition, repeated white balancing is necessary if you wish to mask the time change.

Though great emphasis is placed on achieving perfect white balance so that whites are always white and the color in all the shots of a particular sequence will cut together during post-production, I must insert a caution about such a sterile approach. An old saying states that you have to know the rules before you are permitted to break them. It certainly applies here.

An example might involve taping an afternoon sporting event on a realtime basis using several cameras switched live. Watching the monitor you would notice a change in the color balance of the shots as the afternoon progresses. You should be able to sense a warming in the color of the light and see shadows lengthening. That is normal and you expect these changes. It's a natural phenomenon that shows the passage of time. The trick is to be able to recreate such an event out of sequence and maintain a convincing look indicating the passage of time once your shots are cut together.

That's where the art of lighting comes into play. You need a feel for the scene and must decide early on whether you are going for complete realism or want an unnatural or artistic look to each scene. It would be very difficult to achieve and maintain a desired look if you did not understand how the television system reacts to light and how light interacts with scenic elements. Even interior shots may need to show time of day, and if they are of any length may require the use of some lighting techniques to show passage of time during the scene.

If you want a warmer look to all the exterior shots done throughout the day (as if you had been shooting around sundown), you can "paint" the picture with the camera controls as the day progresses to compensate for changing conditions and add the necessary

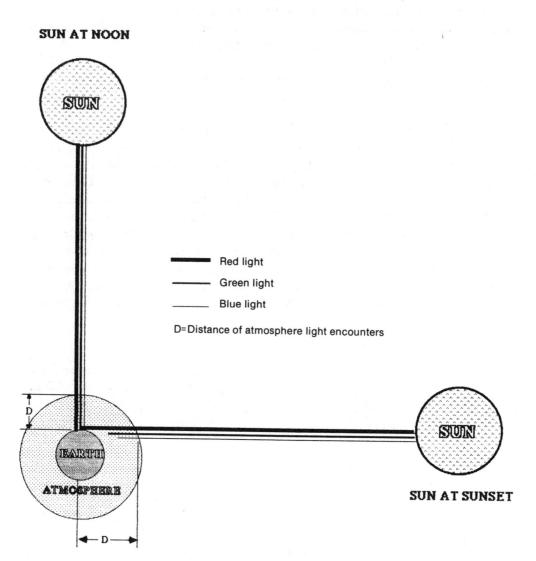

Figure 1.6: Effect of Atmosphere on Color Temperature

red-orange to the picture. This requires a very well trained video engineer who has excellent color discrimination, and it leaves room for inconsistencies. A much simpler and more accurate method is to fool the camera during setup. We said in the beginning that the assumption made by the auto white circuitry is that the subject is a white card lit with 3200 °K light. When you are shooting outdoors, the daylight correction filter will compensate for the higher color temperature of the light and remove the excess blue before the electronic balancing process begins. The circuits assume that a white card is the subject and produce the required voltage for each of the primary colors.

Although vectorscopes are covered in greater detail in Chapter 2, let's take a few minutes to look at the faceplate of a vectorscope now (see Figure 1.7). While the waveform

monitor is designed to give you information about the luminance or brightness value of your scene, the vectorscope presents a graph of the color or chrominance content of the signal. You will notice that red is located at the 103° position on the display. The complement of red is eyan, and it is located 180° from red at 283°.

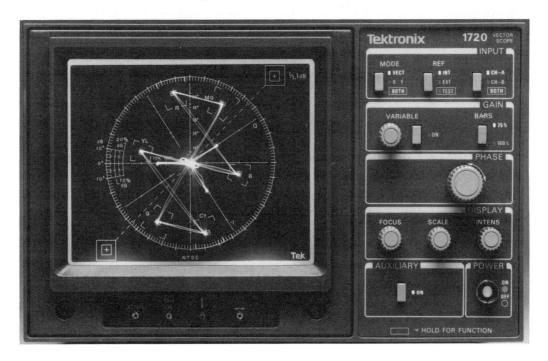

Figure 1.7: A Vectorscope Display

Photo courtesy Tektronix, Inc.

Remember, the camera always assumes you are shooting a white card when you white balance. It will then produce the proper voltage ratios if the right color correction filter is in position. If you shoot a cyan-tinted card during the white blance procedure, the camera will compensate for the cyan by reducing the blue and green voltages (since cyan is composed of blue and green) to achieve the standard ratio that we have been talking about in order to produce a white field on the television screen. As a result of reducing the blue and green voltages, when the camera is focused on the scene, the picture will be warmer than usual. Since the circuits have been tricked into thinking there is more blue and green light in the spectrum than actually exists, the camera produces a red-orange field when it is aimed at a true white card after such a bogus white balancing procedure. The circuits have not increased the red voltage output in this unorthodox white balance procedure, but the scene appears more red since they have reduced the complementary voltages.

Such a procedure will produce a consistent warm look for all of the shots taken throughout the day. *Warning:* Do not try this technique for the first time on an important shoot. Run some tests before you start your shooting schedule. Use various tinted chips to see what effect they produce. Keep accurate records of your tests and use the chip that your

tests indicate will produce the desired result. This method will assure greater consistency throughout the shoot and will make painting much faster. Your test will show that the cyan chip you use for this white balance procedure should have very little saturation or the resulting flesh tones will be too red.

This method will produce a technical solution to the problem of producing warmer-looking scenes, but do not forget the aesthetic considerations involving the shadows in your scenes. Do not shoot wide shots at noon with the shadows falling directly beside their sources. The situation is bound to be noticed by your viewers. Close-ups and medium shots can be done throughout the day without drawing attention to shadows. Save your long shots for the beginning or end of the day when the shadows will fall naturally at oblique angles to the subjects, as they do around sunset.

WORKING WITH SOURCES OF MIXED COLOR TEMPERATURE

Novices normally have great difficulty when they encounter mixed color temperatures on a set. These problems are at their worst when you are shooting indoors on location. A common situation is one in which you have to interview someone in an office lit by fluorescent lights. The subject is sitting in front of an undraped window, and you have a lighting kit with standard 3200 °K lights. If you are lucky, you will come back to your edit room with footage of a person surrounded by a blue haze, with a strangely colored forehead and an extremely hot background. I say lucky because you may end up with footage of a talking silhouette. We will examine some solutions to this situation in a minute.

You are faced with two problems: (1) There are three different color temperatures of light involved. (2) There is excessive contrast between the subject and the background. It is very difficult to deal with if you try to light the subject well enough to overcome the intensity of the light coming through the window. In order to overcome these discrepancies you must use special filter material called color correction media to color balance the various light sources and neutral density sheets to control the excessive contrast. A variety of highly specialized materials is available to handle these types of situations. Failure to convert all of the light sources in any scene to a common temperature will cause expensive and sometimes impossible color correction problems in the post-production phase. Never take the attitude, "I'll fix it in post." In many cases you cannot fix it, and when you can, it is usually very costly. Do it right in the first place—when you are lighting. One hour of color correction in the edit suite will buy all the filter material you will ever need.

New Products to Solve Lighting Problems

One of the most encouraging developments in lighting during the past few years is the application of space-age technology to produce products that will solve these and other problems faced by the lighting designer. Experiments are progressing with special coatings on the interiors of multidischarge lamps and fluorescent tubes to produce a spectrum that can be color corrected to standard photographic temperatures. Special reflectors have been developed that absorb ultraviolet and infrared radiation. Lamp and reflector designs are being perfected that permit smaller, more efficient instruments, and lamp spectrums are more compatible with pickup tubes and the new charged couple imaging devices. There are more durable and accurate filtration and reflector materials available as the result of new plastics and dyes.

Fluorescents present a substantial problem. Though they were developed back in 1867 by Becquerel, they did not appear on the consumer scene until the 1940s. Even then they did not receive wide acceptance. One of the first wide uses was in supermarkets because of their need to light large areas evenly. Store owners complained to lamp manufacturers that fluorescents made the meat look blue and that oranges and other produce looked bad. As a result the tubes were redesigned to correct these problems. Had the first complaints come from a cinematographer rather than a butcher, we probably would not be cursed with the strange spectrums these lighting sticks produce today.

Solving the Problems of Mixed Color Temperature

Let's analyze that interview scene where the talent is seated in front of an undraped office window and the office is lit by fluorescents. We will achieve satisfactory results using some "inside" information about a variety of readily available accessories.

Since the primary rule of good lighting is that all the sources must be the same color temperature, you have to decide which temperature you want to make standard. Will you color correct the daylight and fluorescents to match your 3200 °K sources, or will you convert your studio lamps to daylight and leave the fluorescents alone or correct them to daylight also? You can do any of these things by using the correct color correction media, and you must do something to bring all your light sources to the same color temperature.

If the window is behind the talent, and we will put it there for purposes of illustration, it may not be a wise decision to leave the window alone and place booster blue correction filters on your 3200 °K lamps to convert their color temperature to daylight. While you can satisfy the criteria of matching the color temperature of sources this way, you will still be left with an impossible contrast problem. In all probability, if you expose for the window, the talent will end up in silhouette because your lighting kit will not be powerful enough to overcome the strong backlight. If you expose for the talent, you will "blow" the window. It will become a screaming white blob behind the talent. The excessive white level will not be handled by the white clipping circuits of your camera, and you will experience breakup on playback. Your problem will be aggravated by the fact that you will also lose efficiency when you convert from tungsten to daylight by placing a booster blue filter in front of the source. If you require a full blue to convert 3200 °K to a nominal 5500 °K daylight, you will reduce your light output by 64%. The transmission of full daylight blue is 36%. If you can get by with half blue to convert 3200 °K to 4100 °K daylight, you will reduce your light output by only 48%. The transmission of half blue is 52%.

The easiest thing to do would be to close the drapes or pull the shade on the window, but you may want to see out the window to help establish location. You can accomplish this goal by placing a sheet of ND material on the inside of the window. This polyester-based material comes in rolls 100 feet long by 48 inches wide. It is optically clear, does not affect color temperature and can be reused many times if properly cared for. Static cling will usually be strong enough to hold the sheet in place on a small window. Larger sheets can be taped in position.

Once you have reduced the incoming light sufficiently, you can set up your front lighting in the normal manner, using booster blues in front of each studio lamp. As with the ND filters you screw on the front of your lens, ND sheets come in .3ND, .6ND and .9ND to reduce the light source by one, two or three stops.

If there are other windows in the room, off camera, their light can serve as general fill or can be bounced into dark areas of the scene with a reflector without any color correction. The natural light will cut down on the amount of color-corrected incandescent light you need to add to the scene.

Filter material commonly known as 85 converts daylight sources to 3200 °K. Some 85 is combined with .3ND, .6ND or .9ND filtration material to reduce daylight and change its color temperature in one operation. If you choose to correct daylight to tungsten so you can work directly with your 3200 °K sources, it would be necessary to gel the off-camera windows or cover them so they would not add daylight to the scene. Obviously it is better to be able to use the additional window light without having to color correct it.

The term gel is used here as a verb. Gel was the original material to which dyes were added for the purpose of coloring light sources in the theater. A solution of liquid gel, with dye added, was poured into large pans and permitted to solidify into thin sheets. It is still used as an economical alternative to modern plastic filtration material in low wattage theatrical instruments, but it will not withstand the higher temperatures of quartz halogen lamps. Gel is frequently used as a verb to describe the act of placing color correction or ND material in the color frame of an instrument or on the surface of a window.

The fluorescent lights could be left alone if you use daylight as your standard. Their color temperature will blend in rather well with daylight. Or you can convert them to daylight by using a Minusgreen filter. Fluorescents can also be converted to 3200 °K by using a Fluorofilter filter in front of the tubes. You can place a color-correction sheet above the plastic lens or grid of the fluorescent fixture, or, if the tubes are exposed, you can purchase sleeves of filter material that slip right over the lamps. If you find yourself shooting repeatedly in the same office location, you may wish to leave your sleeves or sheets in the fixtures to save time on your next setup. A drawback to this approach is that the Fluorofilter reduces the light output by 64%. Its transmission is only 36%.

You can purchase special fluorescent lamps rated at tungsten or daylight temperatures for installation in areas frequently lit by fluorescents. These lamps are more expensive than regular fluorescent tubes but they may be worth it if you shoot often in a given office

area that is lit by fluorescents. If you are working on a tight budget (and who isn't), it may be possible to transfer the cost for these lamps to building maintenance. This would give you a threefold gain. There is no cost to your department to relamp the fixtures, you get a 3200 °K source to work with and you also save time by not having to gel the fixtures the next time you shoot in that area.

The Spectra 32 fluorescent tube from Luxor Lighting Corp. (see the Appendix) is rated at 3200 °K and given an 82 on the CRI scale. The Luxor Vita-lite fluorescent is rated at 5600 °K and given a 91 on the CRI scale. Such lamps are the best choice for lighting in a makeup room because they provide excellent color rendition of subtle makeup shading. Their color temperature will match the light sources on the set and they will not add heat to the makeup area. Do not use a string of household lamps around your makeup mirrors. Their color temperature makes critical evaluation impossible and their heat becomes uncomfortable as the actors work close to the mirror.

How Filters Work

The issue of using color correction filters to correct for the strange spectrums of discharge lamps and fluorescents seems to be shrouded in an aura of mystery. While having lunch one day, two lighting designers were asked by an expert in the area of color correction, "What do you do to correct for fluorescents on location?" They looked at each other and one replied, "We start drinking early." Second case: The author of an excellent and very thorough text on filmmaking offers a scientific explanation of filtration formulas. In summing up things and trying to explain the reasons for selecting certain filters, he states, "Don't try to figure it out; it's like a game and those are the rules."

The issue also seems to be made overly complicated. After numerous conversations with leading experts in the design and manufacture of filter materials, I find confusion of terms in efforts to explain how filters work. It is not uncommon to talk of booster blues and imply, if not state outright, that they add blue light to the tungsten spectrum to balance it with daylight temperatures that contain more blue. That sounds fine. It even looks fine. If we view a light source that has been gelled with booster blue, there is a definitely bluer tint to the light that passes through it.

A pamphlet that is no longer in print, describing light control media, stated, "There are gels to add enough green to daylight sources to match fluorescent phosphors permitting an overall correction with a single lens filter."

If the drinking water at your house has a funny taste, you buy a filter for your faucet and it makes the water taste better. Does it add good taste to the water that passes through it? No. It removes the chemicals that cause bad taste. That is all filters can do—remove things, whether they are objectionable chemicals in a water supply or objectionable frequencies of light. Why then do the experts talk of adding green or boosting blues? Actually, the people who make such statements are not the physicists and chemists who formulate these filters and who know such statements to be false. The problems are caused by copy-

writers and salespeople who try to simplify the technical aspects of their products. The result is greater confusion on the part of the users who are not better informed, but misinformed.

The Rosco Cinegel pamphlet is an excellent resource to have. It illustrates products currently available to control color temperature and to reduce intensity and products that reflect light sources. The pamphlet is available free from Rosco (see the Appendix). It presents an overview of their products and gives practical application examples. You should also send for their swatchbook that contains samples of Booster Blue, Reflection Media, Light Control Media, Diffusion Media and Daylight Control Media. Once you are familiar with these products, you will see that someone has already invented material to solve many of the problems you face daily in interior and exterior location lighting and in studio setups. Lack of knowledge about these and other helpful products available to the professional will cause you to come home with compromised video. There is no need to settle for unsatisfactory lighting, because the tools exist to correct the problems you face.

Think back to our efforts to fool the camera during white balance so that it would produce a warmer look. We did not add red to the picture. We balanced on a cyan chip. In effect, we were removing a color complementary to the red, namely cyan, to create the appearance of more red in the picture. The same is true of color-correction filters. They cannot add green as the text of the pamphlet stated, but they can remove magenta, which is the complement of green. That will produce an apparent increase of green in the light that passes through them.

Look again at the faceplate of the vectorscope in Figure 1.7. You will see that green is at 241° on the scale. Its complement, magenta, is 180° opposite that point at 61°. When we remove the magenta, the light appears more green because its complement is lacking. Light that passes through neutral density material is dimmer, not because the filter adds black but because it subtracts equal amounts of the red, blue and green light. Filters can shift emphasis by removing complements of problem frequencies when they are present. They can also remove the offending frequency directly, if it is present in the spectrum at levels in excess of those needed to conform to the desired color temperature.

When a source, like the sodium vapor lamp, produces a wildly erratic output with many holes in the normally continuous spectrum of a blackbody source, filters are not able to compensate for the missing components. If you filter out the offending frequency, you create even larger holes in the spectrum and generate new problems for yourself. Since frequencies that complement the offending spikes do not exist, you cannot filter them out to shift the apparent output of the source. In short, completely effective color correction is a physical impossibility. Some color correction is possible, but do not consider yourself a failure when the colors are not perfect under such adverse lighting sources. Keep in mind that even the human eye does not perceive colors accurately under such lights and the viewer does not expect to see natural colors in such locations.

Table 1.1 is a list of some commonly encountered light sources and their approximate color temperatures.

Table 1.1: Common Light So	ources and Their	Approximate Color	Temperatures
----------------------------	------------------	-------------------	--------------

Source	Color Temperature (°K)
Candle flame	1,900
Sunlight—sunrise or sunset	2,000
100-watt household lamp	2,865
500-watt household lamp	2,960
1000-watt household lamp	2,990
Quartz-halogen studio lamp	3,200
Photoflood and reflector flood lamps	3,400
Sunlight—early morning	4,300
Sunlight—late afternoon	4,300
Daylight blue photoflood	4,800
Carbon arc	5,000
Sun arc lamp	5,500
HMI lamp	5,600
Direct midsummer sunlight	5,800
Overcast sky	6,000
Summer sunlight plus blue sky	6,500
Skylight	12,000–20,000

QUALITY OF LIGHT

It is possible to measure the color temperature and the intensity of light with the proper meters. I will discuss the aspect of intensity later, but for now I would like to deal with the third characteristic of light which plays a very important role in the aesthetic look or "feel" of the scene. That characteristic is the quality of the light. Quality can be judged by the density and sharpness of cast shadows. Granted it is a subjective evaluation, but on one end of our scale we have harsh specular sources that cast dense shadows with sharp, well-defined edges. The highlights are specular and the contrast range is high. On the other end of the scale we have soft diffuse sources that cast transparent shadows with poorly defined out-of-focus edges. The highlights are softened and the overall contrast range is lower.

The quality of the light accounts for the different look of two outdoor scenes. One take is shot on a heavily overcast day. The other is shot at the same location on a bright, sunny day. Despite proper exposure and color balance, the two scenes will look very different because of the quality of the light at the time of shooting.

As a lighting designer you should not only be concerned with putting the right amount of light in the right places, but you should also evaluate and control the quality of the light you use. Fortunately, there is a battery of filtration products available to allow you to do just that. There are accessories to precisely control the quality of studio light and to change the basic quality of exterior light. These diffusion materials will be discussed later in the text.

The majority of lamps used today generate light when an electrical current is passed through a thin tungsten filament. The filament heats up as a result of its resistance to the

flow of electrons. The heated filament emits photons of light that radiate in all directions from many points along its surface. One of light's unique properties is that it does not require a medium in which to travel from place to place. Sound and heat cannot travel through a vacuum, but light can. Sound and heat are slowed down by travel through liquids, but light is not.

The harshest form of light is known as point source illumination, where all of the energy emanates from a single point and travels outward as a series of straight lines like spokes radiating from the hub of a wheel (see Figure 1.8). These straight rays cast crisp, well-defined shadows. There are no crisscrossed rays to soften the edge of cast shadows. This is the type of light present on a bright, cloudless day, like the one described in the previous example. The only artificial light sources that produce near point source illumination are the carbon arc and the HMI lamp.

Since the majority of lighting instruments use some configuration of a tungsten filament enclosed in a glass or quartz envelope, we will take a look at what happens to the light rays that are produced by such multipoint filaments. If we pick only one point along the filament to illustrate the properties of light, we can study the effects that lamp construction have on the visible spectrum (see Figure 1.9).

Figure 1.8: A Radiating Point Source

Figure 1.9: Typical Lamp's Effects on Light Rays

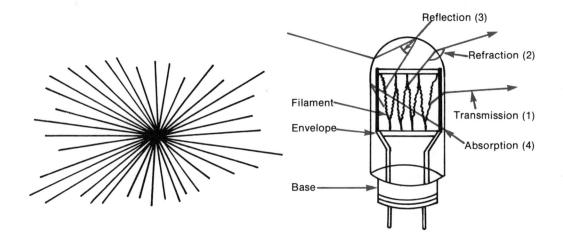

The ray that passes most directly from the filament to the atmosphere outside the envelope is an example of efficient *transmission* (1).

In the process of that transmission the ray is *refracted* (2), or bent, as it passes through the envelope to the outside air. Light will be bent whenever it travels from one medium to another of a different density. The same behavior can be observed in Figure 1.1, which shows light passing through a prism.

The next ray we observe does not pass directly through the envelope. It is *reflected* (3) from the interior surface one or more times before transmission occurs.

A fourth ray does not escape the envelope at all. It is an example of absorption (4). The absorbed ray is converted to heat energy by the envelope. The four characteristics of light shown in this figure are emanating from a single point along the filament. The fact that these behaviors are occurring at an infinite number of points along the filament in a random sequence produces a quality of light that is much less specular than that produced by single point sources. The random aspect of the transmitted rays can be altered and reshaped by the lamp housing, internal reflector and lens system of the instrument.

Lamp Output

While the electric light has been a great boon, a modern-day consumer advocate might argue that it is a device promoted and sold by utility companies to take unfair advantage of the public, to boost corporate profits and to bilk people out of their hard earned money. How could such claims be backed up?

If you wade through a course in physics, you come up with a formula that equates a watt of electrical energy with 673 lumens of light. Therefore it is reasonable to assume that a regular 100-watt light bulb would provide your living room with 67,300 lumens of light. What a deal that would be. The fact is, the box that my 102-watt lamps come in states that the initial light output of each lamp is 1,535 lumens. That is the initial output, and it gets worse as time goes on. Not very efficient. This means that only about 2.25% of the electrical input is converted to visible light. The other 97.75% is converted to infrared radiation (heat) and invisible ultraviolet radiation. If you think that is bad, a lowly 6-watt bulb puts out only about 6.5 lumens per watt. The picture does get somewhat brighter as lamp wattages increase. A 1500-watt lamp produces about 25 lumens per watt. Still it is nothing to write home about. As for studio lamps, they are also incandescent sources and bound by the same set of inefficient circumstances that plague the ordinary household lamp. They are no more efficient than household lamps. In Chapter 3 we will investigate some other, more efficient, methods of generating light. It is generally accepted that tungsten sources produce 20% light and 80% heat.

Invisible Radiation

You just read that some rays of light are converted into heat as a result of being absorbed by the envelope. If you look at Figure 1.2, you will notice that on either end of the visible spectrum there are forms of invisible radiation. At the top is infrared radiation and at the bottom is ultraviolet radiation.

Ultraviolet waves are extremely short and, fortunately, most of them are filtered out by the dust and moisture particles in our atmosphere. Like the gamma rays and X rays

that are shorter still, they are harmful to human tissue—they can cause skin cancer and other problems. They also have a negative effect on photographic film and television pickup tubes. Even though the human eye cannot detect ultraviolet waves, they have an effect on the eye and on the emulsion of photographic film and the photosensitive layer on the pickup tubes of a television camera. In the human eye these waves can cause cataracts. In film and television cameras they cause less accurate color rendition. Though the quality of visible light generated by HMI lamps is very pleasing on the set, you should know that it also produces a high volume of ultraviolet radiation that could be harmful after long hours of exposure.

Infrared light is the longer of the two wavelengths, and far more of these rays penetrate the atmosphere because of their wavelength. They are not easily broken up by the particulate matter in the atmosphere. We cannot see them, but we feel them in the form of heat. In fact, as some of the incoming ultraviolet rays pass through the upper atmosphere, their short wavelengths bounce around the particles and are converted to heat energy or infrared radiation. Like ultraviolet radiation, infrared waves also affect photographic film and television cameras. In some cases the effect is positive, such as infrared photography or night-scopes that allow us to see in the dark. Because of their long wavelengths, they can penetrate clouds and many other substances on earth, much as radio waves do. They are just slightly shorter than our lowest radio frequencies. While they do not cause harm to the human body, they do cause discomfort in the form of excessive heat. HMI lamps produce very little infrared radiation, so the set stays cool.

Instruments like the Mini-cool that are designed to use an MR-16 lamp filter out the harmful ultraviolet radiation and render truer colors on film and tape as well as reducing the potential ill-health effects of ultraviolet exposure. They do generate a lot of infrared radiation, but use a high-tech reflector design that permits heat to pass through it and escape out the back of the instrument rather than be projected forward with the beam of light. The end result is a beam of light that is not hot. Though the heat is projected away from the actor, do not let the name "cool" light fool you. The instruments themselves get very hot and should be handled with the same insulated gloves used to adjust or focus any other lighting instrument that has been operating for even a short period of time. (See Chapter 11.)

FALLOFF

Another property of light that is essential to understand is falloff. Most of us know the catchphrase, "light falls off at a rate equal to the square of the distance," but we store it in that section of the brain reserved for useless information acquired in high school physics. It is not useless, however. It is extremely important to the proper placement of instruments and the selection of accessories. Perhaps an understanding can be gained most easily by looking at a couple of examples.

Example 1: You are shooting outdoors, using only natural light, with the sun located above and behind the camera. Your meter reading of the actor standing closest to the lens reads 5000 footcandles. You move to a second actor standing 25 feet behind the first and

25 feet

5000

footcandles

5000

footcandles

take a second reading. It is 5000 footcandles. You walk to a building 25 feet behind the second actor and take your third reading. Again, 5000 footcandles. (See Figure 1.10.)

Figure 1.10: Lighting Intensity Falloff Outdoors in Sunlight

Example 2: You are shooting in a theater, using a 125-amp carbon arc spotlight to light the scene. It is in the projection booth above and behind the camera. You take a meter reading of the actor who is standing closest to the lens. It is 750 footcandles. You move to a second actor standing 25 feet behind the first and take another reading. It is 490 footcandles. You walk to the backdrop 25 feet behind the second actor and take your third reading. It is 330 footcandles. (See Figure 1.11.)

5000

footcandles

25 feet

In example 1 (Figure 1.10) there was no difference between the readings, though there was a 50-foot difference between the point of the first meter reading and that of the third. In example 2 (Figure 1.11) there was a 260-footcandle difference between the first reading and the second, 25 feet away, and there was a 160-footcandle difference between the second and third readings, again 25 feet apart. This was a total difference of 420 footcandles over the 50-foot distance. Less than half as much light is reaching the backdrop as reaches the first actor. Why the difference? What principles are involved? And how should they guide us in placing instruments?

While math is not my strongest suit, it is necessary to look at a formula here for computing falloff, $F = 1/d^2$. It states that light falls off at a rate inversely proportional to the square of its distance.

Whenever I resort to anything as distasteful as mathematics, I do so to clarify a concept that must be fully understood to avoid lighting attempts that are doomed from the start. The test of the following information will not be whether or not you can compute falloff

Figure 1.11: Lighting Intensity Falloff Indoors in Artificial Light

using the formula, but whether you position instruments in the most effective spots on troublesome locations.

For example, in Figure 1.12, if we place a light 4 feet from the head of a subject and square that distance, we will get a value of 16. This represents a given amount of light. The distance from that same instrument to the subject's shoes is 8 feet. When we square that distance, the value is 64. Using the resulting fraction, 16/64, we see that only 25% of the light that reaches the subject's head will reach the shoes. That is a 4 to 1 exposure ratio, hardly even lighting.

Using the same formula and placing the instrument 12 feet from the subject's head, we find that 66% of the light that reaches the head will reach the shoes. That is a 41% improvement over the first case. Moving the instrument back 16 feet from the subject's head means 75% of the light reaching the subject's head would reach the shoes—an overall improvement of 50% in the falloff of light between the subject's head and feet.

The example shown represents ideal mathematical structures. In actual practice the results are not that precise, owing to design considerations of the light source and its lens systems. However, the lesson to be learned is that you should place instruments as far from subjects as possible to eliminate severe falloff problems.

You should understand that by moving the source farther from the subject you will be decreasing the overall light level by a factor that is inversely proportional to the square of the distance. However, that reduced level will be more evenly distributed over the subject. In Figure 1.10, there was no difference in the meter readings because the sun is so far away that falloff is not measurable over reasonable distance changes. If you were to

take a meter reading on the top of a very tall building and at ground level, there would be no measurable difference between the two readings because of the extreme distance between the sun and the relatively close distances between the two readings on earth.

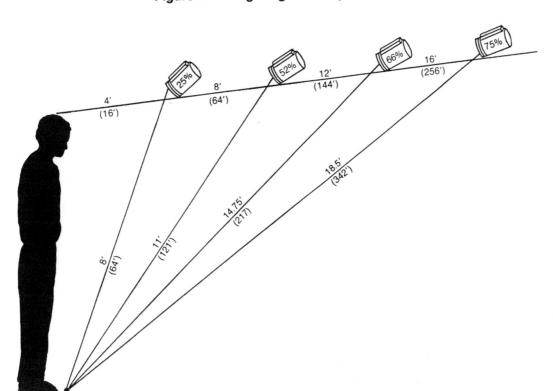

Figure 1.12: Lighting Intensity Falloff

When working in homes and offices with low ceilings, there is a tendency to place the camera and lights close to the subjects to lessen the lighted area and reduce power requirements. This becomes problematical when there is any movement by the subjects. If they stand, their heads suddenly seem to fluoresce while their lower bodies are underexposed. Raising the instrument as high as possible and moving it back as far as possible will help even out the great differences in intensity between seated and standing subjects.

Once you have done what you can to let physics reduce the effects of falloff by moving the light as far from the subject as possible, you must turn to accessories to complete the elimination of the problem. There are three different things you can do to even out the light on a subject that moves closer to, or farther from, the light source during a scene.

The simplest solution, if your instrument is equipped with an accessory shoe, is to place a graduated scrim in it and turn the scrim so it reduces the light at the top of the beam. Graduated scrims are invaluable tools and come in many degrees and configurations. You can achieve the same effect using ordinary window screen in a gel frame holder, and the shape of the reduced intensity area can be tailored to specific situations. Another

quick fix is to place a section of neutral density (ND) filter in the top portion of a gel frame and insert it in the accessory shoe.

The third solution involves a little more hardware, but the philosophy is the same: reduce the light output in the upper portion of the lighted area. If you are using an instrument without an accessory shoe, you can mount scrims, nets or ND material on a separate stand and place them in front of the source. This method actually offers the greatest control. The greater the distance between the source and the diffusion material, the more pronounced the transition will be.

A graduated scrim can be turned to reduce the lower half of the light beam from a key light to keep excess footcandles off a white suit coat and still provide enough light on the face of a dark-skinned subject.

The rate of falloff differs from instrument to instrument depending on the make and type. Falloff from softlights and floods is greater than falloff from spots because of the diffuse nature of their rays, which dissipate more rapidly. Specular sources fall off less rapidly because their rays are parallel.

The hard part is over. If you have understood all of the information in this first chapter, the remainder of the text will be as easy as burning your fingers on a barn door.

2 Meters, Monitors and Scopes: Looks Good Here!

One of the common wisecracks in television is "Looks good here!" It is uttered by someone who is claiming that the signal is fine at that end, and if there is a problem, it must be the fault of the person at the other end of the line. That "other end" may be down the hall from the studio in the tape room or it may be across the country after several microwave links and a satellite hop. Regardless of how complex the ultimate link is, the fact remains that the original signal must be technically correct.

METERS

The light meter and the color temperature meter are the only tools available with which to predict the final outcome of cinematographers' efforts. They combine those tools with their experience to form judgments about exposure and color temperature correction. In most cases that is enough to get the job done, and good cinematographers will rarely mess up. However, they can never be completely sure of their exposures until they view the processed film.

Light Meters

To maintain proper lighting ratios and exposure ratios it is necessary to use a light meter calibrated in footcandles. There are two kinds of light cells in use in meters today: (1) selenium cells and (2) cadmium sulfide cells. Selenium cells generate a current that is proportional to the amount of light falling on them. The cadmium, or CDS, cell modulates the current provided by a battery in a manner directly proportional to the amount of light reaching the CDS.

Even though CDS meters are more sensitive than selenium cell meters, their added sensitivity is of no value to you if you are shooting in areas that are extremely dark, simply because it will be too dark to make good pictures under such adverse conditions. That added sensitivity helps the photographer who can shoot under all types of natural lighting conditions with extremely fast film. Other qualities dealing with ruggedness and ease of use make CDS meters a good choice for the videographer. Selenium light cells and the CDS type of cell are used in meters of two general types.

Reflected Light Meters

The auto iris system in the television camera is really a form of a reflected meter. It reads the total light reflected by the subject and adjusts the iris so that the camera does not produce a signal strength greater than a preset value, usually 100 IEEE units. IEEE (pronounced eye triple E) stands for the Institute of Electrical and Electronics Engineers. If you are my age you may still refer to the IEEE as the IRE (Institute of Radio Engineers), but it has merged with the AIEE (American Institute of Electrical Engineers) and changed its name. The IEEE scale on the waveform monitor ranges from -40 IEEE units to 140 IEEE units. As a point of reference, -40 IEEE units = .3 volt and 140 IEEE units = 1 volt.

Like a camera's auto iris system, the hand-held reflective meter measures the total light reflected by the scene. It is aimed at the scene from the camera position and the reading is taken, producing an *average* reading for the scene. If you are more concerned about specific areas, such as the flesh tones of an actor, you can walk close to the subject and point the meter at the actor's face with your back to the camera. A warning about the obvious: be sure not to cast a shadow on the subject when you take your close reading.

Spot meters are a specialized form of reflective meters. (See Figure 2.1.) They measure a narrow angle of the total scene, usually 1°. They have a built-in reflex viewing system so that you can determine the area being metered and are useful for measuring specific parts of the scene from the camera position. If you are shooting a singer who is lit by a spotlight on a dark stage, a normal reflective meter will yield incorrect readings if it is used from the camera's position in the auditorium. From the camera's position, the spot meter can be aimed to measure only the brightly lit singer to yield a valid reading for exposure purposes.

But why use a light meter at all if this form of metering is the same as the camera's auto iris system and the waveform (WF) monitor, which gives you very precise and accurate measurements on any section of the scene. The reason is that it is far more portable than a camera and WF monitor and will permit you to light a scene without having to set up expensive video gear and pay a technical crew to stand by while you do your thing. Final decisions about exposure can be made once the camera system is up and running. At that time you can use the camera and waveform monitor to give you absolute assurance of the end results and to make critical decisions about the final look of a scene before rolling tape.

Incident Light Meters

Incident meters are used by standing near the subject and aiming the meter's light-sensitive cell toward the camera. (See Figure 2.2.) The cell may be covered with a hemisphere or a flat disk of some translucent material. The purpose of this translucent material is to filter out certain wavelengths in the spectrum that could cause the cell to give incorrect readings. Just as the television camera must be aimed at a standard white card during white balance (see Chapter 1) to produce an accurate color signal, light meters are calibrated against a standard at the time of their manufacture. They are calibrated to express accurate exposure readings when the light being measured is reflected from the surface of an 18% gray card. The dome or disk, known as a diffuser, converts the incoming light to the 18% gray card standard. If the diffuser were not in place, the light would shine directly on the cell and result in a nonstandard reading.

Figure 2.1: Spot Meter

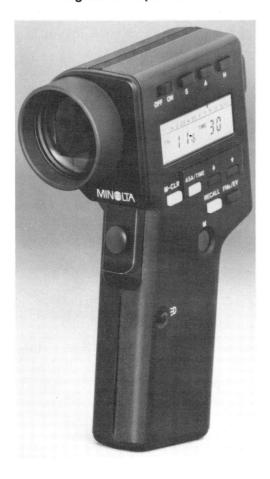

Figure 2.2: Incident Meter

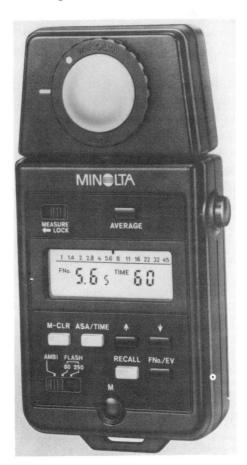

Photo courtesy Minolta Corp.

Photo courtesy Minolta Corp.

The hemisphere or dome diffuser allows you to measure light from as great an angle as 300° so you can measure all the lights focused on a subject.

The flat disk diffuser has a narrower angle of acceptance, usually about 50°. This allows you to measure the output of a specific instrument that is aimed at a subject lit by multiple instruments.

As you take your readings, be sure to aim the disk or dome toward the camera. Especially in the case of the domed meter, do not block any of the light that would normally fall on the subject in the position you are metering. The domed meter is particularly helpful when you are trying to set and focus individual instruments used to light an actor's blocking. (Blocking is the path that actors are asked by the director to take when moving from point to point on the set.) It is important that you know where actors will be moving during the shot before you begin your lighting setup. Face the cell of the meter toward the camera and walk through the blocking to see the combined effect of all the instruments. (Many meters allow you to swivel the cell portion of the meter so you can see the reading from the back side of the cell while it is facing away from you toward the light.) You can let the meter guide you in your instructions to the grip (see Chapter 5 for an explanation of a grip's role) in terms of the placement and focus of each unit. Lighting intensity can be consistently maintained throughout the blocking pattern if that is your intent, or you may wish to create areas of light and shadow.

Placing the dome on the meter is helpful when you are taking readings to determine the exposure ratio of the set so that you can establish and maintain lighting continuity from shot to shot. If you walk to the foreground of the shot and take a reading, you can adjust the light to your predetermined level. Then you can move to the background area of the set and adjust the light so that you can maintain your predetermined ratio for that scene. We will discuss ratios and continuity in the next section of this text.

Videographers, unlike filmmakers, have other tools available to help them determine what the exact results of their efforts will be. We will cover those in a minute, but first we will discuss a second instrument common to video and still or motion photography.

Color Temperature Meters

Just as the intensity of light can be measured with a light meter, the color spectrum of light can also be quantified through use of a color temperature meter. One of the easiest meters to use for this purpose is the Minolta Color Meter II. (See Figure 2.3.) Its relatively high cost may be a valid reason for not having one of your own in your gadget bag, but there clearly are times when one should be rented for site surveys and actual shoots where you will be confronted with light sources operating at a variety of color temperatures. As indicated in Chapter 1, it is important to know the relative amounts of red, blue and green light in the various sources that illuminate your scene.

The color temperature meter is used in much the same way as an incident light meter. The meter's diffusion disk is aimed toward the source in question, and a built-in microcomputer memorizes several important factors about the light source. When you push the button

marked "K," the actual color temperature is digitally displayed in degrees Kelvin in the meter's readout window.

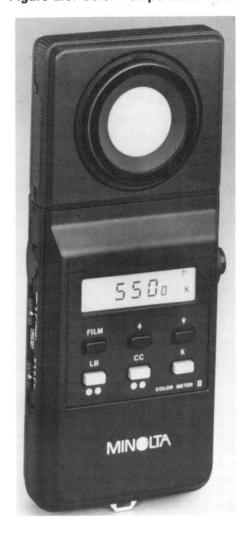

Figure 2.3: Color Temperature Meter

Photo courtesy Minolta Corp.

When you push the button marked "CC," the meter displays the color compensation index in a plus or minus figure. A reading of +3, for example, would indicate the need to filter a cool white fluorescent source with a 1/4 Minusgreen filter to balance with a 5600 K daylight setting on your video camera. The correct filter to use for a given reading is indicated on a chart that is printed on the back of the meter. While the chart is calibrated for film rather than video, a free Cinegel overlay that correlates the values displayed by the meter with Rosco's video filtration media can be obtained from Rosco.

This overlay is the same size as the chart on the back of the meter and can be peeled from its backing and stuck over Minolta's chart.*

If you push a button marked "LB" on this meter, you will get a reading indicating the correct light balancing index for the source light. For example, a reading of -131 would correlate to the need for use of Tough Blue 50 to boost a 3200 °K lamp to match existing daylight sources according to the Rosco overlay mentioned previously. The letters "CC" or "LB" will appear in the window along with the index number so there is no confusion regarding which area of the conversion chart you should refer to.

Knowing exactly which conversion filter materials to use in order to color correct for various mixed color temperature sources can save a great deal of time and money when you are faced with difficult lighting situations. Earlier color temperature meters were more difficult to use and were designed in such a way that an error in reading the analog displays or interpreting charts was likely to contribute to some problems in selecting the correct filter material. The digital meter, combined with recent developments in filter material, makes it possible for good color correction to be made on location in seemingly impossible situations.

ADDITIONAL TOOLS

Videographers have three tools that are unavailable to filmmakers which assist in achieving proper exposure and color balance—the color picture monitor, waveform monitor and vectorscope. Used properly, these tools can guarantee results. They may also be responsible for failure of some people in video to really learn their craft.

There is a tendency among some video people to think the camera's auto white circuits will take care of problems involving sources with mixed color temperatures, that the auto iris will take care of exposure and the zoom lens will permit convenient camera location to get the shot quickly. What more could you want? Some cameras will even focus automatically.

Accomplished film people would laugh at such thinking. They will have specific goals in mind when a scene is shot and be concerned about such things as depth of field, contrast ratios, exposure ratios, film stock, filter packs, lens focal length, camera angle, etc—things that some video people do not consider or even know about. Personally, I have only shot about 10,000 feet of motion picture film in my life, so this statement does not come from someone schooled in the film community who has converted to video. I realize that film people have been in the business of exposing life to a recording medium for a great deal longer than video people have, and they have learned their craft well. There

^{*}Many manufacturers do not recognize the fact that many of their products can be used for video as well as for film and they make no mention of that fact in their design and advertising. Such lack of promotion should not discourage use of these highly useful products in your video productions.

should be no arguments between practitioners of the two media. They share common problems and can use common solutions. Each medium has its own unique advantages.

Perhaps if the motion picture industry had grown up with all the automatic tools commonly available to today's video crews, they would have become as lazy as some members of the video community.

In addition to the light meter and color temperature meter used by film crews, video lighting directors have the color picture monitor, the waveform monitor, and the vectorscope to guide them in determining proper exposure and achieving a specific look. The purpose of discussing these technical aspects is not to make you a technician. It is intended to give you an understanding of how these tools can assist you to consistently obtain the look you want. It will also prevent you from being bullied by the technician whose solution to all problems is to demand more light. You should know what the system can and cannot do. Generally speaking, if your color monitor is properly calibrated, what you see is what you will get. There may be problems in the nonvideo areas of the signal, such as sync and blanking, that require technical attention, and the waveform monitor and vectorscope will assist the technician to discover and correct them.

Color Monitor Setup Procedures

The waveform monitor will provide you with the greatest amount of technical information about your setup, but a properly adjusted color monitor is your best friend when you are making decisions about the aesthetic aspects of the picture. Is the depth of field what you want? Are the exposure ratios correct? Does the lighting lead the viewer's eye to the center of interest? Is the mood of the scene correct? Can you see the detail you are looking for? Is the picture noisy in the dark areas or overexposed in the highlights? These last two aspects can also be determined by using the waveform monitor.

I have been on location when people looked at the monitor and said that they did not like the look of the shot. Perhaps they wanted more detail in the dark areas. Instead of changing the lighting or some aspect of the camera setup, they adjusted the monitor until they saw what they wanted. Such people should be locked up someplace. At the very least, the controls on their monitor should be locked to prevent them from "improving" the picture.

You need an accurate, calibrated visual indication of the camera's signal. You should invest in a high-quality monitor because cheap color sets will not render colors accurately and are, in fact, designed to mask noise and other factors that are sure to show up on good monitors in the post-production suite later on. Once the monitor has been properly set up using the correct test signals, *it should be left alone*. If the scene does not look right to you after monitor setup is complete, change the lighting, the f-stop or some other aspect of the camera setup until you achieve the look you want. Diddling with the monitor will do nothing to correct the problem, and it will make any later evaluations you make with that monitor invalid.

Using Test Signals

As mentioned in Chapter 1, the camera produces a proper color signal based on its ability to reproduce white. White is the reference used in the auto white balance procedure. A similar situation holds true with a color monitor. The technician should begin the setup by making sure the set is properly converged so the red, blue and green guns are not misaligned. Once that is accomplished, continue the setup procedure using a monochrome or black-and-white signal. A gray scale generated by a signal generator is preferred, but if you do not have a test signal generator, you can play back a videotape of a black-and-white movie or a gray scale produced by a signal generator. If you use a black-and-white movie, you should select a scene that contains black areas, gray areas and white areas. If the monitor introduces any color or tint into the picture from your monochrome signal, a technician should adjust the screen and gain controls of the monitor. Again, these are adjustments that you should not make yourself.

You may be tempted to shoot the chip chart with your color camera to perform this test, but this would not provide a true black-and-white signal, and if the resulting image on the monitor showed signs of color anywhere, you could not be certain if the problem was the result of improper monitor adjustment or incorrect camera encoder setup.

Unfortunately, there is no scientific method of establishing precise monitor setup in the field without expensive lab equipment. Even though there is still room for error in the first method described here, using test signals will provide far better results than will any random adjustments based on subjective viewing of regular program material. The second method, employing SMPTE color bars, is extremely easy and accurate.

Color Bars

This next step in the setup process is subject to error caused by your visual perception, but it should be reasonably accurate. Using the monochrome signal, adjust the monitor's brightness control for proper levels of the black areas of the picture. The details in those areas should be readily apparent. If the monitor is equipped with cross-pulse capabilities, activate the cross-pulse signal and adjust the brightness so that the blackest picture area is just slightly brighter than the blanking area. (See Figure 2.4.) This is one adjustment that will change from location to location, depending on the ambient light falling on the face of the screen. Naturally, you should try to position the monitor so that bright studio lights or the sun will not wash out the picture.

Before continuing, a word about color bars. There are three basic types of color bars generated by cameras and test equipment. The first standardized bars conformed to the Electronic Industries Association (EIA) standards of 1967. Technically they are RS-189 bars, commonly known as full-field bars, illustrated in Figure 2.5. These were revised in 1976 to become RS-189-A bars, commonly known as split-field bars. (See Figure 2.6.) Though both versions are intended for use in setting up color monitors, among other things,

they are not very well suited to the task. They serve other test functions far more efficiently than providing a standard for color monitor setup. During the monitor setup procedure just described, it was assumed that a version of EIA bars was all that you had available.

Figure 2.4: Image from a Cross-Pulse Monitor and Blanking Information

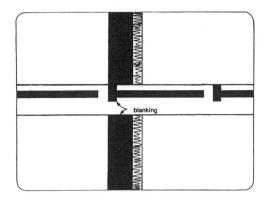

Photo and illustration from Professional Video Production (Knowledge Industry Publications, Inc.)

Figure 2.5: EIA Full-Field Color Bars (RS-189)

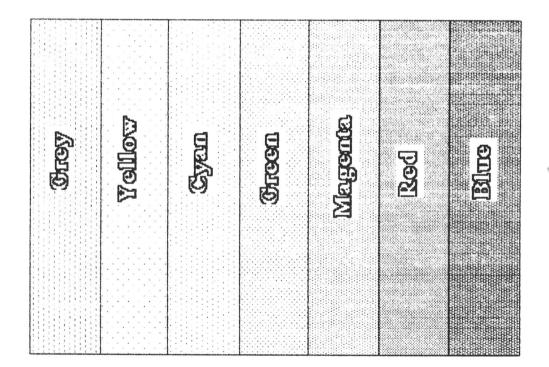

In 1978 a SMPTE committee report recognized the shortcomings of EIA color bars with respect to monitor setup and proposed the color bars shown in Figure 2.7. At last

there was some science to an otherwise educated-guess procedure for monitor setup. As with many good ideas, this one about an improved form of color bar was not widely accepted until recently. I cannot imagine why.

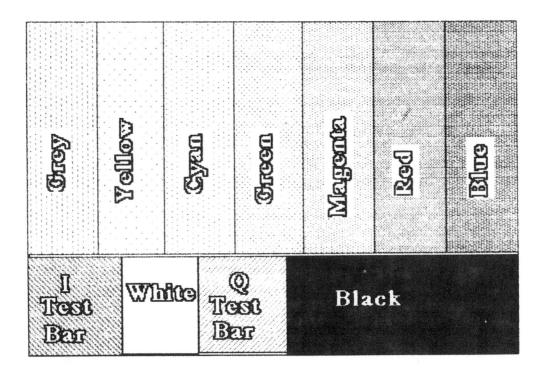

Figure 2.6: EIA Split-Field Color Bars (RS-189-A)

A simple and accurate brightness setting can be accomplished using the SMPTE color bars. Brightness is set with the aid of the three vertical black minibars that are located in the lower right-hand corner below the main red bar of the signal. The three black bars are very close in value specifically to provide a reliable key to brightness adjustment.

The left bar of the trio is just a bit blacker than black. The small center bar represents true black. The right bar is just slightly brighter than true black. The idea is to adjust the brightness control of the monitor so that the bar on the left cannot be seen. If it is visible, the brightness control setting is too high. If the bar on the right cannot be seen, the brightness control setting is too dark and should be brought up just enough so the right bar is visible. At the proper setting the blacker-than-black minibar and the center, true black bar will not be visible. Only the whiter-than-black bar should be visible. This simple, foolproof method of adjusting brightness is more accurate than the cross-pulse method previously mentioned and requires less time, fewer test signals and assures far greater accuracy.

Black

Tellow
Cyen
Cyen
Cyen
Red
Red

Figure 2.7: SMPTE Color Bars

Adjust the contrast control for proper levels in the white picture areas. Details should be visible in the white areas, and the brightest white produced by the monitor should not be so bright that it causes eye strain. Like the adjustment of the brightness control, the contrast adjustment will change from location to location depending on ambient light conditions.

Color Reproduction

eodd W

Once you have adjusted the brightness and contrast controls, you are ready to start making adjustments that affect color reproduction. If you use the older EIA bars, change your signal source from a monochrome tape or signal generator to the color bars from your camera or a signal generator. Obviously, the camera is the least complicated source for this signal, especially on single-camera shoots.

The two controls involved in color adjustment are the color and hue, sometimes called tint.

The color control adjusts the saturation or amount of color present. It should be adjusted so that the color bars appear normal and are not oversaturated. When colors are oversaturated, they begin to "bloom" or "bleed" into the colors that surround them. Usually when you are looking at full or split-field color bars, the red bar is the first to bloom into the magenta bar on its left and the blue bar on the right when the color control is set too high.

The hue or tint control is perhaps the most subjective adjustment of all. The idea is to adjust the hue so that the colors appear natural—not too red and not too green. I prefer to make the adjustment watching the red and magenta color bars. When the magenta is correct, not too red and not too blue, I am satisfied with the setup. Some like to make this judgement watching the cyan bar. Your preference about which bar to use as a reference for hue setup should be based on your own sensitivity to color.

Using EIA bars, it is a bit tricky to adjust the color (saturation) and tint (hue) properly. If your monitor has a "blue only" setup switch, you should activate the setup switch so that only the blue gun displays the color bar signal. Rotate the color control so that the outer two blue bars are of the same brightness. The hue control should be adjusted so the inner two bars of blue are of equal brightness. When all four bars are of equal brightness, the monitor is properly set.

One of the most difficult judgments to make is determining when the outer two bars are equally bright when adjusting the color control. Their distance from one another is the biggest factor in making your judgment. Since the inner bars are closer together, the hue adjustment is a bit easier. No matter how good a job you think you have done using EIA bars, you will find that no two people seem to come up with the same settings using the same bars on the same monitor. A better mousetrap was needed.

Here is the SMPTE solution. That narrow row of seemingly useless colors below the regular color bar display of the SMPTE signal is an ingenious blend of tints that can be used in conjunction with a blue-gun-only setup switch to provide completely accurate color and tint adjustment. It is foolproof.

The idea is to display the SMPTE bars using the blue gun only and adjust the color and tint controls so that the upper portion of each bar is the same brightness as the smaller section at its base. This is a very easy judgment to make since the two sections are always contiguous and the slightest discrepancy in brightness is easily discerned. When each of the seven segmented bars looks the same from top to bottom, you have accurate adjustment of the color and tint controls.

Once the monitor is adjusted, keep your fingers off the monitor controls. If the set is lit and you do not feel there is enough detail in the black areas, add more light. *Do not* mess with the brightness control of your monitor. If white areas of the picture are losing detail, reduce the light falling on them or, in the case of windows with natural sunlight coming through, increase the neutral density (ND) filtration. If you have no additional ND filter material available, use the color monitor and waveform monitor as guides to stop down until you get the detail you are seeking. Then you will have to add more base light to the scene to keep the black areas from compressing to the point where excessive detail is lost in the dark areas.

If the picture looks good on the monitor, and by good I mean that it conveys the mood or atmosphere you want, do not let the engineer bully you into adding more light because 100 IEEE units are not present somewhere on the waveform monitor. Not every scene must have a full range of brightness from black to peak white.

Waveform Monitor

The waveform monitor (WFM) has two basic functions. It measures the amplitude and the timing of video signals. For a lighting director, the only concern is with the measurement of the amplitude of the signal. The amplitude has a direct relationship to the brightness of any area of the picture. For this reason, you can use it as both a spot meter and a reflective meter.

You should be familiar with two technical matters associated with the WFM. The first is its unit of measurement. A light meter is calibrated in footcandles. The WFM is calibrated in IEEE units.

The IEEE scale is etched on the left side of the face of the WFM as shown in Figure 2.8. Your concern is with that portion of the signal between the 7.5 IEEE unit mark, which represents TV black (referred to as Setup), and the 100 IEEE marking, which represents TV white. The portion of the signal below the 7.5 unit level is the responsibility of the engineer.

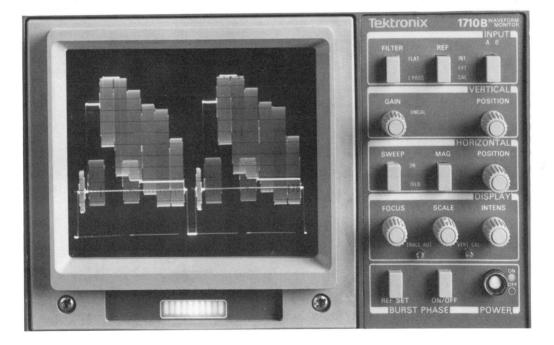

Figure 2.8: Waveform Monitor

Photo courtesy Tektronix, Inc.

The WFM will give you exact information about the intensity of all areas of the scene and the individual elements in a given area. You can meter each shot with the WFM and make a note of the brightness of various elements. You can view the brightness of all elements of the shot, or you can zero in on specific areas in close-up (CU). Note the level

of specific areas, such as the background, in your first setup for a series of shots and then check the next setup to make sure the level is the same for each area noted in the establishing shot. If the values are the same from shot to shot, you know you will have no trouble matching ratios during post-production. Be especially observant of peak white and black areas so they do not bounce around from shot to shot in a given series.

Sections of the WFM display may be viewed in normal or expanded detail to give you precise information about any specific area of the picture. In this way it functions somewhat like a spot meter, but it provides far more accurate information. While the waveform monitor is actually the responsibility of technicians, you should use it to fine tune your efforts. In general, keep flesh tones from 40 to 50 IEEE units. Highlights should be at about 85 units with burnouts (such as practical lights on set, or a window) at 100 units. Ask your engineer to set the clips in your camera at 100 units rather than 110 IEEE units as some do.

The second technical matter you should be aware of is the *filter* switch. Be sure the WFM is not in the flat response mode when you take your readings. In the flat response mode, it will display the color (chrominance) information as well as the brightness (luminance) information. Your only concern should be with brightness or luminance information. The filter button has two positions, flat or 1 pass (low pass). Use the 1 pass position for your readings; it will remove the color information.

The waveform monitor has a Vertical Rate Display mode and a Horizontal Rate Display mode. In the vertical mode (see Figure 2.8) it displays each complete field of the television picture. The left half of the display is Field One (Lines 1, 3, 5 and so on). On the right is Field Two (Lines 2, 4, 6 and so on). This setting allows you to evaluate the entire picture. If you want to check the brightness of a specific small area, you can zoom to a CU and observe the WF display.

In the Horizontal Rate Mode, the timing of various elements of the signal can be checked, but this mode is for the technician's use only.

Vectorscope

The vectorscope provides information about the two chrominance aspects of color, *hue* and *saturation*. Its circular display is divided into 360 1° increments. (See Figure 2.9.) The six primary and secondary colors are represented by boxes etched at various positions within the circle on the faceplate. The saturation of the color can be determined by the length of its trace from the center of the display.

As a lighting director you can use the vectorscope to help you maintain color consistency of a given element in the scene from one shot to the next. A client's logo or product color is sure to be a very important element in any shoot, and there is an easy way to make sure that the last shot looks as good as the first one the client raved about.

(Red) (Magenta) 103.7° 61.3° 59 Q-33° (Yellow) 167.1 20 30 40 50 60 70 0° Color reference (Chroma-level scale) 1809 burst 347.1° (Blue) 59 I-303° 241.3° 283.7° (Green) (Cyan)

Figure 2.9: Vectorscope Display Parameters

Illustration from Professional Video Production (Knowledge Industry Publications, Inc.)

A surefire trick that I employ is to light the first shot to the client's satisfaction regarding product color rendition. Say the product is a set of bright red shock absorbers. Once the product's hue and saturation have been established, you can take a grease pencil and mark the trace that represents the product on the faceplate of the vectorscope. If you are unable to determine which portion of the vectorscope's display represents the product in question, zoom in to a close-up and fill the screen with the product. Now the product's trace on the vectorscope will be obvious. Follow that trace on the scope as the camera operator zooms out to the shot called for by the director. With the iris set for that shot, mark the trace with a grease pencil on the faceplate of the vectorscope or on a piece of acetate you have placed over the faceplate. Now you will know the exact color of the product and the saturation of that color. In the case of the red shock absorber, the trace will be near 260° out a specific distance from the center of the display. The position of the trace in degrees indicates the color, and the length of the trace from the center tells you what the saturation is.

When you light the product shot that will precede or follow your first setup, you can check for matching hue and saturation on the vectorscope by comparing your grease pencil mark to the current trace of the product on the scope. Adjustments may be required to produce a similar trace on the scope, but once the product trace of the current shot matches the earlier marking, you know the shots will cut together in the edit suite.

The technician will use the vectorscope for other purposes, but this is one way you can use the tool to assist with your job function. Again, it's another assurance unavailable to the filmmaker that you have at your fingertips.

			,	
				1

Lamps, Reflectors and Lighting Instruments: What Is the Difference?

There are two basic types of illumination: specular and diffuse.

Specular illumination is the type found outdoors on a bright sunny day, when the light rays are strong, sharp and nearly parallel to each other. As a result they cast sharp, well-defined shadows on your exterior location site. There are also artificial sources of specular illumination for use in the studio or on exterior sets. They are carbon arc sources or specially designed discharge lamps with smooth, well-polished reflectors and some form of lens system.

Diffuse illumination is the type seen on a cloudy, overcast day when the sun's rays are diffused by the clouds to produce soft, scattered rays. Under these conditions the rays are not parallel to each other and produce flat lighting with poorly defined shadows. This type of lighting can be simulated in the studio as well, using special instruments or placing a diffusing material between the lamp of any instrument and the subject. It is also possible to create diffuse light outdoors on a sunny day, in a limited area, by placing a large piece of diffusion material, called a butterfly, between the sun and the subject. Naturally, there is a limit to the area you can tent in this manner. (See Figure 3.1.)

LAMP TYPES

As lighting director you have total control over the look of the finished product when you shoot in the studio, and you have a wide range of control on exterior locations. One of the first options you have is your choice of lamp types. The term *lamp* does not refer to a kind of lighting fixture, like a table lamp, but to what is commonly called a light

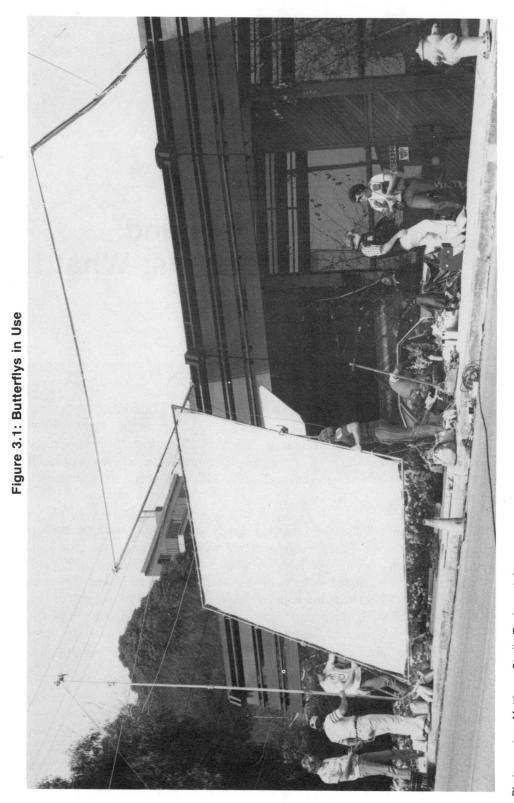

Photo courtesy Matthews Studio Equipment, Inc.

bulb. A tulip farmer deals with bulbs...a lighting director deals with lamps. A lamp is an envelope that contains a filament. Lamps are rated in terms of the wattage they draw. Generally speaking, you expect a 1000-watt lamp to be twice as bright as a 500-watt lamp. While this is true when comparing lamps of a similar type, we will see that it is not always the case. We will take a look at come common lamp types.

Household Lamps

The most common type of lamp is the one used in ordinary household fixtures. It consists of a tungsten filament enclosed in a pear-shaped glass envelope that contains a mixture of gases. Usually the lamp contains a frosted coating on the inside of the envelope to produce a more pleasing, diffuse light with soft shadows and has a medium screw base. These lamps burn at a color temperature below 3200 °K and are generally not suitable as a light source for video. There are two similar-looking lamps that are exceptions to this rule.

Photo Lamps

The first is the photo lamp (see Figure 3.2). It comes in two types, 250-watt ECA and 500-watt ECT. These lamps fit into ordinary household sockets and burn at a color temperature of 3200 °K. They are inexpensive and available at most photo supply stores.

Figure 3.2: Photo Lamp

Photo courtesy GTE Products Corp.

They can be used in place of household lamps when shooting interiors to provide practical illumination that matches the color temperature of your location lighting instruments.

The second type is the photoflood lamp (see Figure 3.3). Shaped like ordinary reflector flood lamps that screw into household sockets, these 3200 °K lamps provide an even, directable light source suitable for a variety of location lighting situations.

Figure 3.3: Photoflood Lamp with Barndoor

Photo courtesy Mole-Richardson Co.

All of the lamps mentioned so far share a common problem inherent in their design. As the filament burns, particles of tungsten evaporate and are deposited on the inside of the glass envelope in the form of a dark powder. This process continues throughout the life of the lamp causing a continual reduction of color temperature and a decrease in light output. The older the lamp, the lower its color temperature and lumen output. Early tungsten studio lamps, used in scoops, Fresnels, Lekos and other instruments, were manufactured

like large versions of standard household lamps. They were clear glass envelopes with different base designs to align the filaments properly with the instrument's optics and reflector. Like regular household lamps, they also grew darker and changed color temperature as they aged. To counteract these shortcomings and increase the useful life of larger lamps of this type, the manufacturer put sand inside the envelope. The instruments were designed to be used with the lamp burning base down. During operation the sand rested in the base. When the vaporized filament deposited a visible black film on the inside of the envelope you could shake the sand around inside to remove the tungsten film from the inner surface of the envelope. When the shaking was completed, the blackened material would settle with the sand to the base of the lamp. This first form of dry cleaning could have been called one-watt martinizing.

Quartz-Halogen Lamps

The problems of light loss and declining color temperature were solved with the invention of the quartz-halogen lamp. Currently the most common light source for interior location lighting, these lamps offer several distinct advantages over earlier tungsten lamps. They are much smaller than earlier designs of comparable wattage, making possible smaller and lighter fixtures for location lighting. The tungsten filament of these lamps is enclosed in a quartz envelope that is filled with halogen gas. The quartz envelope can withstand greater temperatures than the glass envelope, making the smaller lamp size possible.

Thanks to a man named Emmet Wiley who developed the halogen cycle, these lamps maintain a constant light output and color temperature throughout their lives. Even though their filament evaporates like those in common household lamps or earlier tungsten studio lamps, it is constantly being regenerated. As a result of the halogen cycle, the evaporated tungsten is never deposited on the inside of the envelope. Instead, it is redeposited on the filament to maintain consistent output and color temperature.

The majority of quartz-halogen lamps have clear envelopes and produce specular light with their relatively small filaments that are enclosed in short quartz envelopes (see Figure 3.4).

If you want softer, more diffuse light on the set, there are quartz lamps designed to produce less specular light. These lamps have a longer tubular shape to provide greater filament area (see Figure 3.5). Some have frosted and textured envelopes to diffuse the light further. Though some of these lamps are used in broads which produce a fairly harsh light, others are used in fixtures designed to provide softer, more even illumination such as scoops or softlights. Even though these lamps produce a softer light, I still do not consider them to be a diffuse source unless they are housed in a softlight. Any other openfaced instrument, like those commonly found in location lighting kits, will require the use of diffusion material in front of the lamp to produce a truly diffuse light.

A couple of points to remember when working with quartz lamps. Never handle them with your bare fingers. The oil from your skin will react with the quartz envelope and

cause a blister to form on the quartz envelope when the lamp is turned on. The blister will expand until the envelope explodes. Obviously, this could harm people and material on the set. Always use gloves to replace lamps, or use the paper or foam cover that comes with each lamp. If you do touch a lamp by accident or if you aren't sure if someone else may have touched it, you should clean the lamp with a soft cloth soaked with isopropyl alcohol. Even if you take these precautions, point open-faced fixtures away from people and set decorations when you first turn them on. If it should explode, you can minimize the harm done.

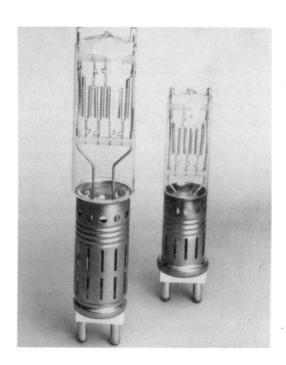

Figure 3.4: Quartz-Halogen Lamps

Photo courtesy GTE Products Corp.

When installing the longer, tube-type lamps that have contacts on both ends, you may wonder where to place the small bump that exists on the surface of the lamp. This is a result of the vacuum sealing process in manufacture and it does not make any difference whether this seal is facing the reflector or the front of the instrument.

You should pay close attention, however, to the manufacturer's instructions regarding the correct operating position of the lamp base, up or down. Failure to follow these recommendations will substantially shorten the lamp life and may cause damage to the instrument's socket.

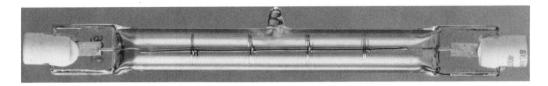

Photo courtesy GTE Products Corp.

PARs and FAYs

Two types of quartz halogen lamps, PARs and FAYs, are constructed like automobile headlamps. That is, the filament and reflector are sealed together in a quartz envelope with the front surface of that envelope acting as a lens and the silver-coated neck of the lamp acting as an internal reflector. They are manufactured to provide one of three basic patterns of light distribution; spot, medium flood or wide angle flood. If you need to change the focus of instruments using these lamps as light sources you must install new lamps of the appropriate focal length. The PAR type lamp is a 3200 °K source (see Figure 3.6) and the FAY lamp is a 5600 °K source because of a dichroic coating on the front surface of the lens. This coating has a tendency to wear off and cause a shift in color temperature as the lamp ages, or as the result of being touched during installation, setup, strike or packing.

Figure 3.6: PAR Lamp with Available Lenses

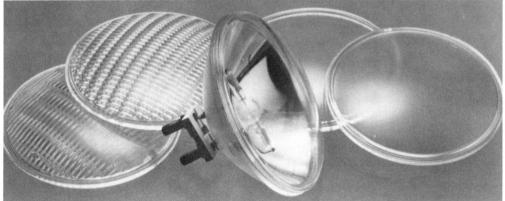

Photo courtesy GTE Products Corp.

MR-16s

One of the newest applications of modern technology to television lighting is the development of MR-16 lamps. (See Figure 3.7.) The first versions of this lamp were intended for use in 35mm slide projectors, but the focal point requirements of such an application made them inappropriate for use as a general-purpose light source. Originally designed

by Emmet Wiley of General Electric (the man who gave us the quartz-halogen cycle), MR-16 lamps consist of a quartz-halogen capsule permanently mounted in a multi-mirrored ceramic reflector bowl. The reflector has special optical coatings that permit the majority of infrared and ultraviolet radiation to pass through it.

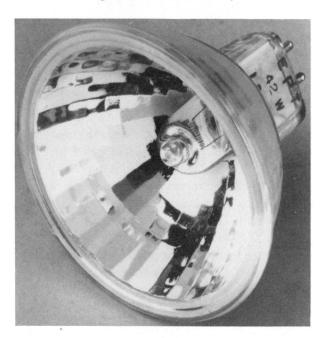

Figure 3.7: MR-16 Lamp

Photo courtesy GTE Products Corp.

The redesigned version suitable for general lighting purposes is the result of additional design work by George Panagiotou of Cool-Lux and comes in 12-, 14.4-, 30- and 120-volt sizes ranging from 50 to 250 watts. They are available in a variety of prefocused ranges: narrow spot, spot, narrow flood and flood. (See Chapter 11.)

As with all quartz sources, you should not touch the lamp capsule of these units with your fingers. When handling these lamps, it is also important not to touch the inside surface of the special mirrored reflector. The integral reflectors are chemically coated to provide very efficient projection of the visible light spectrum forward while allowing the infrared and ultraviolet radiation to pass backward through the reflector and be vented out the top and rear of the instrument, away from the talent.

Carbon-Arc Lamps and Carbon Arcs

The carbon-arc lamp is the closest thing we have to true point source light and consists of a gas-filled quartz envelope containing two carbon electrodes. A high-voltage DC current is discharged between the electrodes to produce an intensely bright light that is

color balanced to daylight temperatures. These lamps are used in expensive, bulky instruments that are not suitable to most small-budget interior location work.

Carbon-arc fixtures are much older and larger than units using carbon-arc lamp sources. When used today, they are used outdoors because they do not have envelopes around the carbon electrodes and are referred to as plain carbon arcs. Since the arc is not enclosed it is necessary to vent the resulting fumes away from the operator and the talent. Because of the need to have a technician to service each instrument during operation and the need for a high-voltage DC power distribution system, it is unlikely that you will be involved with such light sources for the average television production. If you tape a theatrical production in an older auditorium you may run into carbon-arc sources in their follow spots. These spots have their own DC power converter built in to the base of the unit and are generally vented through flexible tubing to the outside or some ventilating system. Since the other light sources in the production will probably be balanced for 3200 °K, a color correction filter such as a Tough MT/Y will be required to convert the follow spot to tungsten color temperature. The exact color correction material required will depend on the type of carbon rods being used. Consult the carbon rod package for details and filter the output accordingly.

Discharge Lamps (HMI)

Used with increasing frequency for location lighting, the HMI (halogen metal iodide) discharge lamp offers several advantages over other types of light sources. It is a manmade discharge lamp that comes close to being a true point source. There are other forms of discharge lamps like mercury vapor or iodine street lamps that produce extremely poor spectrums for photographic purposes. The HMI discharge lamp, however, is designed primarily as a photographic source with a spectrum well-tailored for the job. Many of the earlier objections to these light sources, like flicker or erratic output, have been overcome and they now deserve your serious attention as a possible light source for interior or exterior location work.

This highly efficient lamp produces 5600 °K light with a unique day-lite spectrum and a high color rendering index (CRI). The CRI is a number assigned to light sources indicating their ability to render test colors accurately. The higher the number, the more desirable the source. These lamps contain an optimum combination of various metal halides of rare earths. The quartz envelope contains rod-shaped tungsten electrodes to produce an arc from the extremely high DC voltage supplied by an external ballast. Like other quartz sources, these should be handled with the same precautions. While the HMI system is more costly to purchase or rent than conventional instruments and each instrument requires its own rather bulky ballast to boost the standard 110 VAC to the required high voltage DC, it offers other economies that must be examined before eliminating it from your lighting plan (see Figure 3.8).

Unlike other quartz sources, these lamps cannot be used immediately after they are turned on. They require a short warm-up period before they reach the correct color

temperature. Also, as a result of the ballast involved, they cannot be dimmed electrically as quartz halogen sources can be.

Figure 3.8: HMI Discharge Lamp

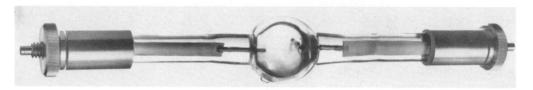

Photo courtesy GTE Products Corp.

Consider these statistics from a manufacturer's data sheet. A 575-watt HMI instrument has the light output of a conventional 2000-watt unit with a daylight filter. A 1200-watt HMI equals a 5000-watt conventional unit with daylight filter, and a 2500-watt HMI equals a conventional 10,000-watt unit with daylight filter.

Economy is relative. How else could you put 10,000-watts of light on a set using two instruments and two 15 amp circuits without melting the talent and having to gel a window in the shot with 85? The answer is that you could not. And it takes less time to set up and strike two instruments than it does to deal with five or more instruments and the multiple shadows they produce.

Currently, a 2500-watt HMI rents for about \$70 per day, an equivalent 10,000-watt baby tenner quartz halogen rents for about \$50 per day. The more expensive HMIs could mean that you do not have to rent a generator, and they produce less heat output than their conventional counterparts. HMI lamps also have a longer life than quartz halogen lamps. All things considered, HMIs can be far less costly in the long run.

REFLECTION

In addition to lamp selection, another important factor that determines light quality is your choice of reflectors. Understanding some of the physics involved will help you select the best reflector and instrument type to achieve your desired results. Reflection is the redirection of rays from a surface. Like transmission, reflection can be either specular or diffuse.

Lighting involves three different types of reflectors: (1) external reflectors that redirect light to the subject; (2) the reflective surface of the subject itself; and (3) internal reflectors in an instrument that focus the source, increase its efficiency and help determine its quality. Some instruments even provide for the use of interchangeable reflectors to alter the quality and color temperature of the instrument.

External Specular Reflectors

If the angle of the reflection is equal to the incident angle of the source ray, it is a specular reflection (see Figure 3.9). A front surface mirror would create the most specular reflector, but any smooth, shiny surface will produce specular reflection. Eyeglasses, polished metal, calm water, high-gloss paint, moist faces, windows and vinyl are just some of the things that can produce a specular reflection. These last items mentioned may be specular reflectors, but they will alter the quality of light reflected from their surfaces as a result of their basic color.

Smooth, glossy surface

Angle of incidence = angle of reflection

Figure 3.9: Specular Reflection

If the source is specular, its specularly reflected light casts hard, well-defined shadows. A silver specular reflector will not change the quality of the light that falls on it. It merely redirects the light source at an angle equal to the incident rays falling on it. When the camera is on the axis of a specular reflection, a glare or hot spot will result. To remove the glare, you can move the camera or the light, or it may be possible to reposition the subject. If the subject is bright and shiny all over, it's best to use a diffuse light source such as a softlight. In some cases complete tenting may be required.

Tenting is the technique of partially or completely surrounding the subject with translucent diffusion material (see Figure 3.10). The lights and camera are placed outside of this enclosure with a hole cut for the camera lens to extend inside. Tenting is a common technique used to shoot silverware and other highly reflective objects with complex curved surfaces.

External Diffuse Reflectors

When the reflector is textured and breaks up the light that strikes it we have diffuse reflection (see Figure 3.11). Unlike specular reflectors, diffuse reflectors always change the quality of the light that falls on their textured surfaces. The reflected light produces

less harsh shadows and lessens the color intensity of the subject. We will examine that effect shortly.

Figure 3.10: An Example of Tenting

Photo courtesy Matthews Studio Equipment, Inc.

Since the final quality of an instrument's output is determined by the combination of lamp type, internal reflector type and lens type, if any, when you want a very harsh light for a scene you should begin with a specular source (a small area filament in a clear quartz envelope or HMI lamp) and a specular reflector. A carbon arc spot would be an even more specular source.

Less specular light is produced by a combination of a specular lamp and a diffuse reflector. The softest light possible is produced by using a diffuse lamp and large diffuse reflector arranged in such a way that the lamp is never visible from the front of the instrument.

Internal Instrument Reflectors

Reflectors serve several functions in lighting instrumentation. They gather, concentrate and direct the light from the lamp. They determine the efficiency of the instrument in terms of its ability to produce the greatest candlepower per watt. They affect the "throw"

of the instrument, or the distance it is able to project light efficiently. They also determine the quality of the light. There are several characteristics of reflectors that can be generalized.

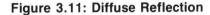

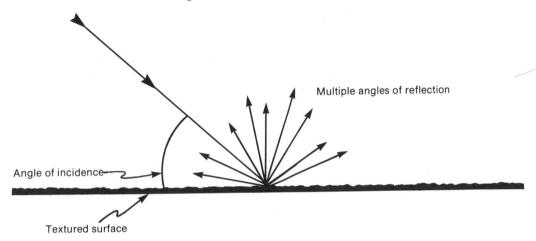

The size of the reflector affects the quality of the light. Smaller reflectors tend to produce more specular light. Larger reflectors tend to produce more diffuse light.

The shape of the reflector affects the focal point of the instrument, its coverage area and efficiency. There are four basic shapes for reflectors, shown in Figure 3.12, in order of their light gathering efficiency. For purposes of illustration they are all assumed to be specular reflectors.

The texture of the reflector affects the quality of light as well as the instrument's throw. A smooth, polished reflector produces a specular beam. It is used in instruments that must be placed great distances from the subject.

Figure 3.12: Reflector Shapes

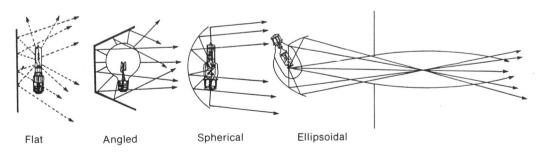

A shiny, randomly textured reflector produces a somewhat less specular light with medium throw and is ideal for use in key lights.

Shiny, multifaceted reflectors in any of the four basic shapes shown in Figure 3.12 can increase the efficiency of that basic shape. This concept in reflector design is economi-

cally achieved today by computer-aided design (CAD). The angle of each flat facet is precisely positioned to improve the precision of the reflector's focal point.

A dull, randomly textured reflector produces a soft light with shorter throw characteristics. Instruments with such reflectors are commonly used for fill and general or base illumination.

A white, matte surface reflector produces the softest light possible. It produces an extremely widespread, shadowless light generally used for fill or base light. I say generally because it is not uncommon today to use such reflectors for key lights as well, especially in situations where fluorescents are the presumed source of illumination for the location.

LOCATION LIGHTING INSTRUMENTS

There are three types of instruments commonly used on location. They are: (1) focusing spots; (2) floods; and (3) fixed focus instruments.

Focusing Spots

These are my favorite instruments. They may be open-faced like the Lowel Omni or DP or lensed instruments like the LTM Peppers. The Peppers provide greater control, but are heavier to transport and could be more fragile. Fortunately their excellent design makes it very easy to remove the lens for shipment.

All focusing spots, whether open-faced or lensed, can function as narrow beam spots with relatively long throws, or be adjusted to provide light over a wider area in the flood position. When focusing spots are in the flood position their output is more specular and it is possible to create more defined shadow lines with flags or barn doors in the beam they produce. When these lights are in the spot position, their output is more diffuse and barn doors are almost useless in efforts to shape and limit the pattern.

Changing the Focus

With open-faced instruments focus change is achieved by moving either the reflector or the lamp by means of a focus knob or lever. When this control is set to the spot position, the lamp is moved close to the reflector, producing a less specular source. When focus is set to the flood position, the lamp is moved away from the reflector to produce a less diffuse output. The focus is continuously variable between the extremes of its range. This capability increases the applications for these instruments.

A common problem with most open-faced focusing spots is that they produce multiple shadows. One shadow results from the focal point of the filament and another from the secondary focal point created by the reflector. Since the relationship between the lamp and the reflector is not fixed, this double shadow situation is impossible to eliminate.

It is preferred that the instrument be designed to move the reflector rather than the lamp during the focus procedure. This avoids physical shock to the filament. If the lamp itself moves when the control is adjusted, there can be a jolt to the filament as you reach the end of the focus range. With the lamp on, this jolt will frequently result in a broken filament. When using instruments that move the lamp rather than the reflector, use caution when focusing to avoid premature burnout.

Some focusing spots, like the Lowel Omni and DP, also permit you to change from a specular reflector to a diffuse silver or gold tone reflector, giving even greater control over the quality of light produced. The ability to attach barn doors, scrims, filter holders and umbrellas gives these instruments even more versatility.

Focusing spots with a lens system, like the Fresnel, have an entirely different method of controlling focus and are discussed later in this chapter under "Studio Lighting Instruments."

Inkys

The inky is known by various names depending on the manufacturer (see Figure 3.13). It is the smallest focusing spot available and is extremely useful for tabletop photography and close-ups of people or small subjects. It is a small Fresnel, rated from 100 watts to 250 watts. (See definition of Fresnel later in this chapter.) There is no substitute for this instrument when you need just a little light here or there to decrease contrast or bring detail out of small shadow areas. Wrinkled necks can be made to look more flattering in close-ups using this instrument and some diffusion material. The use of snoots, scrims and barn doors can bring even greater control to the output. Their extremely small size and light weight make them ideal for location work. Until the LTM Pepper series of inkys was available there really weren't any quality instruments being made in this size range.

Floods

There are three basic types of floodlights. All of them provide diffuse light that spreads evenly over a wide area. Some produce softer light than others. They can be used for a variety of applications, depending on your overall lighting scheme. They are described here in order from the least to the most diffuse.

Figure 3.13: Inky

Photo courtesy LTM Corp. of America.

Broads

The broad is a portable flood consisting of a shallow, angled diffuse reflector which can be used with a clear or frosted tubular quartz lamp. Even when used with the more diffuse frosted lamp, the broad produces a widespread but relatively harsh light, with well defined shadows. Most broads have two or four barn doors that offer some control of the light pattern. These barn doors usually will not rotate or expand, so their application is limited.

These floods can be used as fill or key lights but, because they lack precise control and have medium throw, they are better utilized as background lights and fill sources when bounced off a ceiling or a reflector board. Due to their relatively harsh output, they must be heavily diffused in order to serve as fill lights aimed directly at the subject. Many do not offer a convenient way to hold diffusion material in front of the lamp, so select carefully for the specific job you intend to have them serve. The Lowel Tota is a multi-purpose broad that can be accessorized to serve several functions.

An extremely useful form of small broad is the Nooklite by Mole-Richardson. In common usage the term nook is used generically to denote any compact broad instrument. Such instruments can be hidden easily behind pillars, beams, furniture, and a variety of other set pieces to provide flat, even fill light. Careful placement of nooks can add a great deal of depth to sets by providing separation of scenic elements. (See Figure 3.14.)

Broads serve well as a source of sunlight through set windows and doors. They can be grouped together and placed behind a diffusion material such as tuff spun or rice paper to provide simulated sunlight like that found on a cloudy day. If you do not diffuse the broads they will create a more specular source that casts more well-defined shadows on set like sun on a cloudless day.

Figure 3.14: Nooklite

Photo courtesy Mole-Richardson Co.

Scoops

Unlike broads, scoops are not very portable (see Figure 3.15). They are large round instruments with diffuse parabolic reflectors. Some have gel frame holders that permit the attachment of barn doors and color or diffusion media. Some have a focus control. They produce a very soft light. Their large size and soft, uncontrollable output make them impractical for most location work. If ceiling height and transportation space permit, they are an excellent choice for base light and fill applications in high-key scenes because of the ease in blending their coverage areas. This same characteristic would make them a poor choice for low-key scenes where precise control of spill is a must.

A smaller form of scoop which can be very useful on large location sites as well as some of the smaller ones is the utility light. Though it is sold in hardware and department stores under a variety of different names, it is nothing more than a small, aluminum reflector bowl (from 9 inches to 12 inches) with a standard household lamp socket. Generally they have some wimpy metal clamp attached with a ball and socket arrangement so they can

be clamped on the edge of something and aimed at the subject. You can use the various wattage photo lamps and photo floods in these little wonders to supplement lighting in a variety of locations. They are also an effective means of placing a little light overhead in small areas of a factory or warehouse. Remove the clamp and suspend them on lamp cord over the area of action. They can be painted and hung within the shot. If you carry a few with you, you'll find a variety of uses.

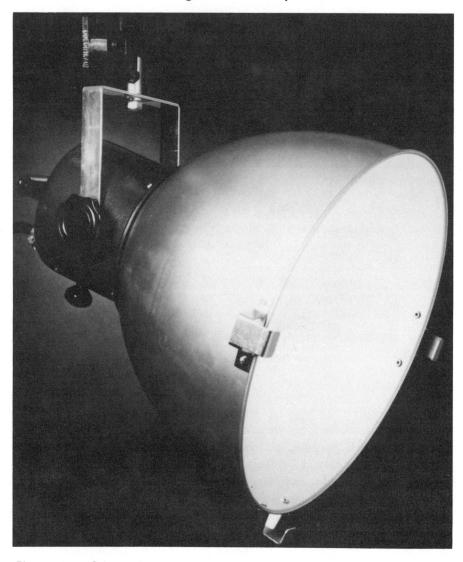

Figure 3.15: Scoop

Photo courtesy Colortran, Inc.

Softlights

Softlights come in standard and portable forms. (See Figure 3.16.) Both are very popular for location lighting despite their large size. The standard softlight is a large, rectangular instrument made entirely of metal. It is designed in such a way that no direct light from

the source is able to reach the subject as with other instruments. Instead, it is bounced off a matte white surface onto the matte white reflector and then directed toward the subject. The quality of this light is far more diffuse and widespread than that produced by any other instrument. They may contain two or more lamps that are individually controllable so you can vary the light output as required.

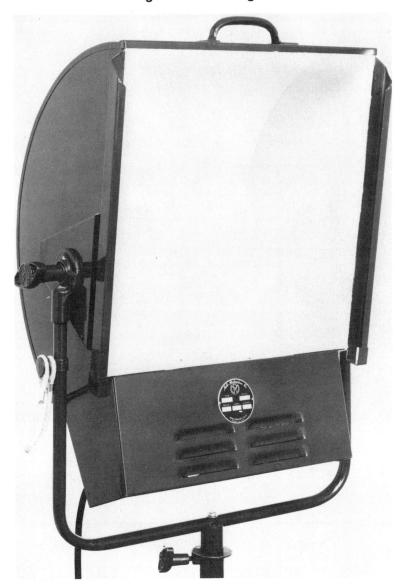

Figure 3.16: Softlight

Photo courtesy Mole-Richardson Co.

Portable softlights are made with lightweight, collapsible metal frames. (See Figure 3.17.) The reflector is made of a textured silver or matte white coated fabric that is stretched over the frame. Their output is not as diffuse as regular soft-lights owing to the smaller

reflector area and more specular nature of their reflective surfaces. Extreme light weight and portability make them excellent for location work. They usually have two lamps and some have barn door and color media attachments. Like their heavier counterparts they produce a very pleasing, near shadowless illumination that can be used as fill or key light. They are sometimes referred to as "zips." (The term zip is also used to refer to ordinary household lamp cord. It is often called zip cord.)

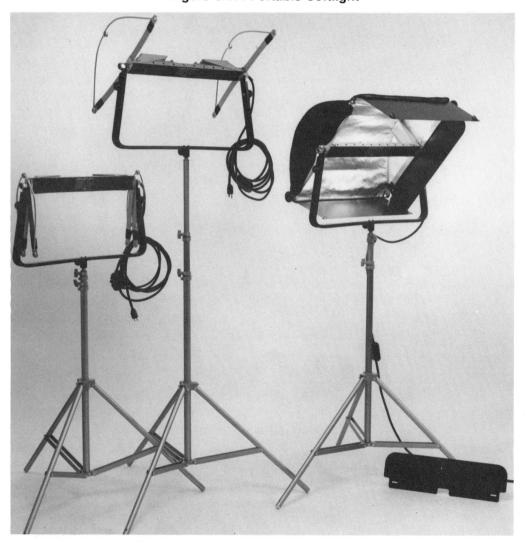

Figure 3.17: Portable Softlight

Photo courtesy Lowel-Light Manufacturing, Inc.

Softlights can also be created using an umbrella. Some systems, like the Lowel unit shown in Figure 3.18, are specifically designed to work with certain instruments in their product line, but any instrument may be aimed at an umbrella to create a softlight. Light from such units is more specular than that provided by a traditional softlight source, but it is still a very good means of softening light on the set.

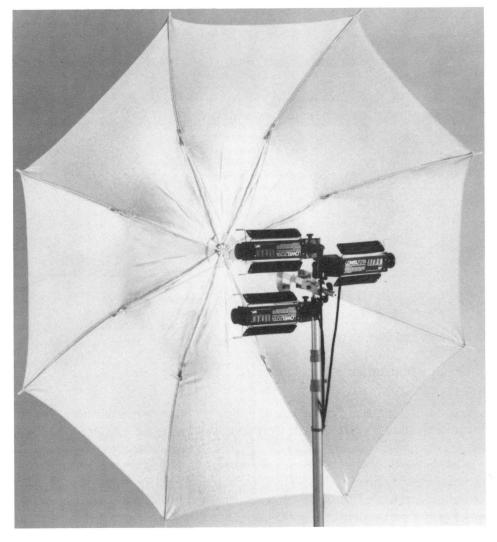

Figure 3.18: Umbrella Lighting

Photo courtesy Lowel-Light Manufacturing, Inc.

Softlights on a much larger scale are available commercially. They may be called cones or overhead clusters and are commonly used for lighting automobiles and other shiny surfaced subjects. (See Figure 3.19.) Generally they contain one or more lamps that are shielded from direct view and their output is directed toward the inner surface of a large matte white box-like fixture. They are often used with diffusion material covering the opening to further diffuse the output.

You can create effective cluster lights on set using Fome-Cor to construct a large box-like container. Once you have taped the five pieces together, place the unit several feet from the subject and aim any number of instruments into it. The light that is bounced out of such an arrangement makes ideal illumination for fashion lighting and other occasions that require an extremely even, soft illumination.

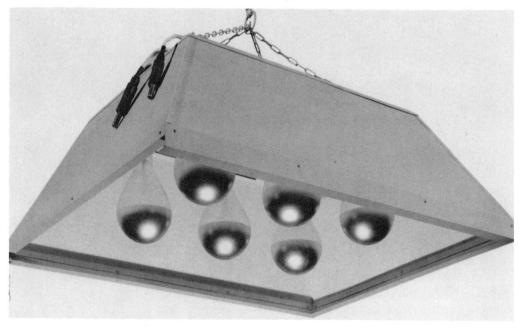

Figure 3.19: Softlight Cluster

Photo courtesy Mole-Richardson Co.

Fixed-Focus Instruments

Fixed-focus instruments will project their light in a given pattern that cannot be altered by instrument adjustment. As stated, PAR and FAY lamps are manufactured like auto headlamps and prefocused to provide wide, medium or narrow beam patterns. These lamps are used in the multi-lights and PAR cans described next. A third type of fixed-focus instrument was discussed above in the "Floods" section. Some scoops and most softlights have a fixed coverage pattern. The intensity of fixed-focus instruments can be altered by changing lamps, but the beam pattern will remain the same despite the lamp wattage used.

Multi-Lights

I have used the generic term multi-light to describe a series of instruments that utilize PAR or FAY lamps. The most common is the Nine-Lite or Molefay or Molepar (see Figure 3.20). First introduced by the Mole-Richardson Company, this instrument is capable of lighting large areas on interior sets or providing excellent fill light for exteriors.

The Nine-Lite contains nine PAR or FAY lamps arranged in three vertical columns of three lamps side by side. The columns pivot individually permitting the light pattern to be concentrated in a narrow area or spread out for more broad coverage. Each lamp has its own switch so that you can control light output. The lamps can be spots or medium or wide angle floods or any combination of the three. Their color temperature can be daylight

(FAY) or tungsten (PAR). Diffuse or specular metal snoots, called intensifiers, may be placed in front of each lamp for greater control of the light quality and coverage. In addition, scrims, conversion filters and barn doors may be mounted in front of each lamp. Lamps are usually rated at 500 or 1000 watts, so these instruments require a great deal of power and generate a lot of heat.

The long throw and specular quality of these fixtures make them a good choice for lighting large interiors directly or as bounce light sources when more diffuse light is required. They come in a variety of configurations, ranging from single lamp fixtures to three-, four-, five-, six-, nine- and twelve-lamp arrangements. Some new types of multilights are discussed in Chapter 11.

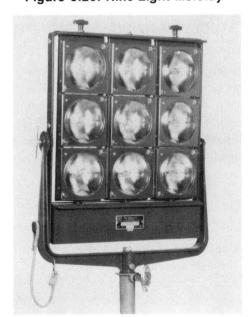

Figure 3.20: Nine-Light Molefay

Photo courtesy Mole-Richardson Co.

Figure 3.21: PAR Can

Photo courtesy Mole-Richardson Co.

PAR Cans

The PAR can is a simple instrument. (See Figure 3.21.) It is nothing more than a metal housing that contains a socket designed to accommodate a single PAR lamp of any focal length. Because of their simple, lensless design they are lightweight. They have a relatively high light output and are frequently used for events such as rock concerts and stage productions for which long throws are involved. The light is specular and the instrument design does not lend itself to much control of the spread. That control is limited by your choice of the appropriate focal length PAR lamp. Newer PAR instruments are designed with HMI lamps for very powerful, if somewhat harsh light for location and studio work.

STUDIO LIGHTING INSTRUMENTS

While the following instruments are not restricted from use on location, they are generally used in the studio because of their size and weight. The additional weight is caused by their lens systems which offer greater control of light output than their lens-less location counterparts. Location in this case refers to small room interiors. Larger instruments are very much a part of outdoor location shooting and shots that involve large interior spaces such as concert halls and auditoriums.

Fresnels

The Fresnel (pronounced fir NEL') lens was invented around 1800 by the brilliant French physicist Augustin Jean Fresnel. One of its first uses was to improve lighthouse beacons of the time. Fresnel's extraordinary work in the area of optical physics and his discoveries about the nature of light and its method of transmission produced a body of work that forms the basis of modern day lens and reflector design. The distinguishing characteristic of the Fresnel lens is a series of concentric rings that form steps on the front surface of the lens.

Simply put, when light passes through glass having two parallel surfaces, the glass cannot redirect that light. In Figure 1.1 the light is redirected when it passes through the prism because the surfaces of the prism are angled. (Incidentally, Fresnel also explained the Roy G. Biv order of refracted light and measured the wavelengths involved.)

Knowing the need to have nonparallel surfaces to redirect light, the first lens makers produced a plano convex lens. (See Figure 3.22.) Such lenses are thick, heavy and break easily. Since the aspect of design that makes them function is the fact that the back surface is not parallel to the curved front surface, it is reasoned that you could remove the center section of the lens as long as the portion extracted had parallel surfaces. (See Figure 3.23.) This results in a stepped lens which can bend light in the same way as the heavier plano convex unit because the back surfaces of the lens are at the same relative angle to the

front as they were in the plano convex lens. So much for the excess weight, but we still have a lens that requires the same depth from the farthest rear surface to the front of the curve.

Figure 3.22: Plano Convex Lens

Figure 3.23: Stepped Lens

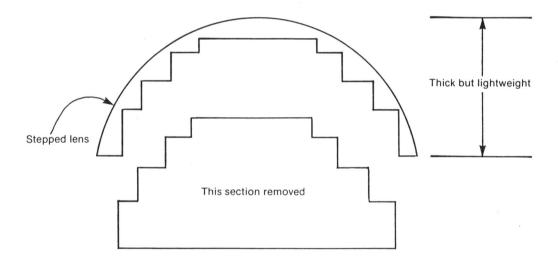

Fresnel reasoned that if the key factor in redirecting light is the difference between the angles of the two surfaces, then it should be possible to slice up a stepped lens and place all the rear surfaces of each step in a straight line, leaving the front surfaces with their original curvature. In this way you have the Fresnel lens—a flat thin lens that has the same light bending characteristics as heaver, thicker, fragile plano convex units. (See Figure 3.24.)

In a Fresnel instrument the lamp is backed by a spherical reflector located at a fixed distance from the filament. It redirects the light to a focal point at the plane of the filament producing a single focal point for the reflector and the lamp. Remember, the location of the focal point for a reflector in an open-faced instrument changes in relation to the filament focal point as it is moved to affect focus. This creates two focal points and produces multiple shadows.

Figure 3.24: Fresnel Lens

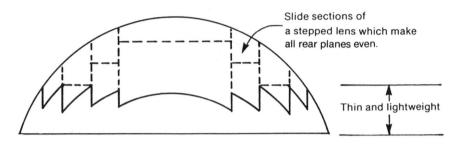

To change the focus of a Fresnel from spot to flood, the lamp and reflector together are moved closer to the lens. (See Figure 3.25.)

Figure 3.25: The Spot and Flood Focus of a Fresnel

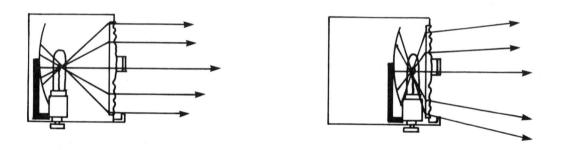

All Fresnels provide for the addition of color media holders, scrims, barn doors and snoots to give the designer maximum control of the output. Instruments start as small as 3-inch, 100-watt inkys and range up to 20-inch, 10,000-watt units. The 3-inch designation refers to the diameter of the lens. Like the open-faced focusing spot mentioned earlier, Fresnels have a good range from spot to flood. (See Figure 3.26.)

Figure 3.26: Fresnel Instrument

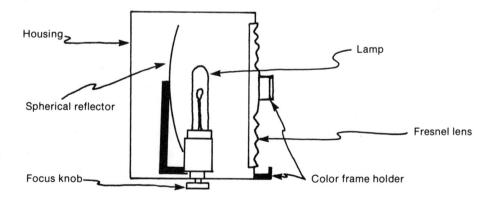

Lekos

The Lekolite, commonly referred to as an ellipsoidal because of its reflector shape, was invented by Messrs. Levy and Kook who founded Century Lighting and gave the instrument its name. Lekos offer the most precise focus of light output. When absolute control of spill is mandatory, the Leko is often the best choice. The reflector is a specular ellipse so the light output is specular, but it can be modified with filter material to achieve a diffuse quality. A wide variety of lens systems is available to meet the throw and coverage requirements of any given situation. Many Lekos have four built-in shutters located near the gate pattern and make it possible to shape light patterns exactly. These shutters can be moved to many different positions to vary the shape of the lighting pattern.

If four-sided geometric patterns are not what you require, you can insert a wide variety of templates or "gobos" into the pattern gate of these instruments to project intricate patterns or shapes. There are many excellent commercial gobos available, or you can make your own. If you require circular pools of light, you can use a circular gobo or select an instrument that has an adjustable iris in place of the usual shutters to produce the exact diameter circle required from different throw distances.

Lekos are particularly useful for projecting patterns on the background, foreground or floor of a set to create some interest or suggest offstage items such as windows or trees. The lens barrel can be moved in or out to control the sharpness of the image projected.

Consult with your dealer before purchase so the gobos you are ordering are the proper size for the instrument you are using.

The lens system can consist of one or more Fresnel lenses, step lenses or plano convex units. In all, there are over 25 different configurations.

The design in Figure 3.27 has a couple of disadvantages. The lamp must be burned base up making it difficult to angle the instrument properly in order to reach some areas of the set. It also places the filament at a less than optimal position within the elliptical reflector. Modern day computer programs make it possible to design and manufacture a more efficient elliptical reflector. These newer axial-designed Lekos (see Figure 3.28) place the lamp on the focal axis in the center of the reflector and allow you to burn the lamp base in any position.

Regardless of which form of Leko you rent or own, a common problem is reduced light output due to poor alignment of the filament in the elliptical reflector. Rented instruments are especially plagued by this problem. It is not uncommon for Lekos to be so misaligned that their output is reduced by 66%. If you have worked with certain instruments at a given throw and wattage on a number of occasions you will know what their output should be. If you have no previous experience with an elipsoidal instrument and end up renting one that is misaligned, you will probably not detect the misalignment unless there is gross error in the filament placement. As a result, you may install a higher-wattage

lamp (which may only add to the alignment problem), or you may add additional instruments to bring the intensity up to the desired level.

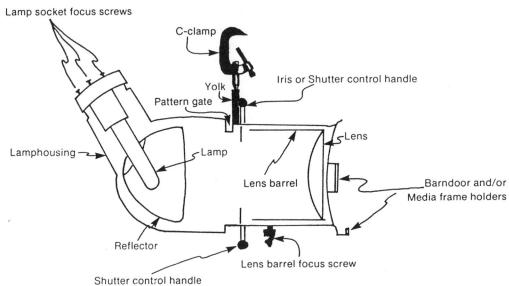

Figure 3.27: Older Form of Leko

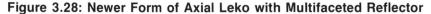

Lekos are very precise optical instruments, and even a slight deviation from the intended position of the filament in relation to the reflector results in great degradation of light output. A misaligned filament not only reduces output, but affects the quality of the coverage pattern. Instead of producing an even field of light a misaligned instrument will produce hot spots, dead spots, color aberrations and may even project an image of the filament on the talent or set walls or floor.

Alignment problems result from harsh handling, or the replacement of lamps or sockets. Even when a lamp is replaced with one of similar wattage there is enough difference in the orientation of the new filament to reduce output. When the new lamp is of a different wattage entirely, the chance for misalignment is even greater. You can align the lamp properly using the series of screws on the outside of the lamp holder at the base of the lamp. The idea is to place the filament along the optical center of the reflector at the focal point which is situated at a very precise distance from the back of the reflector.

The alignment screws in most older instruments cannot be adjusted easily and do not appear to be any more than fasteners that hold the lamphousing together. The latest designs from Strand and Colortran, however, provide a joy stick at the base of the lamp to make alignment simple. More efficient heat sinks on the socket keep the instrument cooler during operation and extend lamp and socket life. To make an alignment gauge, cut a rectangle of 16 to 22 gauge sheet metal to the exact size of the colorframe holder of the Leko to be aligned. Use a #50 drill to make a small hole in the exact center of the metal rectangle. You now have your alignment gauge.

Place the instrument about three feet from a white wall with its beam perpendicular to the surface of the wall. Insert the alignment gauge in the colorframe holder and darken the room so you can see the image of the filament and the reflector projected on the wall through the small hole of the gauge. With a poorly aligned instrument there will be light and dark areas of the reflector caused by the incorrect filament location. By adjusting the four or five screws in the cap of the lamp housing you will be able to realign the filament within the reflector. The object is to move the filament to the center of the reflector. When it is properly aligned you will see the bright glowing areas of the reflector increase in number and in area. When you have maximized the bright areas of the reflector and created an even pattern of light on the wall, remove the hot gauge with a pair of pliers and aim the instrument at a wall 25 feet away. You should see a much brighter, even field of light. If not, some minor adjustments of the alignment screws may be necessary. Generally it will not require further work.

This procedure gives you the brightest flat field of light possible. If you need more light for your particular situation, you can increase the light output in the center of the pattern by moving the lamp slightly forward in the reflector. This involves an equal adjustment of the three or four perimeter screws and a tightening of the center screw in the lamp base. In order to gain light in the center of the projected pattern you will have to sacrifice output at the edges and a darker ring will appear there.

These instruments are commonly designated as 6 by 9s or 8 by 8s, etc. The first number in the designation is the diameter of the lens in inches and the second number indicates the focal length of the lens.

4 Video Contrast Ratios: Help, They Don't Match!

Contrast ratio refers to the maximum allowable difference between the brightest area of the picture and the darkest. While film can accommodate ratios as high as 100 to 1, television is commonly considered to have a contrast ratio of 20 to 1. Current technology has improved this ratio to 30 to 1 when the finest cameras available are used. New formulations for tube targets, the use of CCDs and improved circuits are the reasons for this increased range. From a practical standpoint you should still work with the older 20 to 1 ratio, however. This gives you about a 4 f-stop range.

Limited contrast ratio is frequently used as an excuse for not being able to produce aesthetically pleasing pictures. That is hogwash. You can create a great sense of depth and produce very good-looking pictures working within the limits of the transmission system. The earlier problems of extreme highlights causing pictures to bloom and distort have been greatly reduced with the development of automatic beam optimization (ABO) circuits. Some newer CCD cameras eliminate the problem of blooming and streaking almost completely. Current tube-type cameras are able to handle highlights ranging anywhere from two to four f-stops above 100 IEEE units and CCD cameras can handle highlights six to eight f-stops above 100 IEEE units. Unless you are shooting live or recorded outdoor events, over which you have no lighting control, there is no reason to tax the system with contrast ratios it is incapable of handling.

REFLECTIVE SURFACES

In Chapter 3 you read about the reflective aspect of light as it related to the quality of that light. Two types of reflectors were discussed, those used in lighting instruments to gather and intensify light and those placed in front of lights to redirect and/or change

the quality of their output. There is a tendency to regard these as the only forms of reflectors, but, in actuality, everything we see is a reflector. If it were not a reflector, we could not see it. We would have that mythical blackbody spoken of in Chapter 1. The problems of contrast ratios arise with different materials having different degrees of efficiency in reflecting light.

Just as you should be concerned about the type of reflector that is contained in the instrument you use and about the type of reflector board you select, you must be concerned about the reflective quality of the subject matter that you are lighting. When you consider every subject you see as a reflector, you will tend to make better subject selections for your scenes. Your function as a lighting director is to put less light on highly reflective subjects and more light on those subjects that reflect light less efficiently in order to bring the reflective difference between the two extremes within the 20 to 1 figure. When the degree of light placement is specific enough to reduce excessive reflective differences between various subjects, you will not exceed the 20 to 1 ratio of the system's transmission capability, and you will still make all the pictorial elements visible and recognizable to the television viewer.

A Classic Problem

A classic example that comes to mind from my own experience involves a rather simple situation. At an early and uninformed period of my career, an appliance dealer said he wanted to show his best console color TV operating in a living room setting. It sounded simple. The television arrived at the studio, a bulky affair with a highly polished walnut cabinet. The first problem was to get the engineering staff to feed it a closed circuit RF (radio frequency) signal.

The television was placed against the back wall of a corner setting that was formed by two light blue flats from the scene shop. That looked bare, so a picture was hung on the opposing wall and the ubiquitous rubber tree plant was placed in the corner alongside the console. I used a number of scoops to light the scene. After all, I did not want a lot of ugly distracting shadows cast on the wall by the plant, and I knew that the soft light of the scoops would not cast distracting shadows. By now you are probably laughing because you know the results of such an approach. When I looked at the floor monitor of the live camera feed, the console cabinet had no detail. It was just a dark form silhouetted against the light blue walls. The image of the closed circuit program was completely washed out, and there were several hot spots on the curved surface of the TV's picture tube. Since the cabinet was an important aspect of the shot and it had no detail, I reasoned that I needed more light, and I pulled the scoops down lower on their pantographs to increase the intensity of light on the dark cabinet. Naturally, the light blue flats got brighter, and the ratio between wall and cabinet remained the same. The hot spots on the picture tube moved a little, but they got even hotter. I was not lighting the scene; I was illuminating it.

It was time for another approach. What I needed were instruments with greater control over spill and the ability to intensify light in certain areas while cutting back in others.

By using a series of highly spotted Fresnels, I was able to bring out greater cabinet detail and reduce the glare on the face of the picture tube, but I still had a number of hot spots on the screen. The rubber plant seemed to soak up light and required a Fresnel of its own to bring out any detail in its leaves and make it look lively. Other Fresnels were used to light the background. It took a great deal of time, and the production manager was screaming that we had to get ready for the news block.

How to Solve the Problem

Today, I would use my knowledge of physics to analyze the reflective surfaces involved, select instruments and accessories accordingly and make short work of such an assignment. The biggest problem would be the TV. The highly specular faceplate and the extremely dark cabinet are at odds with each other. Putting enough light on the cabinet from a single bright source would wash out the closed circuit program and cause an extremely bright hot spot on the CRT. Since precise control of light needed, I would select a Leko that would allow me to shape the light pattern to conform to the shape of the cabinet and keep excess light off the back wall. With enough light to bring out the cabinet detail, I would hang a rectangular French flag in the light path about 3 feet in front of the Leko so that it cast a dark, well-defined shadow on the CRT. This would remove the hot spot and the problem of contrast of the closed circuit playback. One instrument would light the TV. Another carefully focused Fresnel would take care of the rubber plant, and two special instruments could light the background. The use of a Leko with a window pattern gobo projected on the back wall would create the illusion of an off-screen light source and add depth to the flat walls with its pattern of light and dark stripes. The adjoining wall could be lit with a carefully placed Fresnel, and if necessary, a dot could be placed to remove a possible hot spot on the CRT. The lighting time would be 15 minutes; the results, believable and excessive reflective ratios of subject, controlled.

Avoiding Noise

In addition to staying within the contrast limitations of the television system, you must also put sufficient base light on the entire set so that no areas produce video that is below the signal-to-noise ratio of your camera. We tend to worry more about highlights in lighting for video than we do about the dark areas. These areas can produce noise in the video if they are not lit to a minimal level. Areas from which there is no light reflected toward the camera will not reproduce as black on the waveform or picture monitor. They will be filled with creepy-crawly salt and pepper and colored splotchy noise.

If the brightest element in the scene is 100 IEEE units or peak white level, the rest of the picture will obviously ride up and down as manual or automatic adjustments are made. If you are fortunate enough to be working with a 30 to 1 contrast range, 30 steps down from that peak amplitude is the noise threshold of the system. It does not go up or down by adjustment of controls. It just sits there. And to make matters worse, every

time your master tape is dubbed down a generation, the threshold level of this noise is raised by a contrast step or two.

If you do have a contrast ratio of 30 to 1 to work with, that translates into a range of about five f-stops. You can use the camera as an expensive light meter to determine the contrast range in a scene. Zoom in to a tight close-up of the brightest area of the scene and determine the f-stop for 100% amplitude on the waveform monitor or until the zebra stripe appears in your viewfinder. Now repeat the measurement looking at the darkest area of the scene. The f-stop range you identify translates into a contrast ratio by a base 2 power law (see Table 4.1).

Table 4.1: Contrast to f-stop Conversion

f-Stop Range	Contrast Range
1	2:1
2	4:1
3	8:1
4	16:1
5	32:1
6	64:1
7	128:1

Now you can see how improper lighting translates into noisy pictures. If your scene has a five f-stop range and a highlight suddenly appears and drives the auto iris down two f-stops, your remaining contrast range is now no better than 8 to 1. Any scene elements below that threshold will be driven into the mud. All you see on the screen is system noise.

On the other side of the coin, if your scene has only a two or three f-stop range from peak white to black, the picture is going to look flat and washed out, with very little color saturation, if the auto iris opens up in search of some highlight.

LIGHTING RATIOS

Lighting ratios are determined by comparing the intensity of the key light to that of the fill. (If you are uncertain about key and fill lights, turn to Chapter 5.) Generally only a small area of the scene, such as an actor's face or body, is involved in computing a lighting ratio. Once that ratio has been established for a given position on the set, it should remain the same throughout a series of shots in that area. While the actual position of the key and fill light may change in height or horizontal angle to accommodate movement from shot to shot, the ratio between the two should not change so that the shots will match when cut together. You may wish to change the intensity of the key and fill to control the depth of field in a series of shots. These changes will present no problem when the shots are cut together in post so long as there is a proportional increase or decrease in both the key and fill to maintain the same ratio between the two.

High Key

The lighting ratio between key and fill is important in establishing the mood of a shot. If the key light measures 160 footcandles and the fill light provides 80 footcandles at the subject's location, you have a high-key setup with a 2 to 1 lighting ratio. Take special note that there is an inverse relationship between the term "high" key and the "low" ratio used to achieve it. In high-key shots the ratio of key to fill on the subject is low, like 2 to 1 or 3 to 1. High-key ratios are usually used in comedy and nondramatic situations. Backgrounds in high-key shots are generally brighter than those in low-key setups. The overall effect of high-key lighting is brighter shots with less texture. The look is similar to what you would expect when shooting outdoors on an overcast day.

Though it has been stated that backgrounds are usually brighter, by definition, in high-key shots, they do not figure into the calculation of a lighting ratio. They only come into play when exposure ratios are calculated. (See "Exposure Ratios" later in this chapter.) There is nothing to prevent high-key lighting from being employed in front of a black backdrop.

Low Key

Low-key ratios are used in more dramatic situations in which the inverse ratio of the key to fill is high. An example of dramatic low-key lighting would be a situation in which the key light measures 200 footcandles and the fill measures 25 footcandles. In this case the ratio would be 8 to 1. The result is deeper shadows and a more textured look. Lighting ratios deal only with modeling light on the subject, but as a general rule, low-key shots are involved in scenes in which the background is at a lower intensity than the background used for high-key ratios on the subject. More specular light sources are used for both the subject and the background when low-key ratios are being used.

When shooting video film-style, it is important to maintain the same lighting ratio throughout a series of connected shots in order to preserve continuity and make the shots cut together smoothly during post. Generally we think of continuity as something that deals with props and costumes being in the same positions from shot to shot (and this form of continuity is very important), but continuity of lighting ratios is of equal, perhaps greater, importance. With multicamera, real-time television production, such as sporting events or award shows, continuity is automatically maintained. When video is shot film-style, lighting each shot separately as filmmakers do, failure to keep track of lighting ratios can become a big problem in post, especially if a series of connecting shots is made over a period of two or more days.

The lighting ratio alone is not the only factor that determines the mood of the shot. In Chapter 7 we will examine a number of stock setups that can be used to convey mood and time of day. Changing the position and direction of the key can have just as great an influence over mood as the ratio involved can have.

Determining Lighting Ratios

There is a variety of ways to determine an appropriate lighting ratio for any scene. The biggest influence should be the subject matter of the script and the way it is being dealt with. The director's intent and the elements of the set should also influence your approach. You may be asked by the director for a 2 to 1 high-key setup, or you may be told to work at a given f-stop in a high-key or low-key situation. Whatever the criteria, you will need to know the proper techniques for metering your setup.

Depending on the size of your crew and the setup involved, you have a couple of choices regarding metering techniques. You can use your incident light meter, with the flat diffuser disk or the hemisphere dome. If you are using a setup in which the fill light is positioned in front of the actor, instead of being off to the opposite side of the key light, the fill will also contribute light to the key side of the subject. In such cases you should turn off all the set lights except the key and fill and take a meter reading using your incident meter with the hemisphere dome in place. Place the meter in front of the actor's face and point it toward the camera. Take your reading. Say it is 250 footcandles. That is the key, or "K" value, that will be used in the formula that follows. Next have an assistant turn the key light off, and take a reading. This time it is 85 footcandles. That is the value of your fill, or "F" value. Now let's determine the lighting ratio. Using the formula LR = K/F, LR = 250/85 or LR = 3 to 1 (approximately).

This technique is time and labor intensive because of the need to first switch all set lights off except the key and fill and then eventually switch off the key light. This is because the hemisphere dome will accept light from a wide angle, as much as 180°, and you do not want other set lights to contaminate your reading. That same factor also makes it possible for you to get an accurate reading of the combined key and fill lights in order to get a true value for the intensity of light that will be striking the actor on the key side. Once that value is known, you must measure only the fill light to calculate the correct ratio.

A metering technique that is much quicker and less labor intensive involves the incident light meter and the flat diffuser disk. In this case the reduced angle of acceptance eliminates the need to kill all the set lights except the key and fill. To determine the lighting ratio, point the flat disk directly at the key light and move the disk around slowly. You will notice a slightly higher reading in one specific position. Use that high reading as the K value in the formula. Next aim the flat disk directly and the fill light from the position of the actor's face. To avoid turning off the key you can use your hand to shadow the key light from the disk. As before, move the meter slightly to determine the highest reading from the fill light, making sure you continue to prevent the key light from falling on the disk. Make note of your F value and compute as before.

EXPOSURE RATIOS

The exposure ratio is the figure that indicates the brightness differential between two or more areas of the same scene. It is not the intensity difference between two instruments, the key and the fill. If you want, you can think of it as a lighting ratio on a grander scale. A typical example would involve measuring the intensity of light on the acting area and

making another measurement of the intensity of the background. If the background is lit fairly evenly, only one measurement is required for the entire background. If the background

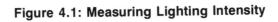

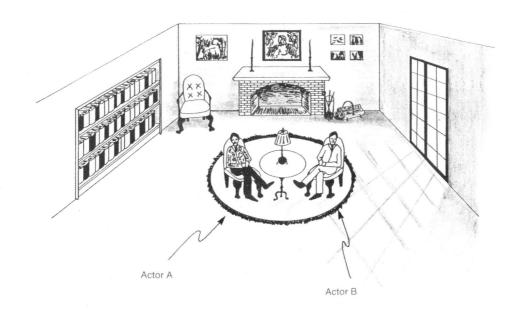

is lit unevenly as the result of windows or practical lamps on set, these areas should be measured separately.

For example, if an effect light is projected on the back wall of the set to simulate sunlight streaming through a window on screen right, that area of the background will be brighter than the screen left area of the back wall that does not have a projected effect. We would expect screen left to be darker because of the absence of effect projection and the natural falloff characteristic of light. To illustrate, we will call the screen left section of the background area 1, the screen right area of the background is area 2 and the acting area center screen is area 3 (see Figure 4.1).

Because exposure ratios involve the intensity of larger areas lit by more than one or two instruments, meter readings are always taken using the spherical diffuser. You want to measure the effect of all the instruments that contribute to the intensity of a given area. When you meter an area to establish and calculate exposure ratios, use the spherical diffuser with all set lights for the master or wide shot on at operational levels.

You want to be able to determine the ratio between various areas that will be involved in the scheduled shots. The formula is ER = A1/A2. The intensity of each of these areas involved should be measured while aiming the meter at the camera with all the set lights operational.

If the shooting schedule calls for a master wide shot, two medium shots and a closeup, as shown in Figure 4.1, you will need to meter the three areas involved. You do not have to maintain the same footcandle readings in the two areas involved in each of the narrower angle shots, but the ratios must remain the same. You may want to decrease the light in area 3 and area 2 to reduce the depth of field for the close-up of actor B. The intensities can be lowered, but the ratios between the areas involved must remain the same to maintain lighting continuity.

When shooting indoors where you have complete control over lighting ratios and exposure ratios, you should have no trouble staying within the 20 to 1 contrast ratio of the television system. Problems may be caused by the nature of the subject, such as extremely shiny objects. Those reflections can be reduced by treating their surface to control the potential problems.

Problem highlights from highly reflective subjects can be controlled by reducing the light that strikes them with dots, fingers, flags, scrims or nets, or by spraying them with dulling spray, hairspray or certain types of a light dusting of spray paint of the appropriate color. Matte silver gaffer tape can also be used effectively on some silver subjects to reduce glare. Naturally, any paint you spray on a subject must be tempered by the disposable nature of the subject. Shiny bald spots and high foreheads on talent can be treated with Arrid Extra Dry deodorant spray to reduce glare and stop perspiration; the unscented variety is preferable. For purposes of tact, glue a plain paper wrapper around the can before taking it on set, and tell the talent you are using a special material to improve his on-camera appearance, if he asks any questions. Outdoors, the use of butterflys, scrims and fill light can bring contrast ratios under control. We will examine these accessories in detail in Chapter 6.

5 Instrument Functions: What Do They Do?

Before we can discuss instrument placement, it is necessary to define eight primary instrument functions. Depending on where instruments are placed, their relative brightness and the areas they light, they perform different functions. In one instance a Leko may be positioned far upstage and aimed at the back of a rock star, serving as a backlight. In another application that same instrument may be located downstage, projecting a cloud on the cyc and functioning as an effects light. The functional uses suggested here are only general guidelines. In reality your backlight may function as a key with just a bit of front fill. The specific setup will be dictated by needs, conditions and location limitations, plus the aesthetic requirements of the script.

KEY LIGHT

The subtitle of this book is *The Art of Casting Shadows*. One reason for that subtitle is to emphasize the importance and necessity of shadows in good lighting. The instrument that provides the biggest clue to the location of the presumed light source is the key light. Because its intensity is greater than any other light on the subject, it will and should create shadows. The angle and density of shadows serve as clues to the type and location of the presumed source. They also provide clues to time of day and the nature of the source.

If an exterior scene is extremely bright and has harsh shadows falling at a steep angle, it would not be unreasonable to assume that the action is taking place around noontime on a sunny day. By the same token, an exterior scene that has softer shadows falling at a very oblique angle in a warm light is likely to be taking place either during the early morning or late afternoon hours.

We would expect to see well-defined shadows falling at a steep angle at noon on a cloudless day. Therefore, we place a specular lighting instrument high overhead to imitate the sun at noon, and the angle of the cast shadows determines where the instrument is placed. Later in the day we should expect the sun to be lower on the horizon, casting more oblique shadows, so we would lower the instrument to cast an appropriate shadow angle. Instrument location is determined by the mood we wish to create, the basic setup we are working with and any motivating or practical lights that are in fact, or are presumed to be, the source of light for the scene.

Do not underestimate the importance of the statement, "any motivating or practical lights that are in fact, or are presumed to be, the source of light for the scene." This is a very important consideration in setting the key light. You should not always think in a traditional manner regarding key-light placement. If the subject is walking away from the camera down a long narrow hallway toward a glass door leading to an exterior location, the key light should actually be a strong backlight. Always use the situation to determine location and type of key-light instrument.

If the location is an office without windows, we expect to see softer shadows and, therefore, would choose a softlight source or would heavily diffuse the light from more specular instruments.

The mood or atmosphere of a scene evokes a certain emotional response from the viewer and is established by the exposure and lighting ratios used by the lighting designer. Low-key scenes—and I am not referring to the height of the key light instrument—create a dark and somber mood, while high-key scenes are associated with happy, energetic situations. Using the cast shadows as your guide, the first thing you do is place the key light. The prominence of the shadows created by the key light is affected by the type of light source, specular or diffuse, and by the amount of fill light you add. Background and backlights, along with effects lights, help to complete the illusion.

Your choice of lighting setup will be based on how you wish to model or illuminate the facial features of the subject or the contour lines of the product. The most flattering setup (the portraiture setup) is one in which the key light is directed down on the actor from an angle that casts a small shadow of the nose directly below it or toward either side of the nose by the nasolabial folds, or "smile lines."

Since the key is generally assumed to be the apparent light source of the scene, such as a window, table lamp, overhead lights or the sun, we must analyze these elements of the scene when choosing the key's location. If a preceding long shot established a bright table lamp on screen left, you would be ill advised to key the subject from screen right in a close-up even though the lamp in question is not part of that shot.

Traditionally, a Fresnel or open-faced focusing spot will be used as the key instrument. It is a specular source that can be diffused and shaped with accessories and the focus control to provide the degree of sharpness you want from cast shadows. If you dim the key to get the intensity you want for the f-stop you desire to shoot at, you will destroy

the color temperature and consequently the flesh tones. It is advisable to relamp the instrument with a lower wattage lamp to establish the desired level. It is true that you can reduce intensity by using scrims or ND filters. They do not change the color temperature, but they do cause you to use more electricity than you need. This, in turn, adds needless heat to the location. You may also be able to take advantage of falloff and move the key farther away from the subject to reduce its intensity.

Recent trends in lighting also include the softlight as a viable key-light source. Unlike more traditional key instruments, the softlight is not as controllable with respect to spill and shadow intensity, but it can be used as a key source. This is especially advisable when the subject is prone to severe specular highlights such as those found on highly polished metal objects or on foil or cellophane wrapped products. Softlight is also more flattering to the face of subjects, especially if they have age lines or skin imperfections.

FILL LIGHT

Placed in front of, or on the opposite side of, the subject from the key, the fill light's job is to establish the desired lighting ratio and control the density of the shadows created by the key. It should not be strong enough to create its own opposing shadows. If it does project shadows, it becomes a second key and destroys the illusion.

In the hallway example previously mentioned, the fill may be nothing more than a softlight aimed down the hall from the camera position to provide just enough detail in the actor's clothing or on the walls of the hall. It may also be that you want no fill at all if it is a dramatic situation. Just use the silhouette against the strong backlight that functions as the key.

Because of its quality, a softlight is usually chosen as a fill-light instrument since it is unlikely to create conflicting shadows. Its intensity can be controlled by scrims or diffusion material placed in front of it or by switches that control individual lamps in the instrument. You will still have the inherent problem of controlling spill from this instrument. If you are working in a confined area in which a softlight's spill would add too much light to the background to permit you to control the desired exposure ratio, especially in low-key situations, you can use a heavily diffused focusing spot. So long as it is diffused sufficiently and does not match or overpower the effect of the key, it would be the better choice since its lens system makes it possible to minimize spill.

The fill light should be placed near the camera, at eye level, to prevent it from casting its own shadows on the subject's face. While this placement eliminates one potential problem, it might create another. It may cast a distracting shadow of the subject on the background. If this occurs, there are several things that can be done to correct the situation.

You could diffuse the light further to lessen the severity of the cast shadow. If that does not produce an acceptable result, you could move the instrument closer to the object. Less distance between the subject and a diffuse light source will soften the cast shadows.

If you are unable to move the fill closer because of intensity problems or the fact that it might enter the shot, you can try moving the subject and the fill farther away from the background. This will also lessen the density of the shadow that falls on the wall. When all else fails, try a more directional source and position the cast shadow to an area of the closeup that will be least distracting. These cast shadows are only a problem in low-key setups. High-key backgrounds generally have enough light to mask the shadow cast by a fill.

BACKLIGHT

The backlight is the third function discussed, and it serves a very important role in modeling subjects. Since television is a two-dimensional medium, the backlight is essential to separate the subject from its background and give the illusion of depth to the scene. When used with a key and fill, it is frequently referred to as three-point lighting. If two backlights are used, it becomes a four-point setup. In addition to providing separation, backlights add contrast. Backlights should not only be used to separate actors from their backgrounds but also to separate various elements of the set from each other to further the illusion of depth.

Ideally the backlight is a Fresnel or focusing spot that is placed above and directly behind the subject so that it strikes at an angle of about 45° from the floor. This will require a physical separation between the subject and the back wall of the set. If the backlight is at a greater angle to the floor, it could begin to act as a toplight and cause distracting shadows and highlights on the forehead, nose or chest of the subject. If the angle is much less than 45° it could cause lens flair.

The biggest problem with backlights on location is where to hang them. Since they should be directly behind the subject, it is not possible to mount them on a stand as with the key light and the fill. If you did, the stand would be in the middle of the shot and appear to grow out of the head of the subject. If the location has a standard suspended ceiling, the easiest method is to use a drop-ceiling scissor clamp like that described in Chapter 6.

If there is no suspended ceiling you might be able to use the Lowel Tota-mount support. It is a very useful device that can be gaffer taped to almost any surface and will support a small instrument for backlighting such as the Lowel Omni or Cool-lux Mini Cool. The Omni light provides focus and barndoor control and provides for the use of scrims and neutral density (ND) filters to control intensity. In some locations, such as a typical warehouse, the scene is staged in a large open space that does not have a back wall near the subject and has a ceiling that is too high to permit mounting. In such cases a horizontal boom can be attached to a floor stand with a gobo head to suspend the instrument in the proper location. You may also install a rigging system for general lighting purposes that is supported on stands or towers out of camera range. Find some method to get the job done. Do not get the shot without a backlight because it is too difficult to find a way to mount the light. You will not get professional results without one.

The specular nature of the backlight and the color of the subject's hair (if any) and clothing will all have an effect on the desired intensity. These factors make it difficult to establish a standard ratio between the backlight and the key and fill lights. For this reason you should have the subject or a stand-in run through the blocking while you rehearse any camera moves that will be part of the finished take as you adjust the light. While making the adjustments, look at the picture and waveform monitor so that you are sure of the results. If you do not use this technique, you may find the backlight level is too bright or too dim to produce the desired effect. You are also likely to discover at the last minute that the backlight creates lens flair at some point during the shot. The solution may be to adjust the barndoor of the backlight or to place a flag above the front of the lens. If the camera is stationary during the shot, the flag may be stationary also. If the shot involves camera movement, a flexi-arm or gobo arm may be fastened to the camera dolly so that the flag will travel with the camera and prevent flair. Unlike key and fill lights, you can dim backlights with an autotransformer or SCR (silicon-controlled rectifier) dimmer to achieve the degree of separation you desire. Since they light the back of a subject, the shoulders, hair, etc., you do not need to be concerned about color temperature or their effect on the white balance of the camera. Cool-lux and LTM manufacture compact inline dimmers to assist with this problem. (See Chapter 11.)

HAIR LIGHT

I tend to think of a hair light as a limited area backlight that is used in conjunction with the backlight. As the name implies, it is used to illuminate the hair and cause a nice highlight for a modeling effect. Because of its limited coverage area, it is not an effective light to use when the actor is moving around a great deal. It should be a narrow-beam specular spot, generally with a snout to provide controlled coverage. Because you can literally paint with light in the same way an artist paints with a brush, the hair light can be very useful when the talent is blond and wears dark brown, blue or black clothing. Here a backlight that strikes the hair and shoulders of the subject will have to be a compromise. If it is strong enough to give the separation you desire between the shoulders and the background, it will certainly be too hot for the hair. If you set its intensity for the hair, the clothing will soak up what little falls on it, and the backlight will fail to provide the necessary separation.

For this, use a stronger backlight on the shoulder area and flag it off the hair. When you flag an instrument, you place a flag or barndoor (see Chapter 6) in the light path to cast a shadow on an area of the set or talent that you do not want lit. Then you can use the limited scope of the hair light to provide a lesser level of backlight for the hair. Remember, if you pay attention to detail, you have total control over the look of the picture. When things do not look exactly as you would like, the fault is yours. Think it through and fix it.

The reverse approach would be taken if the talent had black hair and very light-colored clothing. A dim backlight would be used to provide the small amount of light necessary to separate the clothing from the background. At such a low intensity, it would have no effect on the talent's black hair. Then add a high-intensity hair light to give some sparkle

to the talent's black hair. You could also place a blue or amber gel in this hair light to produce a more flattering result.

KICKERS

The kicker is also a limited coverage backlight, but it comes at the subject from behind and off to one side or the other. It is usually used for dramatic effect to simulate some motivated source or for the sheer effect produced. Unlike the hair light, which is always mounted above and behind the subject, kickers can come from any position above or below your subject.

The term kicker is also used to describe specular reflections that come from various areas of the set such as the glass in a picture frame, a shiny spot on the actor's face, eyeglasses or their rims. These types of kickers are usually undesirable and can be removed by changing the angle between the object and the light, by changing the camera position or by spraying the area or questionable item. Polarizing filters may also solve the problems of kickers. Kickers are seen as long thin vertical spikes on the waveform monitor and will frequently cause the auto iris to close down, leaving everything in the mud.

SIDELIGHTS OR RIM LIGHTS

Sidelights are an acceptable substitution for backlights. They are instruments that are placed to one or both sides of the actor to provide separation from the surroundings. Unlike kickers, these instruments are located just in front of the actor. They result in a rim of light around the edges of the body. Used primarily for musical numbers to give dancers a light, airy quality, they can also be substituted for a backlight when it is absolutely impossible to mount one.

BACKGROUND LIGHTS

Background lights are instruments used to light the walls of a set or the studio cyclorama. Their only function is to provide a basic light intensity on the background material in a set. Since they do not light actors, they can be dimmed as a means of controlling their intensity without affecting flesh tones. Dimming cuts down on necessary hardware such as flags, scrims, neutral density filters and stands. It also reduces power consumption and heat generation on location. Background lights have a great influence on the exposure ratio and the overall mood of the shot. In smaller setups the background light may be provided by spill from other instruments that are lighting the subjects, or special instruments may be placed around the set specifically for that purpose. Spots or floods may be used as background lights, depending on desired results.

Background lights should be placed just as carefully as any of the other instruments in the setup. Remember that you are always trying to create the illusion that the scene is lit by some primary source such as the sun, daylight coming through a window or fluorescents overhead. There may be two or more sources of light if the scene is indoors and is lit by multiple lamps in the room or outdoors at night surrounded by a variety of artifical sources such as streetlights, marquees, electric signs and light from the windows of buildings. Key lights are placed so that their cast shadows are consistent with those that would be cast by the supposed source of illumination for the scene. If that source is daylight through a window that is located screen right, the actors should the keyed from the right and so should the background elements.

I am always appalled when I see sunlight coming through a window from the right and then see picture frames and bookcases in the background casting shadows toward the right or at some angle other than the cast shadows of the key. These shadows destroy the illusion and are the result of careless and sloppy background light placement by the lighting director.

Any instrument that illuminates the background and casts shadows should be carefully located so that its shadows will be consistent with those created by the key light. Do not say, "I need more light on the background." Say, "I need some light on that bookcase from the key light angle." Or say, "Those picture frames are casting a shadow straight down from the frame. Move the background light so the shadows fall to the left of the frame and down." Pay attention to detail.

EFFECTS LIGHTS

Effects lights are instruments that do not serve any of the previous seven functions. They are used to create an effect, such as the projection of a tree branch onto a wall of the set. They may also be used to supplement regular background lights to bring set decorations such as plants or very dark wood furniture up to desired levels of illumination. As we have seen, plants seem to soak up light and require additional illumination. Fresnels or open-face spots are good for this purpose. You may wish to highlight a piece of dark wood furniture with light from a Leko. Effects lights also create artificial sunlight, lightning or explosion effects, to name just a few. Special Lekos with gobos for projecting intricate patterns or expensive pattern projectors that project moving effects such as fire or passing clouds may also be used. (See the Appendix for examples of available patterns and effects.)

WHAT TO USE

The question always asked is, "What type of instrument do I use for each function?" There are some common sense guidelines, but there are no hard and fast rules. Fresnels and broads make good backlights, but since these instruments may be too harsh for some scenes, you may wish to consider a zip. Fresnels and Lekos make good key lights, but

again, they may be too harsh and a softlight may work instead. A few years ago if I said use a softlight for your key, I would have been laughed at by those in the know. The fact is that lighting styles are changing, becoming more soft, and today softlights are used for keys. Any instrument can be used for fill, providing you have sufficient diffusion material to soften the output. The selection of instrument type should be guided by the aesthetic requirements of the scene. If you do not have the ideal instrument for the job, you should have enough accessories to tailor the output of available instruments to the quality of light you require.

In some cases you do not have much choice. If you want a hair light, you need an inky or small Fresnel with a snoot. Effects lights are best created using Lekos with gobos or a scene projector, but any specular source can be used in a pinch. The size of the cast shadow depends on the shadowing object and its relative distance from the lamp and from the background. You may use a tree branch or some special pattern you have cut from Fome-cor or any other object around the set. If you want a reasonably sharp shadow, use a specular source and place the gobo as far from the instrument and as close as possible to the surface the shadow will be cast upon. If the light is at a right angle to the gobo and to the surface on which it is projected, you will achieve the sharpest possible results. Not all cast shadows should be crisp, so you can play with light angles and adjust the distance between lamp and gobo and gobo and the surface on which it is projected to create pleasing distortions of the original shadowing object.

6 Terms and Tips: Control Yourself

These goodies are used on location and in the studio to control spill (unwanted light), alter the quality of the light or provide mounting support. Some are physically attached to the instrument and some are placed in front on a separate stand to alter or control its output. There are also a number of accessories that are helpful in mounting instruments under a variety of circumstances. Additionally, there are many widgets that are just plain helpful in getting the job done. My list is by no means complete, but represents basic and commonly used items.

Ace is not a hardware store. It is a 1000-watt Fresnel, also known as a baby.

ANSI stands for American National Standards Institute. It is an independent association formed to promote consistency and interchangeability among manufacturers of lamps and lighting equipment. Though various manufacturers have different numbers for the same type of lamp, the manufacturer's number can be referenced to an ANSI number to determine if it is interchangeable with a lamp from another company.

Apple boxes are not designed for fruit storage. They are multipurpose wooden boxes that may be utilized for sitting and standing and for prop elevation. They are glued, nailed and constructed with internal center supports so that they can withstand hefty loads. They come in a variety of graduated sizes. A full apple is 8 inches high. A half-apple is 4 inches high a a quarter-apple is 2 inches high. They form convenient bases for low-angle lights and hi-hat camera mounts or for leading men who can't quite measure up to the height of their leading ladies.

Asbestos gloves are made of a heavy heat resisting material and they will prevent many a burn. They may also cause cancer, so stay away from them. They are no longer sold. Lighting instruments are potentially dangerous if handled improperly or placed too close to other objects. They are *very* hot. A 750-watt tungsten halogen filament burns at a temperature of 5300° F. The outside wall temperature of a lamp is 1100° F. The temperature of accessories placed in the gate of a Leko is 1575° F. You need protection when working with these temperatures. Thin cloth gloves won't do! Buy heavy-duty work gloves or gloves with leather fingers and thumbs.

Baby is a 1000-watt Fresnel, also known as an ace.

Barndoors are black metal flaps attached to an instrument or placed in the accessory shoe on the front of it. They are used to restrict the coverage area of a light source. There are usually two or four flaps that can shape the lighted area. Sometimes they are permanently attached to the instrument, as with some portable broads, or they may attach to the front of an instrument in a bracket provided for that purpose. The best units are able to turn 360° around the opening of the fixture to provide more flexible pattern positioning. They produce a diffused cut-off line. They absorb much heat, so use your gloves when you try to adjust them.

Base light is a diffuse light level on a set that permits the camera to operate efficiently, without producing noise in the dark areas.

Batten is a horizontal pipe from which lighting instruments or scenery are hung.

Bazooka is not a gun or bubble gum. It is a method of supporting lighting instruments over the edge of the catwalk in a sound stage. It looks like an extension arm for a C stand, and it fits into holes that are predrilled in the catwalk.

Best boy may in fact be a girl or an old codger. He or she is a crew member whose duties include repair of broken connectors, switches or cables. He or she replaces carbons in arc lights and lamps in less beefy instruments and cleans and adjusts instruments to make sure they are ready when needed.

Blackbody is the theoretical standard used to determine the color temperature of incandescent light sources. (See "Color Temperature" in Chapter 1.)

Blackwrap is a heavy-duty matte black aluminum foil packaged in a tear-off roll just as household aluminum wrap is. It is used to wrap around areas of a lighting instrument that are projecting spill on some area of the set or is used as a flag, a cutter or as emergency barndoors. It's better than regular foil because it withstands the high temperatures of lighting instruments, and its matte black finish does not produce objectionable reflections anywhere around the set. It is available from Great American Market (see the Appendix).

Borderlight is also called an X-Ray. It is a striplight that is mounted above the acting area. Primarily used in theater, these same instruments may be used on the floor in front of the acting area as footlights or on the floor upstage as cyc lights.

Bounce cards are matte white reflectors used to redirect the light onto the subject after it has left the source. They can also be used to redirect wasted spill to an area where

it is required, without the need for an additional instrument. Any reasonably stiff material will do. Foamboard is lightweight, easy to cut and will stay put when placed in a gobo head and carefully positioned. Since the bounce light from a card is so diffuse, these cards must be placed close to the area you wish to light, just outside camera frame.

Bull switch is a master circuit breaker or fuse box with manual disconnect switch used at the head end of an electrical tie-in system. It is placed between the entrance panel from which the power is taken and your distribution system to provide protection and permit complete power-down of all your equipment.

Butterflys or overheads are large rectangular aluminum frames over which you can stretch a variety of materials to diffuse sunlight or natural light on exterior or interior locations. They may be as large as 20 feet on a side and cover an area large enough to permit shooting close-ups or medium shots. They work well in studios when placed between multiple instruments and a subject, such as a car. They eliminate multiple source reflections from the shiny compound curved surface.

Cameo or limbo lighting is a style in which only the foreground area is lit. The background is allowed to go black. It is a dramatic form that is economical because of the lack of scenery, and it keeps the viewer focused on the people or products without any distracting elements.

Chasers are lamps that are placed in a multi-circuit string and connected to a control device that turns every fourth or fifth lamp on and off in sequence to create the illusion that the lamps are moving in a forward or backward direction. Such arrangements are commonly used around marquees, signs or runways to draw attention.

C-Clamps derive their name from their shape, and they are used when extremely secure quick mounting is required. Nothing works as well. They come in 4-inch, 6-inch and 8-inch sizes. True lighting C-clamps have one or more 5/8-inch studs welded to their frame to facilitate the attachment of portable lighting instruments.

Cliplock is an alligator-type connector used to attach the leads for your electrical tiein system to the bus bars of the entrance panel. These special connectors provide a very strong mechanical connection that cannot be pulled off their point of attachment. A bolt arrangement ensures that the clip will not open.

Color frames or gel frames are thin rectangular sheet-metal sandwiches that have a large hole in the middle. They are used to hold color filters such as gel, diffusion material, heat filters or neutral density or color correction media. In most cases they slide into the bracket that is used to attach barndoors. Both barndoors and color frames can be used at the same time if desired. In some of the more portable fixtures, such as the Lowel lights, they are collapsible frames with clips to hold the filter and diffusion materials mentioned. They prevent instrument heat from warping the material immediately and destroying it.

Cookie (pronounced KOOK'ee) or cucoloris (pronounced kook a LOR is) is used to create a shadow pattern on backdrops and/or subjects. Positioned in front of a light

source, it breaks up an evenly or flatly lit area into interesting pools of light and shadow. You can buy commercially produced cookies made of 1/4-inch plywood painted black or you can fashion your own out of tagboard or foamboard using a utility knife. Be careful not to place such homemade units too close to the light source as they may scorch. Greater separation also permits a sharper focus of the projected pattern.

C-Stand is short for Century Stand. It has three legs (each one slightly higher and longer than the next) that can be folded flat in a 90° angle to the shaft and nested to make transport easier. These legs are spring-loaded and snap into their working position quickly for set up. The shortest leg can be set under most furniture and the tallest leg can fit over or around various other stands or items on set. Though they are somewhat expensive, they are extremely sturdy, take a real beating and are well worth the cost.

Cyc light is a special, high-intensity form of flood or broad that is used to illuminate cycloramas (see Chapter 10).

Cyclorama or cyc is a cloth or plaster surface that is used to surround the acting area and to create the illusion of infinite depth (see Chapter 10).

Deuce is one up on an ace. It is a 2000-watt Fresnel, also known as a junior.

Diffusion material is used to produce diffuse light. Made from a variety of substances, it will alter the quality of light that passes through it, making it more diffuse, producing less dense shadows and creating light that falls off more rapidly. It can be purchased in precut squares or as roll material. You can place it in a color frame or suspend it in front of an instrument using various other devices.

Dimmers are used to lower the voltage applied to the filament of a lamp and lessen its intensity. While they are mandatory for creating a variety of effects, they also reduce the lamp's rated color temperature and are not an acceptable method of reducing intensity of talent light.

Dinky is a 200-watt, 3-inch Fresnel with a sheet metal frame (see the discussion of Inky).

Dots are small round wire loops attached to a wire handle, something like the device children use for blowing bubbles. They can be covered with a variety of things, from thin netting or wire scrim to opaque material, and are used to control or eliminate a specular highlight and other lighting problems. Like flags, they are held between the source and the subject by gobo heads. Unlike flags, their small size affects only a limited portion of the lighted area. They are usually available in 3-inch, 6-inch and 10-inch diameter sizes.

Downstage is the area of the stage that is nearest the audience. The term stems from the early Greek theater where the stage was actually racked. The stage floor nearest the

audience was lower than the floor farther from it. In this way, as actors walked away from the audience, they were not hidden behind foreground players.

Dressing cables is a phrase used to describe the act of arranging the path of lighting and sound cables so that they do not interfere with traffic patterns on the set or appear in the shot. It is important to dress and tape cables out of harms way, especially if you have to run them down halls and across doorways in an office building or other public area. It is not advisable to dress audio and lighting cables along side each other. That frequently introduces a 60-cycle hum in the audio. In effect, what you do when you place these cables parallel to one another over any distance is create a giant transformer.

Drop ceiling scissor clamp and cable holder is a mount designed to close with a scissor action over conventional T-bar drop ceiling frames. It is fitted with a standard 5/8-inch stud to allow mounting of lightweight location fixtures. Some studs also contain brackets that can be used to drape electrical cords across the ceiling without the need for tape or other unreliable antigravity devices.

Edison plug or outlet is the term given to the traditional grounded plugs or wall outlets used in the home. The outlets contain two parallel slots of different lengths. The longer of the two outlet slots or the wider of the two plug prongs correspond to the neutral wire of the circuit. The outlets have a circular ground hole that mates with the ground pin of the plug. Outlets with one T-shaped slot indicate a 20-amp capacity circuit. These outlets do not require a special plug to mate with this T slot. Efforts to defeat the grounding and polarity aspects of such plugs and outlets is *not* a good idea. The polarized aspect of the prongs and the grounding pin can prevent nasty shocks in the event of cable or equipment failure.

Egg crates are not used for storage of poultry products. They are deep wooden frames that form several cubicles, and they are placed in front of a softlight to diffuse the light rays even further.

Electrician is the crew member responsible for bringing the power from its source to the lighting instruments through the distribution system. The source may be a tie-in, a temporary drop or a generator.

Ellipsoidal or Leko is a lighting instrument with an elliptical reflector and a complex lens system that make it possible to place light exactly where you want it without the need for any external accessories to control spill. A series of shutters, an iris or a gobo can be sharply focused onto an area of the set.

Fill light is the diffuse light placed to reduce the contrast of the shadows cast by the key light. It should never be bright enough to cast its own shadow. If for some reason it does cast a shadow, the instrument should be placed so that the resulting shadow falls out of range of the camera.

Fingers are similar to dots in function, but they are long, thin rectangles of material used to block light on a rectangular portion of the subject. They come in 2-inch x 12-inch and 4-inch x 14-inch sizes. They are covered with a variety of diffusion materials.

Flags or cutters are square frames covered with opaque material to block light from certain areas. Such unwanted light is called spill. Flags are placed in front of an instrument on a stand of their own and positioned to cut the light where needed. Depending on their placement, they offer a more defined cut-off point than barndoors because they can be positioned farther away from the front of the instrument. Cutters are similar to flags except that they are like large fingers, long and narrow.

French flag is a term given to flags that are made of metal rather than opaque material or some form of scrim material. They are the type of flags provided in the Lowel kits.

Frezzi is a well-known and well-respected battery-operated, camera-mounted light. Frezzolini was the first firm to produce a rugged camera-mounted DC light for news coverage and the name is often used in a generic sense to describe any such instrument regardless of the manufacturer.

Gaffer is not the person responsible for making mistakes. He is responsible for designing a lighting plot for each scene after consulting with the director, the director of photography or the camera operator. After the plot is approved, the gaffer directs the laying of cables and puts the instruments that are going to be used in place at the proper height. At that point the grips take over.

Gaffer grips are made like large metal spring-operated clothespins. They have one or more standard 5/8-inch studs attached to them and are designed to hold lightweight instruments or accessories in position on pipes, the edge of doors and other objects around the set.

Gaffer tape is a specially formulated 2-inch wide cloth tape, available in several colors, and commonly confused with duct tape or furnace tape found at the local hardware store. Duct tape is not the same and should not be substituted. Gaffer tape will not damage painted or stained wood surfaces. It can be used for anything from securing cables to mending the leading lady's dress. It can be applied to silver subjects such as car bumpers to reduce glare, and it looks convincing on camera. Duct tape is too shiny for this purpose. Always have plenty of gaffer tape on hand.

Figure 6.1: Baby Combo

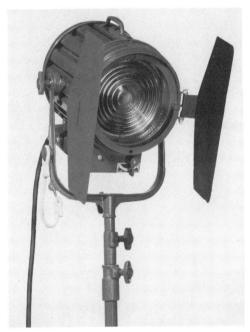

Photo courtesy Mole-Richardson Co.

Photo courtesy Lowel-Light Manufacturing, Inc.

Figure 6.2: Barndoors on a Lowel Omni

Photo courtesy Lowel-Light Manufacturing, Inc.

Figure 6.4: Cucoloris

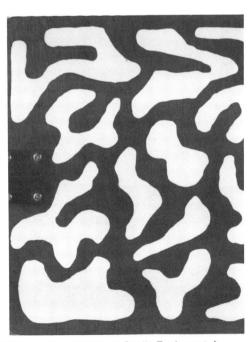

Photo courtesy Matthews Studio Equipment, Inc.

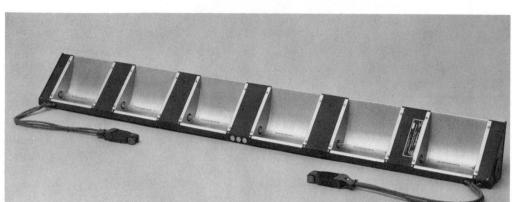

Figure 6.5: Cyc Light Strip with Stage Paddles

Photo courtesy Mole-Richardson Co.

Figure 6.6: Cyclorama

Photo courtesy Arben Design.

Figure 6.7: Dimmer

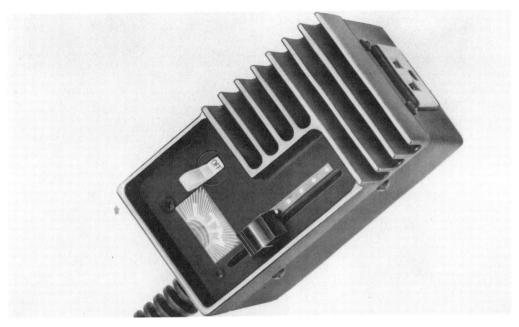

Photo courtesy LTM Corp. of America.

Figure 6.8: Dots

Photo courtesy Matthews Studio Equipment, Inc.

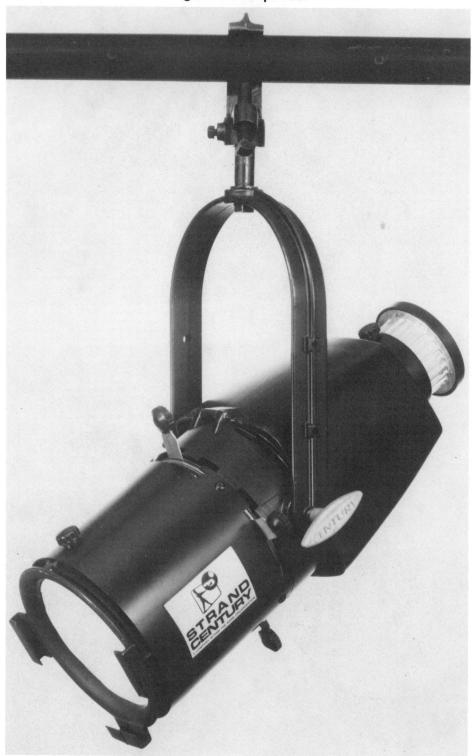

Figure 6.9: Ellipsoidal

Photo courtesy Strand Lighting.

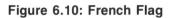

Photo courtesy Lowel-Light Manufacturing, Inc.

Figure 6.11: Frezzi

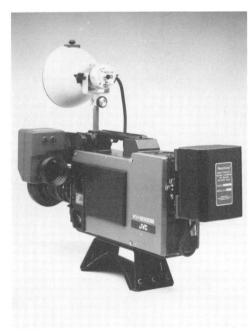

Photo courtesy Frezzi Electronics.

Figure 6.12: Gaffer Grip

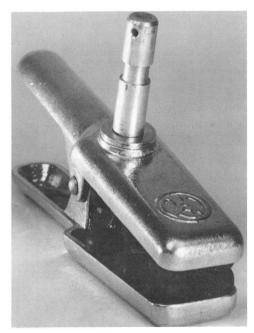

Photo courtesy Mole-Richardson Co.

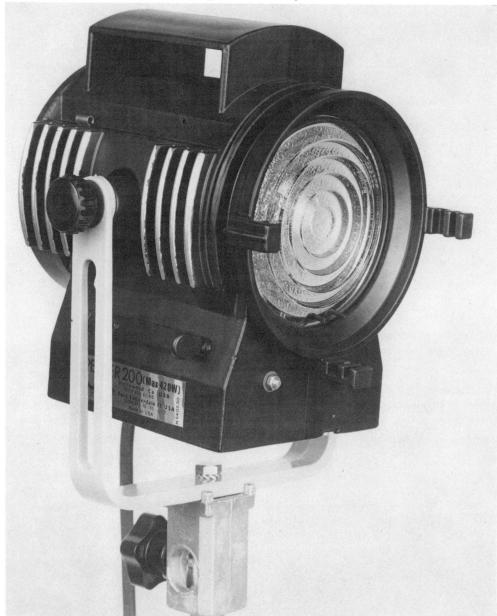

Figure 6.13: Inky

Photo courtesy LTM Corp. of America.

Figure 6.14: Sliding Rod with Grip Head

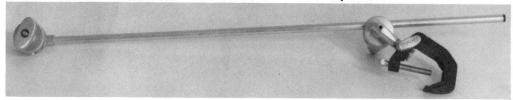

Photo courtesy Matthews Studio Equipment, Inc.

Figure 6.15: Tener

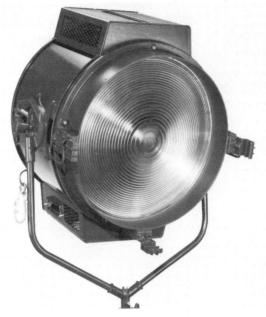

Photo courtesy Mole-Richardson Co.

Figure 6.16: Zip

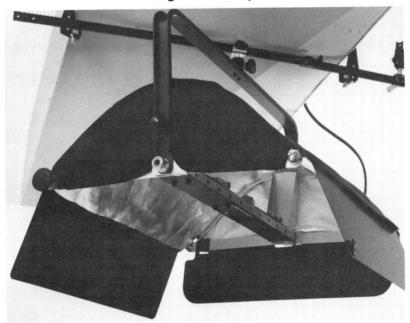

Photo courtesy Lowel-Light Manufacturing, Inc.

Paddington Green
London W2 1NB

Gobo can mean different things, depending on who is speaking. Lighting directors are probably talking about a precut metal disk that is inserted in the gate of a special pattern projector or Leko to project a specific image on the set or actors. These come in a wide assortment of effects ranging from fireworks displays and American flags to Venetian blinds and trees (see the Appendix).

Grips talking about gobos are probably referring to a Tinker-toy-like metal disk that is fastened to the extension arm of an accessory stand. Gobo heads or grip heads are available in 2 1/2-inch or 4 1/2-inch diameters. They mount on standard 5/8-inch pins and are designed to receive 5/8-inch, 1/2-inch and 3/8-inch round accessories. They will also accept irregular shapes and flat objects like handmade flags of foamboard.

Just for fun, if camera operators are talking, they would be referring to some object in the foreground of the set that the camera will shoot through, or move past while shooting the scene. It may be a decorative screen or the andirons of a fireplace.

Audio technicians are probably referring to portable sound deadening panels that can be placed around individual musicians in a studio to isolate the sound of their instrument from others to give the mixing engineer greater control over the mix. Quick now, what is a gobo?

Grips are crew members who set up lighting accessories such as flags, gobos, C-stands, etc., at the direction of the gaffer. They control spill and intensity through the use of a variety of accessories. Their duties may also include the placement of props on the set and assisting the camera operator.

Inky is a 200-watt, 4-inch Fresnel with a cast metal frame (see the discussion for Dinky).

Kelvin is a temperature scale that corresponds to the centigrade scale but has its zero at -273°. It is the scale used to measure the color temperature of light.

Lamp is the technically correct name for a light bulb. It is a gas-filled envelope containing a filament.

Leko is a brand name ellipsoidal named for the inventors (see the discussion for Ellipsoidal).

Lowel clips are extremely handy reusable plastic fasteners that wrap around rolled up cables to keep them together and prevent them from getting snarled with other cables. They are completely adjustable and provide a ring at one end from which to hang the cable. They can be removed instantly and do not leave a sticky residue on the surface of your cables.

Mole pin is a male and female pin plug system made by Mole-Richardson. Heavy-duty copper pins are connected to one end of welders cable to provide an easy disconnect method of heavy current loads in the distribution system of your electrical tie-in. They simply push into heavily insulated matching female sockets.

Neutral density (ND) filters reduce the light output of an artificial light source (or the sun) by a specified amount equally in the red, blue and green spectrum. They do not affect color temperature. They may be built into the camera, attached to the front of the lens, placed in front of an instrument or placed on windows to reduce incoming sunlight. Common values for ND filters are .3, .6 and .9, which reduce light by 1, 2 and 3 stops respectively. When talking about such filters refer to them as point three, point six or point nine.

Nineteen hundred box is another one of those strangely named items with a missing etymology. It is nothing more than a standard 4-inch x 4-inch metal outlet box containing two sets of duplex Edison outlets.

Paddles are rectangular male plugs constructed of a good insulator with brass strips on the narrow edges that mate with the power strips inside a stage box.

Pantograph is a counterbalanced hanging device that lets you quickly adjust the height of a lighting instrument that is hung from the grid. Because of the counterbalance spring you can lower the instrument and it will stay put when you release it. Pantographs permit you to adjust the height over a 12-foot range, so you can place shadows where they are most effective. Some pantographs permit the hanging of two instruments on the same unit.

Photometrics or performance data are light output specifications for a lighting instrument. They state the intensity of the light produced at various distances from the source and indicate the area covered at the stated distances. If the instrument is a focusing spot, that information will be given for the full spot position, the full flood position and possibly for a midrange setting. This information may be presented in a simple numeric chart, with graphic drawings or with photos of the coverage area in addition to printed statistics.

Practical is a term used to describe any lighting fixture or prop on stage that actually works. Items such as table lamps or radios can be practical.

Reflector boards are designed to redirect natural or artificial light. They generally have two sides or faces that offer specular and diffuse reflective surfaces. They are like bounce cards, but their output is more specular, and they have greater throw. They are normally covered with smooth silver foil on the "hard" side and textured silver leaf on the "soft" side. Gold leaf is also available. The warm tone of its reflection is very complimentary to black skin.

Sand bags provide additional weight to C-stand bases and other portable objects that could easily fall over if not weighted down. They are traditionally filled with sand and weigh between 15 and 35 pounds. If a sand bag leaks during a shipment with cameras and recorders it can wreak havoc with the technical gear. For this reason, it is best to use shot bags that contain small metal BBs instead. If you extend your stands, use shot bags.

Scrims or nets are nonelectrical dimmers. They provide a controllable means of reducing light output without affecting color temperature or generating radio frequency interference (RFI). Open-end scrim frames are made of spring steel to provide constant tension on the exposed cloth edge. The open end facilitates feathering or blending the edge of the light beam without causing a harsh line. A lavender scrim causes a 15% light reduction. Singles reduce light output by about 30%. Doubles cut back by about 50%. Exact effect depends on placement. Some are made of cloth mesh while others are made of silk. They can be held in front of the source by gobo or grip heads on C-stands.

Sliding rod is an economical means of adjusting the height of lighting intruments hung from a grid. The rods come in different lengths that allow you to raise or lower the instrument by releasing a thumb screw on a sliding ring that is fastened to the fixture. Lights hung from a pantograph can be adjusted from the floor by using a stick. Lights fastened to a sliding rod must be adjusted from a ladder and require a great deal of time to set up. Unlike the pantograph, which collapses as the light is raised, the sliding rod remains the same length regardless of how high the instrument is placed, and it may hang down in front of some other light and cast a shadow on the set. Some sliding rods telescope into shorter lengths.

Snoots are cylindrically shaped attachments resembling stove pipes. They are attached to the front of the instrument in the color frame bracket. They confine and narrow the light produced by a spot or flood.

Spike is not something you do to a volleyball. It is the act of placing a piece of tape on the floor to indicate where some prop or piece of furniture should be placed, or to indicate where an actor should stand so he will be in the right position for lighting and camera shots. The actor's spike mark is usually two pieces of tape in the shape of a T. When he hits the mark he places one foot on either side of the leg of the T facing in the direction of the T's crosspiece.

Spill is a term for light that falls on some area of the set where it is not wanted. Somewhat like a child's milk.

Stage box is a rectangular-shaped porcelain receptacle in a heavy metal box used to distribute moderately heavy loads of current. It comes in a variety of capacities and configurations. Stage plugs or paddles are inserted into the stage box to tap a portion of the available current.

Stageleft is an instruction describing movement or a location to the left of actors as they face the audience or the camera.

Stage plugs are heavy-duty insulated plugs used with stage boxes for the distribution of current around the set. Large brass strips on each side of these plugs make contact with the brass lining of the stage box. Generally the stage plug is on one end of an extension and nineteen hundred boxes are connected to the other end for distribution through standard Edison outlets.

Stageright is an instruction describing movement or a location to the right of actors as they face the audience or the camera.

Sticks is slang for camera tripod.

Strike means to remove something from the stage area and place it out of the way. It is also used to describe the action of packing up your equipment or taking down a set for storage or disposal.

Teners are not opera singers. They are 10,000-watt Fresnels.

Tree is a high stand, with horizontal arms and a very heavy metal base from which lighting instruments can be hung. Generally used in theaters, it can be employed on any location to mount one or more instruments from the same stand. Sometimes, small tower-like structures for mounting instruments are also referred to as trees.

Trick Y is a Y-shaped cable arrangement used to split a single leg of an electrical distribution system into two legs.

Umbrellas are made of a textured silver fabric like that used in portable softlight reflectors. They make it possible to use spotlights and broads as sources for diffuse light. You simply aim the fixtures at the inside of the umbrella when it is open. The reflected output is very soft and uncontrollable. Like any diffuse light, it falls off quickly so you must be able to position it near your subject. Open-faced instruments work best as sources for umbrellas. If you are using a focusing spot, do not put it in the full spot setting as it may destroy the umbrella material due to excessive heat. Fresnels can be used as sources for umbrellas by removing the lens. (See Figure 3.18 for an example of an umbrella.)

Upstage is the area of the stage that is farthest from the audience (see downstage). When used as a verb, it means that the one actor is pulling focus or audience attention away from another at a time when this actor should not have the attention.

Work lights are permanently installed general lighting fixtures in a studio or stage that are used to provide light for setups and general work on set. They should always be turned off during shooting since they are not color-corrected and will cast multiple shadows and unwanted spill.

Zip is not a postal code. It is a 2000-watt (or less) portable softlight or a name applied to a common household lamp cord, called zip cord.

YOUR GADGET BAG

In many cases location lighting is an unplanned event. You are told to, "Go to Widgets, Inc. in East Nowhere and shoot Mr. Bumfutz and his two assistants as they take a Widget from the drawing board to the shipping clerk." With little advance information you are

driven to the airport with 22 cases of assorted goodies hoping you have what you need. You might, or you might not. If you don't, improvise. That's the excitement and satisfaction of the job. Lest you become too excited or satisfied, a few things can save you anxious moments.

Carry your own gadget bag and keep it filled with those little things that make the unexpected manageable. I use the term bag loosely because I've found that keeping these items in a canvas bag defeats the idea of being organized. If everything is thrown into a bag it makes it difficult to find the specific item you need. You are also likely to leave something behind when you strike everything and pack up to go home. You can't tell from looking into a bag if everything is there.

From a canvas bag I progressed to a metal tackle box with various compartments so things could be organized and I could tell at a glance if something was missing. That created a problem at airports. I now carry a small compartmentalized suitcase that can be X-rayed and placed under an airline seat.

Here are some suggested items that can make your life easier. They are not presented in any particular order of importance. In fact, the most important item is the one you don't have.

- 1. Take along a number of triplets or "3fers," also called cube taps, that allow you to plug three things into a single outlet or extension cord. Buy the heavy duty, grounded type.
- 2. Keep a good number of adapters with you that allow you to plug grounded equipment into ungrounded outlets. Never break off ground pins to accomplish this mismatch. It's unsafe and unprofessional!
- 3. Keep a Volt-Ohm meter to check voltage, fuses, lamps and cords for continuity. Take along a spare battery for your meter. Just when you need the meter most the battery will die and you will be in Littletown, USA on a Sunday with all the stores closed.
- 4. A helpful item to have is a plug-in three-wire outlet analyzer. It looks like a grounded male plug with three indicator lights to show the condition of an outlet without probes or meters. You can confirm working circuits and check for wiring faults like open ground or hot wires and reversed polarity.
- 5. Be sure to carry some tools. An adjustable wrench and a small screwdriver set with Phillips and regular blades will be invaluable in making last-minute repairs. A set of allen wrenches is also a good investment. Often times the focus knobs of instruments are secured or semisecured by allen screws.
- 6. Have plenty of spring-clamped clothespins to hold filters, gels or diffusion material to the front of lighting instruments or barndoors. Be sure to use the wooden version. The newer plastic type will melt down almost immediately and produce a foul smell on set.
- 7. Take black-and-white china markers along. They allow you to write on metal and glass surfaces and mark reference points on the camera's viewfinder, the waveform

- monitor or vectorscope. You can mark focus and zoom stops on the lens barrel and use them for a variety of other tasks.
- 8. A small pencil sharpener can help keep china markers and other pencils functional.
- 9. Don't forget the can of dulling spray. If you do, there's sure to be a stainless steel tank in the background of three shots. Something that works even better to cut down glare on bright metal surfaces is silver or gray "Streaks-n'-Tips" hair color in aerosol cans available at many drug stores.
- 10. You will always find use for a roll of clothesline rope and some heavy twine.
- 11. Monofilament fishing line will allow you to suspend things invisibly and trigger certain special effects from off camera.
- 12. Rubber door stops have many uses. They can keep doors open, such as doors that lock when closed and doors that can't be opened without a special key that is not around. They can level props for the camera and keep things from moving off their marks.
- 13. A utility knife can cut cheese and pizzas to make life during breaks more livable. It also comes in handy for cutting color media and filter material as well as stripping wires and cutting ropes, tape and foamboard. You can also use it to carve out a gobo.
- 14. To keep cords and ropes neat, there is nothing better than a large supply of Lowel-Clips, those plastic wonders that don't leave a sticky mess on your cables.
- 15. Several rolls of gaffer tape are a must. It comes in yellow, blue, green, silver, black and white. Have plenty on hand to tape and mask a variety of things on set.
- 16. Double-stick foam tape is a good thing to keep throw rugs from living up to their name. It can also fasten light-weight pictures to walls and keep frames from tilting. Almost anything that slips out of place can be tamed using this product.
- 17. It is a good idea to carry small squares of different types of diffusion materials, 85, ND in various stops and some booster blue to gel individual instruments or treat small window areas or practical instruments on set.

BEYOND YOUR GADGET BAG

There are some larger items that won't fit in your bag, but they should travel with you as excess baggage if you are flying.

- 1. Always have plenty of spare lamps in a variety of wattages. They permit you to use the lowest wattage lamp necessary for a given location to keep heat and current consumption as low as possible.
- 2. Take plenty of extension cords. Put them on simple reels. If the budget permits it is best to have retractable cord reels to save time in set-up and strike. The best kind to use are those that have a fan-shaped 3-outlet head to permit several fixtures to be connected to a single source outlet.
- 3. If you will be shooting on a location involving windows or glass doors carry rolls of 85 gel to convert daylight to 3200 °K. You should also have roll of ND filter material in several densities and a roll of booster blue to convert 3200 °K lamps to daylight. They should be in individual shipping tubes to protect them from scratches and kinking.

	,		

7 Basic Lighting Setups: Where Do They Go?

Perhaps the most important aspect in selecting the lighting setup for any scene is consistency—consistency on several fronts. First, the choice of setup must be consistent with the mood of the script. It must be consistent with scenic elements and take cues from such things as window placement, placement of practical lighting fixtures on the set, established conventions and unnatural effects that are to occur. This is not meant to imply that setups should emulate nature 100%. One of the joys of lighting is the fact that you can improve on nature and still maintain the illusion that it is responsible for the final look. The purpose of lighting is to further an illusion. When some element of the setup is not consistent with all the other elements, the illusion is destroyed. Good lighting is invisible. Bad lighting is obvious.

There must be consistency from a long shot to a closeup, and there must be consistency within a series of shots. The placement of the key light is critical, and once that has been decided, the degree of fill, the establishment of ratios, the placement of lights to achieve separation of scenic elements and other factors concerning the color and quality of light must be carefully worked out. Good lighting takes time, so do not feel you are doing your job poorly if satisfactory results are not achieved instantly. Naturally, time must be weighed against budget and the shooting schedule, but there is always a reasonable compromise.

I suggest that you light your widest shot for any given scene first. From this setup you can determine your exposure ratios for various areas and follow through with more critical lighting control as your shots narrow. Aside from establishing the various exposure ratios for the scene, you will eliminate the possibility of creating continuity problems between the close-up and the long shot.

If you start by lighting a close-up and project a pattern on the background for visual interest, you may create extremely satisfying results and an appealing set of exposure ratios between the subject and various background items. Problems occur when you try to set up the wide shot and find that you cannot duplicate the basic exposure ratios and shadow patterns that you were able to create in the close-up. Lack of ceiling height and off-camera areas contribute greatly to this problem. You may also find that you do not have sufficient power or instruments to light the entire set at the levels maintained in the close-up you lit first.

Since the most important, effective and frequently used shots in television are the close-up or medium close-up, you will want to carefully consider how you would like to light these shots before you start the setup for the long shot. Then you should try to tailor instrument placement in the wide shots so it will cut with the most effective close-up lighting that you are planning to use. Once again, your wide shot may be the limiting factor. In general, wide shots do not have to be lit as critically as close-ups. We do not expect to see things as clearly from a distance as we do when we get closer. We do expect that the light will be coming from the same direction in both shots, but fill and backlight need not be as closely controlled in the long shot.

A check of terms in Chapter 6 will show that some equipment names have more than one meaning, and terms for lighting setups are far less specific. In my experience there is no authoritative source that defines so called "basic" lighting setups. A director cannot tell the lighting director (LD), "Give me a number 29," or, "I want a Slapitzki setup for this scene" and expect to get a certain look. There must be a discussion of mood, depth of field, preferred f-stop, etc., so that the LD can establish a setup that is consistent with the intentions of the scene.

Therefore, I cannot say, "If you learn the following basic setups, you will know everything there is to know about lighting." The number of different setups is as large as the number of shots to be lit. It is even larger, because scenes can be lit more than one way so long as the approach from shot to shot remains consistent.

What follows are setups indicative of basic lighting concepts. Within each concept there are many possible variations. I hesitate to assign names to each setup since that name would only have relevance in the context shown here. For purposes of clarity I will have to call them something, but you must realize these terms will not permit you to communicate your desires to others. They are meant to capture the essence of a particular approach and perhaps evoke a bit of humor.

In very general terms, keys can be placed in one of four positions relative to the talent's facial position and the camera. The key can be placed directly in front of the talent, it can be located on the side of the talent that is nearest the camera, it can be located on the side of the talent that is farthest from the camera, or in certain situations, it may even be located behind the talent directly opposite the camera. There are also other less conventional placements for the key light that will be discussed at the end of this chapter.

THE CHEAP AND DIRTY, HEAD-ON KEY

The head-on key is perhaps the easiest to set up, and it most closely approximates natural overhead lighting. In this setup the key is placed directly in front of the subject so that both sides of the face are lit equally. Exact placement should be guided by the fact that you want the key to cast the shortest possible shadow from the nose and to highlight the eyes. The results are flattering to the subject when proper placement is achieved. Be sure the instrument is far enough away from the subject so that you do not experience the problems of intensity falloff. If the key is too close to the subject, the forehead will be too hot compared to the chin and chest area. If the source is diffuse enough, you may not even require a fill light for this setup. If the scene is high key, the general base light may be sufficient to act as fill.

The need for very little fill may be satisfied by using a bounce card. If additional fill is required, a small diffuse light mounted on the camera should be enough to do the job. It is quick to set up, and if space is limited, the shadows cast by the key will generally fall low enough on the wall behind the subject to be out of frame for the close-up. Such a setup also works well for low-key setups in which the implied source is a ceiling fixture.

The backlight position and intensity should be determined using the methods mentioned in Chapter 5. Figure 7.1 shows an example of a head-on lighting setup.

Figure 7.1: Head-On Lighting Setup

HAPPY HIGH KEY FROM THE NEAR SIDE

In this setup the key light is positioned high on the side of the subject's face that is nearest the camera, the downstage cheek. It should be situated in such a way that a triangular light pattern strikes the upstage cheek. Since the shadows fall on the far side of the face, away from camera, the placement of the key light in such a setup is not as critical as when the key is from the opposite side and the shadows are cast on the downstage side of the subject. In general, setups with the key located on the near side of the face are less dramatic than setups with the key on the far side and are frequently used in high-key scenes. Like the head-on setup, this setup produces results that closely resemble natural overhead lighting.

If there are fluorescent lights at the location, the key should be a diffused focusing spot or a softlight to emulate the natural look of that environment.

The near-side setup also serves well in interior locations partially lit by daylight coming through a window in the shot. In these situations, daylight sources or converted tungsten sources should be used to bring the light level in the room to within a half f-stop of the daylight coming through the windows. This will achieve a natural-looking ratio between the window and the subjects in the room.

As with most setups, the fill is placed at eye level on the opposite side of the key. The intensity of the fill will control the lighting ratio, and like all fills, it should not produce shadows of its own.

Again, the all important backlight should be positioned in the manner described earlier. Figure 7.2 shows an example of near-side lighting.

Figure 7.2: Near-Side Lighting Setup

DRAMATIC LOW KEY FROM THE FAR SIDE

This setup is just the opposite of the near-side setup. Here the key is placed high above the side of the subject's face that is upstage of the camera so that it casts a triangle of light on the side of the face nearest the camera. Place it so the shadows are cast down and toward the camera. Such a key will highlight the shoulder farthest from camera and leave the near shoulder in darkness. This creates depth beyond that added by the backlight. The key may be specular or diffuse, but specular keys provide more dramatic lighting that has a greater sense of depth. When setting the backlight, be careful not to destroy the depth you have created with this setup. Keep light off the downstage shoulder. This type of setup was used frequently in the old black-and-white Peter Gunn series to create some wonderfully erie scenes.

With the far-side setup, placement of the key is critical because the shadows created are cast on the side of the face nearest the camera and are more obvious than in the previous situation. The key should be placed so that the nose does not cast a large shadow on the

downstage cheek and the actor can move freely without casting odd shadows on the downstage side of the face. Though the basic effect will change as the subject looks toward the key and back toward camera, there will still be sufficient modeling to keep the mood. If the subject's head turns toward the fill so far that the downstage cheek is lit directly by the key, the effect will be ruined. In such a case it is best to change the actor's blocking slightly rather than make lighting adjustments.

In the far-side setup, placement of the fill is also critical. It should slightly overlap the key area and be placed at eye level near the camera. Naturally it ultimately determines the lighting ratio and should not be strong enough to cast its own shadows.

Best suited to low-key, dramatic lighting, the far-side lighting setup still has a wide range of effects.

As stated previously, it is best to stage your long shots before lighting the close-ups. The lighting ratios of the long shots should be higher than those of the close-ups. The far-side setup intercuts well with higher-ratio long shots, maintaining the mood, but providing additional detail in the shadow areas. Since the basic look of a far-side setup places the downstage side of the face in shadow, a ratio of 4 to 1 may be used in a far-side close-up being intercut with the long shot having an 8 to 1 ratio. Figure 7.3 shows an example of far-side lighting.

Figure 7.3: Far-Side Lighting Setup

MOTIVATED LIGHTING

To set aside a category titled "Motivated Lighting" seems to imply that it is somehow a lighting form different from earlier categories. Since all lighting should be motivated by elements in the scene, it is merely an extension of the principles that guide the cross-key or sidelighting setups that follow and the setups already mentioned. It utilizes any

of the previous setups, and it is determined by the location of windows or practical electricals on the set. Even though these natural sources may not be a part of the close-up, if light sources are seen in the long shot or are implied by dialogue, they should serve as your guide to the placement of keys, fills and backlights around the set. Additionally, these practical sources will justify your exposure ratio between subject and background. The use of gobos and the selection of basic instrument types should also be guided by these factors. In documentary production it is best to follow these natural source clues as carefully as possible, maintaining exposure ratios in keeping with the situation. In scripted productions you can be a little freer in your interpretation, or replication, of the natural sources. When practical lights are present on the set and are located in frame, use 3200 °K photo lamps (see Chapter 3) and gel with ND filter material, if necessary, to achieve the proper exposure. Generally speaking, if a lighted lamp is visible in frame, it should be about one-half f-stop above the exposure of the subject. You should measure its intensity with the incident light meter held about 1 foot from the shade.

The materials, color and texture of set walls should guide you in selecting the type and placement of background light sources. Obviously, a shiny white wall will require less light than dark wood paneling to maintain a similar exposure ratio between subject and background.

The creation of natural, believable lighting that contributes depth and an artistic statement to the production is the challenge of any assignment. There is great satisfaction in looking at the monitor and realizing the pleasing picture you see is the result of your efforts. If you have done your job well, the effort will not be noticeable, but the results will.

SIDELIGHTING SETUPS

Sidelighting is used to emulate the mood and direction of various interior or exterior lighting sources. An example might involve a practical table lamp that is located next to the chair in which an actor is seated. Whether the practical lamp is seen in the close-up or not, if it is shown in a wider shot, it affects the placement of the key. The type of key light used will be dictated by the practical source itself. If the table lamp has a translucent shade on it, you could use a softlight or a diffused specular source as your key. If the table lamp exposes a bare bulb, a nondiffused key would probably be more appropriate. At any rate, the key would be located at approximately the same height as the lamp and aimed at the subject from the angle of about 90° to the talent. Naturally you would expect the actor's face to be hot on the side facing the lamp and much darker on the opposite side. You do not need to be overly concerned about the shadows cast by such a key, as it is more important that you reinforce the effect of the real-life lighting than attempt a portraiture-type of setup.

As with any lighting setup designed to emulate some motivating source, you can (and should) cheat a bit to improve on the natural look, so long as you do not destroy the illusion you are trying to create. Many times lighting directors are overly concerned about "pleasing results" and destroy the illusion they are trying to create. The temptation is

to raise the key and bring it farther forward to create more pleasing shadow patterns than would be created by the practical lamp. When the cheating produces portrait-type lighting, you have gone too far. It is time to lower the key and push it back a little to get back to reality.

To lessen the stark look of such a setup, a soft fill light is placed directly in front of the subject and carefully adjusted to bring some detail out of the key's shadow area without adding any conflicting shadows. The fill can do a lot to lessen the often unflattering shadows produced by such a natural setup. The addition of the backlight will complete the illusion and separate the subject from the background. Figure 7.4 shows a typical setup for this form of lighting.

Figure 7.4: Sidelighting Setup

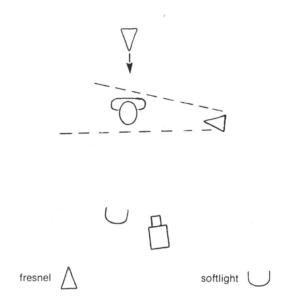

CROSS-KEY LIGHTING SETUPS

The cross-key setup is merely a situation in which natural lights dictate that a second key be added to a sidelighting setup from the opposite direction. This second key should generally be of the same type as the first, and it will serve in place of the fill light. In this case there is no fill, but the backlight is still a part of the setup. Figure 7.5 shows an example of this setup.

Cross-key setups are common in theatrical lighting. In this type of situation, two identical instruments are located to the right and left of the talent at 45° angles. One key is gelled in a warm color and another key is gelled in a cool color. Because of the color difference between keys, the cool-colored key serves the function of a fill light. It creates a convincing illusion that the cool side of the talent is in shadow and establishes the warm-colored light as the key or source light.

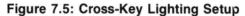

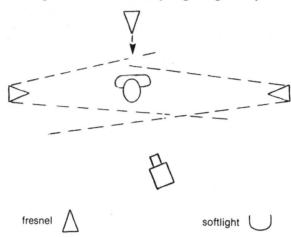

When instruments are placed in the same relative positions to light television talent, the results are not at all convincing. Since television lights are not gelled, the theatrical effect is lost. There is no sense of where the source light is located and the end result is conflicting shadows. It's the old "Get rid of the shadow with another light" approach, and it has no place in good lighting for television.

8 Avoiding Problems: Be Prepared

The greater the preparation, the smoother the shoot. To be properly prepared for an interior or exterior location, you should budget money and time for a site survey. The information you learn from a complete survey will not only affect your lighting approach, but it will affect your shooting schedule as well. The equipment required for a survey is minimal:

- 1. Take your light meter to measure existing light levels. Take the measurements at the same time of day as you plan to shoot in that location.
- 2. A 50-foot tape measure and/or a measuring wheel determines the exact dimensions of rooms, doors, windows, ceiling heights, outlet locations and cable runs.
- A quad-ruled planning pad and architect's scale lets you make quick scale drawings of the room dimensions and window and outlet locations.
- 4. A small screwdriver set gets you into breaker panels so you can determine the proper tie-in equipment required and measure existing loads.
- 5. To help you figure out which outlets are on which circuits, use a night light or low voltage buzzer with an ac/dc adaptor.
- 6. A clamp-on ac ammeter is a good optional item to have. With it you can measure loads on existing circuits without disconnecting the line being checked.
- 7. A helpful item is a wire guage that is used to determine proper fuse size for branch circuits. (An explanation of this follows.)
- 8. Use an instant camera with adequate film and flash to make a photo record that clarifies your drawings and illustrates any unusual situations. You can record views from windows that might be suitable as backgrounds for your shots.
- 9. A compass and watch are useful for determining room orientation and tracking the sun to learn how daylight coming through windows will affect your production.

10. Include a note pad on which to record names, titles and phone numbers of key personnel on staff at the location. Make note of other important information about security procedures, house rules and any unique information.

Depending on the camera you use, all of the above items should fit neatly in a brief-case. You can secure the necessary data efficiently and in a manner that will project professionalism to your client and/or those in charge of the location. That first impression can go a long way in greasing the skids for a cooperative effort between location owners or managers and your crew when it arrives. It is a rare owner who knows what to expect when a location crew arrives, and the more concern and respect you show for the property during the survey, the less likely the owner is to be concerned when gaffers tie into the circuit breaker panels and grips mount instruments on the doors and bookcases.

LOCATION COMPLEXITY

In general, four levels of complexity are possible at any location. In the least complicated situations, you will have sufficient power to light the scene by simply plugging into existing outlets in the immediate vicinity. In the next case you may find it necessary to tie in to the electrical service entrance to draw and distribute enough power for your needs. If you are still short on power, you might request that a special drop be installed by the local utility company. If that is not practical, it is time to call in an auxiliary generator. This generally requires a large, well-trained crew and a great many lighting instruments. It is at this point that you are better off calling in outside help, and since their operation will be left to those you hire, we will not discuss generator setups here.

To determine the complexity level of a proposed location, a thorough site survey is in order. Locations range anywhere from a private home to a multistory office complex, hotel or exhibit hall. Each has its own unique set of circumstances and restrictions which you must accommodate. Obviously a private home with a valuable art collection and antique furniture will involve greater potential for problems than will a three-room apartment on the wrong side of the tracks. Without fail, you should have the proper insurance against property damage, general liability and ''hold harmless'' clauses. Special events coverage may be required (if obtainable) for productions shooting in locations that contain especially valuable items. In general, these rates are quite low, and you should never be without proper coverage. Check with your insurance agent before getting into high-risk situations to see if you are properly covered.

CONDUCTING THE SURVEY

Because of the variety of situations involved with different location sites, there is no one right way of conducting the survey, but there are some general elements that should not be overlooked.

Get the name and phone number of the person authorized to show you through the area you intend to shoot in. Make an appointment early enough so you can take any necessary corrective action on problems before your shoot date. If the site is a large multistory building, take specific notes about its location, the nearest cross streets and which entrance, loading dock or elevator bank your crew is to use when it arrives. Check with building security to see if passes can be issued in advance to admit your personnel when they arrive. Get the names of security supervisors who will be on duty at the time of your shoot and meet with them personally, if possible, so they are fully aware of your intentions.

Make a scale drawing of the shoot area on your quad-ruled pad. Indicate door and window locations and ceiling height. Indicate outlet locations. Use your compass to determine how the room is oriented so you do not try to shoot a scene at a time when the sun will be pouring into your lens or casting objectionable shadows or creating extremely bright pools of light in the area you wish to use as a background. If you plan to gel the windows with 85, be sure you have accurate window measurements so you will have enough gel to do the job. Take readings with your light meter so you know what the normal light levels are in the room. If the area is lit by fluorescent lights, find out what type of lamp is used. Determine if there is a mixture of incandescent and/or mercury vapor, etc. Find out how to turn off the existing lights if they are objectionable. Sometimes they are computer controlled at some other location and no switches are available to you. Do not assume—check it out. If the lights are remotely controlled, find out who is at the switch and how to contact that person during your shoot.

Another item that is not directly connected with lighting but should be checked during the time of your survey is the heat and/or air conditioning system. It is generally controlled remotely and may require careful planning. Again, take nothing for granted.

On one occasion, after hearing some loud air handler units in a room we were scheduled to shoot in, I asked the house engineer if the air conditioning could be turned off during the takes. Special arrangements were made, I met the person at the controls, got the phone extension and felt confident in the arrangements made. On the first day of shooting I requested that the units be shut down and was told it was being taken care of. When tape was ready to roll, the noise was still there. I talked with the engineer who assured me that the air conditioning had indeed been shut down. "Then why do I still hear the air noise?" I asked. "Oh," he replied, "I have turned off the coolant, but I can't shut down the blowers. That would affect this entire side of the building." Wonderful. All the advanced planning had accomplished was to provide a noisy, hot room instead of a noisy, cool one. A substantial cost was incurred in audio sweetening to remove the blower noise. The moral of the story is: Be specific about what you ask for from building personnel.

Ask to see the house electrician. One of your most important tasks is to determine how much power is available at existing outlets or from a nearby service entrance or power distribution centers. If you are able to obtain a current set of electrical drawings from building maintenance or electrical engineering, so much the better. It may be that you are dealing with a union house. In that case you will have to make your specific needs known to the union steward and determine the costs involved to have their people on hand.

Again, get names and numbers and request confirmation in writing if you have any suspicion that the person in authority will not be present at the time of your shoot.

If a union does not have control, you must plan for your crew to do the job efficiently. Outlet circuits are generally 20 amps, or about 2000-watt capacity. If there are many outlets available in the area, be sure to check which breaker panels control them and how many of them are on the same circuit. If you have someone helping you with the survey, you can use a night light plugged into each outlet as you turn off breakers to confirm which ones control which outlet. If you are by yourself, you can plug in a small 6-volt ac/dc adaptor (like those used as power supplies for transistor radios) that is connected to a low-voltage buzzer. When you turn off the correct breaker, the buzzer will stop, and you can make appropriate notes. Check to see what other equipment is likely to be on that circuit so you do not disrupt power to vital equipment such as computer terminals or lab equipment.

When you know which breakers control which outlets, you should then determine how much power is being drawn by other equipment on that circuit.

The easiest way to determine circuit load is with a clamp-on ac ammeter. It has two jaws, like those of a pair of pliers, which can be opened and placed around the wire leading from a given breaker. It will indicate the current being drawn on a circuit. If the current draw is high, it may be caused by a coffee machine or some other piece of equipment that can be turned off or relocated during your shooting schedule. Determine what the current draw is for the appliance involved and compute how much capacity is left for your lighting and technical requirements.

The way to estimate the current draw so that circuits are not overloaded on location is by using the simple rule of thumb that each 100 watts equals 1 amp. The actual formula is Amps = watts/volts. This formula will help you calculate an actual situation. If you do not want to figure it out, Table 8.1 shows common lamp wattages and typical voltages found on location.

If you determine that there is not enough power at available outlets, take a picture of the breaker box with the front panel removed so you will know the correct type of clip locks to get for your tie-in. (We will discuss proper tie-in procedure in Chapter 9.) Measure the length of cable runs to your shooting site and obtain permission to string cables through hallways or adjoining rooms. Always note the names and phone numbers of those who grant permission so they can be reached for confirmation if you run into problems later on. *Take no one's word for anything!* If someone tells you, "I think the breakers for those outlets are in that closet," do not believe them. Check it out for yourself. When you set up, are ready to shoot and a breaker blows, you should not waste time trying to find out where control for that circuit is located and who has the key for the closet in which the service panel is located. Confirm all of these things at the time of your survey. Often times, the nearest service panel is not the one that controls your area, and house electricians may not know where the correct panel is without lengthy delays.

Table 8.1: Watts vs. Voltages

Load (watts)	Line (110	Current 115	Voltage 117	(amps) 120
50	0.5	0.4	0.4	0.4
100	0.9	0.9	0.9	0.8
200	1.8	1.7	1.7	1.7
250	2.3	2.2	2.1	2.1
500	4.5	4.3	4.3	4.2
650	5.9	5.6	5.5	5.4
750	6.8	6.5	6.4	6.2
1,000	9.0	8.7	8.5	8.3
1,500	13.6	13.0	12.8	12.5
2,000	18.1	17.4	17.1	16.7
4,000	36.4	34.8	34.2	33.3
5,000	45.4	43.5	42.7	41.7
7,000	63.6	60.8	59.8	58.3
10,000	90.0	86.9	85.5	83.3

Ask what activities might be going on during your scheduled shooting times. Just because the area is quiet during the time of your survey, do not assume that that will be the case on the day of shooting. You may be coming in on Saturday when the carpets are shampooed, the floors buffed or a new wall is being installed in the room next door. If construction is scheduled or other noisy activity is likely to take place, see what can be arranged. You may have to change your shooting schedule.

Make note of special problem areas. Large shiny surfaces, furniture or plants that may not be appropriate to your production, distracting wall hangings or other items that you want removed or changed in dressing the set properly should be noted. Get permission to make changes, if possible. See if you can bring in other furniture or artwork from surrounding offices or areas. If so, look at the items during your survey and begin the necessary paperwork to have them on set when you arrive to shoot. If the necessary items are not available in-house, you will have to bring them with you. Always replace borrowed items when you have finished with them.

Inquire about methods of triggering fire alarms or sprinkler systems. If the ceiling contains heat sensors and you place a bounce light near one, you may make many enemies and cause extensive damage. Once I was shooting some news footage of a computer demo at a large bank. All the bank executives were clustered around in their pinstriped suits as the computer sales representative extolled the virtues of the hardware. Suddenly the room was flooded with water from the sprinkler system and silent alarms were sent to three fire stations by heat sensors hidden in the ceiling. The heat generated by the computer, the news camera lights and more bodies in the room than usual had triggered the pandemonium.

Many of these points deal with the challenges posed by newer high-rise buildings. Older buildings and private homes pose their own challenges, the most frequent being insufficient power. Unlike newer structures that usually have circuit breakers in the entrance panels, older buildings are apt to have fuses rather than circuit breakers. Checking the fuse rating and type is often not an accurate indication of circuit capacity. This is because

people frequently substitute larger capacity fuses in those panels when increasing power demands cause fuses to blow frequently. It is not uncommon to find 20-amp fuses on circuits designed for 15-amp operation. I have even found 30-amp fuses on such circuits. During the site survey you should check the wire size leaving the individual fuse holders. If the size is not stamped on the wire covering, you can determine it by using an inexpensive wire gauge, which is available from any electrical supply house. Table 8.2 shows the ampere capacity for various wire sizes.

Table 8.2: Wire Size Capacity (amps)

		(
No. 14	15	
No. 12	20	
No. 10	30	
No. 8	40	
No. 6	55	
No. 4	70	

The most common fuse type is the plug fuse. It is made in ratings up to 30 amps. Plug fuses are screwed into the same type of socket that is used in household lamps and ceiling fixtures. A glass or mica window permits you to see if the fuse has blown or not. They are used on the individual branch circuits and are frequently oversized for the wire size of the circuit they are intended to protect.

Rather than carry around dozens of 15- and 20-amp plug fuses to keep location equipment operational, you can purchase a few plug breakers that screw into these sockets. They have a small pin in the center that pops out if the circuit they are protecting is overloaded. To reactivate the curcuit, remove some of the load and push the pin back in again. You do not have to replace the unit as you do an ordinary plug fuse.

Fustats may also be used on branch circuits. They are designed to overcome the problem of using overrated fuses. Though they look similar to plug fuses, their screw bases have different size threads for different ampere ratings. It is less likely that fustats will be overrated, but it is possible since they screw into an adapter that fits the standard plug fuse socket. That adapter may have been improperly sized when it was first installed, so check wire sizes leading from these sockets also. When you know the proper fuse types and ratings, determined by the wire size, take notes and be sure to have proper replacements on hand during the shooting schedule.

In older homes the mains may also be fused with plug fuses, but cartridge fuses will probably be used. These fuses look like shotgun shells and are held in place by brass contacts that fit snugly around each end of the cartridge. If you are in an older industrial plant, this type of fuse may also be used for branch circuits. Take along a fuse puller in your gadget bag to change this type of fuse. The fuse puller is a nonmetallic pliers-type tool that will allow you to safely reach into the entrance panel and pull out cartridge fuses. It is dangerous to use metal pliers for this purpose since you may touch live contacts that could cause severe electrical shock. Unlike plug type fuses, cartridge fuses must be removed from the circuit and checked with a continuity tester or ohmmeter to determine if they are blown or not. Visual inspection will not tell you anything.

Note whether or not the wall outlets are three-wire or two-wire. If they are nongrounded, two-wire outlets, you will want to have plenty of converters on hand during the shoot, as your instruments are certain to have grounded plugs. Never break the ground pin off your instrument plugs to accommodate ungrounded outlets!

If your survey indicates that even a tie-in will not yield enough power to support your shoot, your most convenient and economical solution is to request a temporary drop from the local utility company. See Chapter 9 for more information about temporary drops.

9 Location Lighting: Battling the Elements

EXTERIOR DAYLIGHT SCENES

In earlier chapters we dealt with sunlight and its effect on indoor locations. Locations that may be lit by one or more different incandescent, fluorescent or vapor discharge lamps may also contain large or small window areas that add yet another color temperature to the mix. You will recall that it is necessary to decide which source is the most dominant. Make that your standard and then color correct all other sources to it. When you shoot outside during the day, there is little question about the dominant source or what the standard will be. The problem is that the sun is a tough act to follow or even keep up with.

There is a tendency to characterize daylight as 5600 °K and to set the camera filter to that position before performing the white balance. However, Table 1.1 shows that the color temperature of daylight ranges from 2000 °K to 5600 °K. This wide range of color temperature and the different qualities of light produced by the sun's interaction with the earth's atmosphere and surrounding structures provide you with the opportunity to get just the look you want. The trick is to be patient enough to wait for optimum conditions and fast enough to get the shot or shots needed before conditions change. When the sun is your primary source and it is not the color temperature or quality of light you would like, you can do a lot to modify it for narrow- and medium-angle shots. The extremely wide-angle shot will require greater patience for nature to get it right or a greater budget to assist nature.

Often the attitude that good illumination is good lighting comes into play on exterior daytime locations. Having enough light to keep the engineer happy does not mean the scene is well lit. In fact, unless it is a very overcast day, chances are that you are dealing with excessive contrast for the video system and have highlights the system cannot handle.

You are also likely to have shadows that contain little or no detail. You can begin to solve these problems by using a neutral density filter pack on the front element of your lens. It will reduce the excessive highlights and allow you to work at a larger f-stop. Once your NDs are in place, you can begin to control the lighting even further.

It is an unfortunate fact of life that if your script calls for many long shots, you will need some pretty high-power equipment to deal with specular lighting on exterior locations. You will need generators, arc lights and a sizable budget to pay for the large crew necessary to light properly. The assumption behind this text is that you are not into major motion picture production, so we will not deal with the needs of such costly projects. What we will address is your ability to provide fill and control source levels for medium shots and close-ups.

Often when you need an exterior wide shot, you have to concentrate on lighting only a small area of that shot. Usually some action in the foreground needs attention. Regardless of how confined the area requiring attention may be, you still need some powerful lights and large sheets of diffusion material to temper nature. You are either operating at an extremely small f-stop or are using neutral density filters to reduce your depth of field. In either case, it will take a great deal of supplemental light to get the job done.

Other than using a camera-mounted Frezzi to fill in some shadows on the face of a news reporter doing a stand-up, television shooters tend to take what nature provides and call it fine. There is no need to settle for "what you sees is what you gets," but you will need some different equipment than that required for shooting indoors. If your camera has black stretch, an electronic circuit designed to bring out details in heavy shadows, this can be a big help on outdoor shoots, but additional lighting will still be necessary for good control over the look of your shot.

If you do not shoot outdoors often, you can rent what you need for those few occasions. If you find yourself shooting outdoors in daylight frequently, you may want to invest in some of the equipment necessary to do the job properly. Many reflectors that are used outdoors are also valuable tools for indoor setups; so some of these smaller items will be a good investment whether you shoot outdoors frequently or not.

Controlling Sunlight

The sun can serve as your backlight or key, depending on how you position the talent. Your job is to provide fill (or key and fill) as needed. To some extent, you can also control the intensity and quality of the sun itself.

The quality and intensity of sunlight can be controlled over an area large enough for medium shots and close-ups using a butterfly or overhead. (See Figure 3.1.) This is nothing more than a large, up to 30- by 30-foot, lightweight metal frame over which is stretched a lighting control material such as a diffusion silk. These frames can be supported by two or four legs or can be hung overhead by wires attached to other structures or equipment

at the location site. The choice of material can affect both the quality and quantity of the sunlight that reaches the talent. While all material suspended overhead, scrim or silk, will reduce the intensity of the sun, some materials will also diffuse as well as alter color temperature so that you can get the warm, soft look if you want.

Butterflys also reduce the amount of bounce or fill that is needed to establish desired lighting and exposure ratios. These units are not difficult to set up, but they can be difficult to keep up. Because of their large surface area, they pose a considerable anchorage problem if there is more than a slight breeze. Have plenty of sandbags available to weight down their stands and be sure to keep a close eye on the weather conditions.

As with anything else in lighting, you can improvise if you do not have professional equipment. You can use a bed sheet or shower curtain tacked to scrap lumber suspended from trees and/or a C-stand. Be a little creative, but do not settle for light that is too harsh to satisfy your requirements. Bed sheets can serve as reflectors as well as overhead diffusion material.

Using Reflectors

Other items common to the exterior sets are reflectors and HMIs or nine-lites that are used to provide fill. Obviously the use of reflectors is the easiest way to provide fill light out in the middle of nowhere, but their use is not without problems.

Like the reflectors in lamp housings, reflector boards can be specular or diffuse. One side of these boards is usually called the "hard" side and the reverse side is generally a "soft" side. The hard side of traditional reflector boards is covered with a smooth, unbroken silver paper that produces a harsh and somewhat spotty light. It can be used for relatively long throws and must be repositioned frequently as the sun moves across the sky. The silver material may be replaced with a gold foil to produce a warmer color temperature. If a cooler color temperature is desired, a bluish foil can be applied to lower the color temperature.

The soft side of traditional reflector boards is covered with small squares of silver leaf. The edges of these squares are not adhered to the board, but are bent outward to provide a small flap that diffuses the reflected light and provides a far softer source. Like the hard side foil, the soft side material may be gold or blue to alter color temperature.

Generally these boards range in size from 2 by 2 feet to 3 1/2 by 3 1/2 feet. They are mounted in a gimbaled yoke on a heavy-duty stand to provide a flexible method of aiming. I refer to them as traditional reflector boards because they have been used for years on exterior locations by the motion picture industry. They are costly, their surfaces (especially the soft side) are easily damaged and they are very heavy to transport.

More recent developments in plastics and laminates have made a wider range of reflective material available to the lighting director. Material offered by Rosco in sheets 20 by

40 inches or in 100-square-foot rolls, 58 inches wide, is extremely durable and lightweight. It is available in more than a dozen surface configurations that provide you with a wide latitude of control over the quality and color temperature of the reflected light. This material can be stretched over open frames or laminated to Fome-Cor or the more durable Gatorfoam to form extremely durable and lightweight substitutes for the traditional reflector boards. These homemade boards can be held in place by grip heads on Century stands, commonly referred to as C-stands. Reflector boards made of these materials also have wide application as reflectors on interior sets. In my view such boards are superior to the more traditional units in all respects: cost, weight, durability, flexibility of use and range of control. The natural white surface of Fome-Cor or Gatorfoam makes a good soft reflective surface by itself. You could spray one side of such boards with gold paint for those times when you need a warmer fill.

For close-ups involving small areas of fill, Flexfills, a recent product manufactured by Visual Departures, Ltd. offers a unique solution to extremely lightweight, portable reflectors. (See the Appendix.) The units are circular in shape and come in three diameters: 20 inches, 38 inches and 48 inches. They collapse into compact storage units 7 inches, 14 inches and 17 inches in diameter. They can be hand held or mounted in special stands that are available from the manufacturer. Like some of the materials available from Rosco, these units are reversible and come in several different surface colors.

Reflector boards can be used in combination with one another to provide greater flexibility of talent placement. In Figure 9.1 you can see how a hard reflector was used to reflect the sun onto a soft board to provide fill for the talent. Hard or soft reflectors may also be used to direct sunlight into an interior set for use as key or fill. The reflector may be a single hard board placed low to reflect light on the ceiling of a room for the purpose of fill, or it may be a combination of hard and soft boards. Reflector boards are useful in conjuction with standard studio lighting equipment to reduce the number of instruments required to light a set and to reduce heat and electricity required to light interior subjects. Some lighting directors never focus any light directly on talent but reflect light from the sources to the subject. Reflector boards can also be used to create cluster lights (see Figure 3.19). The extent that you choose to use reflectors should be based on the look you desire and the amount of current available. Remember that they have many uses for interior shots as well as exterior locations.

How Buildings Affect Shots

In the same way that reflector boards can influence the color temperature of the light they reflect on a scene, so can buildings and other large structures such as semitrailers or billboards. If you have ever toured the backlot of a motion picture studio, you may have noticed that most of the buildings, sound stages, carpentry shops, etc., are painted tan. This is to prevent the large buildings from reflecting light with strange color temperatures onto the exterior sets that are located on the studio property. Actual sets on the backlot are painted with realistic colors, but surrounding structures are kept neutral to prevent

color temperature contamination of reflected light. Because buildings and areas of open sky or patches of cloud cover can influence the color temperature of daylight to a large extent, you should perform camera white balance often when shooting outdoors. I suggest that you white balance at least every half hour if the camera remains in the same position (more frequently in early morning or late afternoon). White balance each time the camera changes position regardless of how soon it has been since your last white balance.

Figure 9.1: A Combination of Reflectors

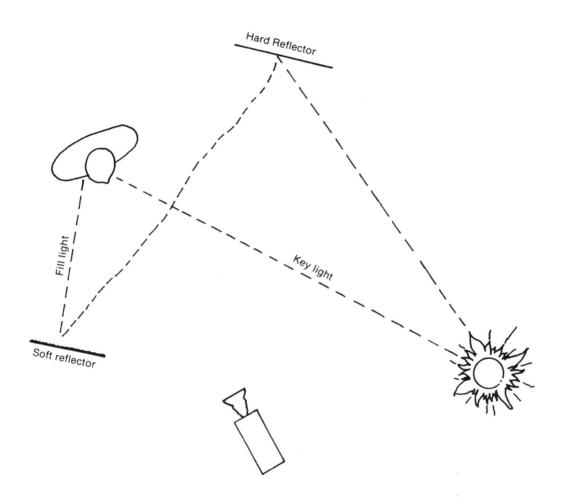

In Figure 9.2 two people are standing in front of a building, carrying on a conversation. Actor A is facing the building. Actor B has his back to it. You might be amazed at the difference in color temperature of the light falling on the faces of these two people at any given moment. Assume you are going to shoot a master two-shot from camera position 1, a close-up of actor A from camera position 2 and a reversal medium shot of actors A and B from camera position 3.

Figure 9.2: Exterior Daylight Setup

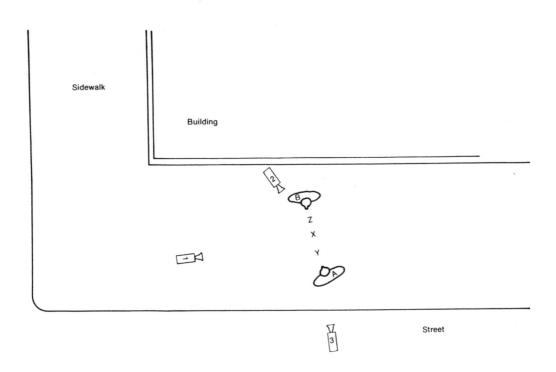

Here are the actual color temperature readings taken at the scene in a span of less than 30 seconds. The first reading is taken with the color temperature meter in position x, facing camera position 1. The second reading is taken at y, facing camera position 2. The third reading places the meter at z, facing camera position 3. First reading is 5200 °K, second reading, 4950 °K and third reading, 5400 °K. The difference in color temperature reading is caused by a number of environmental factors. Things such as open sky, clouds and building surfaces influence reflected light as does the color of the surface under foot, eg., concrete, asphalt, sand, grass, etc. Since such variations in color temperature exist, it is wise for you to conduct a white balance procedure each time the camera is moved to shoot in a different direction, regardless of how recent your last white balance procedure was performed. Keep in mind that the human eye will not react to these differences, but the camera will. You may end up with a series of shots that require expensive post-production color correction if white balance is not performed frequently.

If it is a beauty shot of your client's new headquarters that you are after, an important aspect of the shoot is the site survey. Find out what time of the day the building is lit

most flatteringly by the sun. Building offsets and projections may make it necessary to shoot in the early morning hours or late in the afternoon when the sun is low in the sky and provides a natural fill in recessed areas. Check shadow patterns throughout the day so you can schedule your shot when nature can be the greatest help for the look and feel you want. Attempting exterior architectural shots at the wrong time of day will produce less than optimum results. This is not to imply that a building should not be shot at a time of day when there are no cast shadows, because they can lend a great deal of visual interest. Often shadows may obscure an entrance that must be used for on-camera exits or entrances and require extensive use of supplemental lighting. As with all lighting, plan ahead and work with nature rather than fight it.

EXTERIOR NIGHT SCENES

Up to this point we have dealt with supplementing, assisting, diffusing and changing the color temperature of the sun on exterior shots. In many ways it is easier to deal with the sun convincingly than it is to simulate or amplify moonlight on nighttime exteriors. If the moon is the only supposed light source, the scene is often overlit, producing unnatural results. Exterior night scenes that have a number and variety of incandescent, fluorescent, metal vapor and neon light sources are a great deal more fun and interesting to work on because of the greater latitude and variety of setups available to you.

Whether you are dealing with moonlight or multiple artificial sources as your supposed source of illumination, your setup must take its cue from the actual source and must be consistent with the natural look of existing lighting in order to be convincing.

The moon, like the sun, provides light from only one direction. For some reason moonlight scenes are often lit from a variety of directions. Perhaps this is done on the theory that no one will notice because it is so dark. I notice because, among other flaws, often it is not dark enough. The problem faced is the exact opposite of the one in exterior daylight scenes in which there is often too much light. For night scenes you must provide a base level sufficient to satisfy the circuit requirements of the camera. Beyond that are the artistic considerations of the scene. Fortunately, current cameras and film stocks are sensitive enough to produce good pictures without requiring light levels that are unconvincingly bright for night scenes.

Whether the scene is supposed to take place under conditions lit by moonlight only or by a combination of moonlight and artificial light sources, there is less need to be concerned about normal color temperature. The concern should be with achieving a convincing result. We do not expect to see perfect flesh tones in moonlight or under a variety of nighttime exterior light sources.

In Figure 9.3, the actors walk along the sidewalk from screen left to the gate, open it and go up the steps onto the porch. They stand by the front door for a moment and talk before crossing to the swing on the screen right end of the porch where they sit and talk for the remainder of the scene.

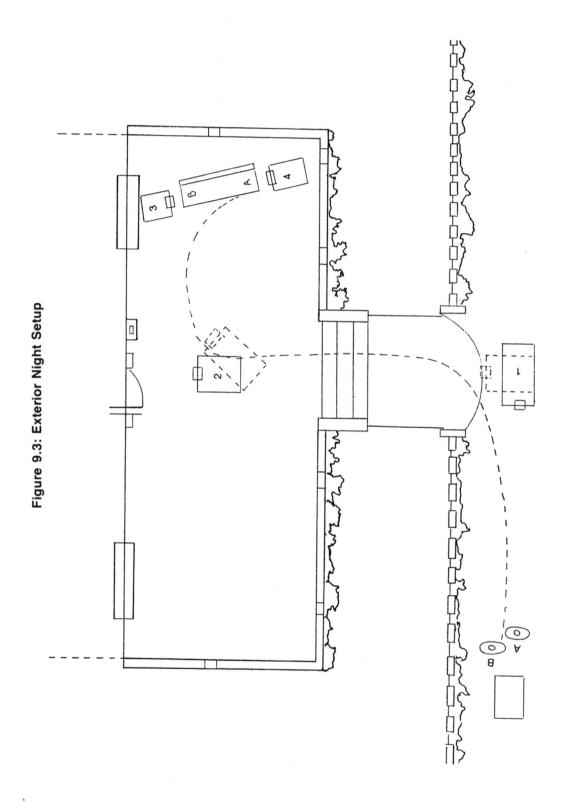

From position 1 the camera follows the action as a two-shot from the sidewalk, through the gate and up to the front door. Then we cut to a closeup of actor B from camera position 2, followed by a two-shot of their heads and then a wide shot from camera position 3 as they cross to the swing and sit. Then there are alternate closeups of actors A and B from camera positions 3 and 4.

This sequence gives lighting an opportunity to make a number of interesting contributions to the feel of the scene. If we establish that the moonlight is coming from screen right, we can light from that direction with blue gels to cover the action of the walk down the sidewalk. The use of cookies to simulate light filtering through leaves will heighten the illusion and add visual interest. It will also make it easier to blend the multiple instruments that serve as sources for the moonlight. Naturally, their light should strike the actors from the same height and angle.

We can add some white backlight to the action as they walk along the sidewalk. An off-screen streetlight can be used as motivation. The lamp and post could be included in a wide shot at the head of the sequence. The backlight will separate the actors from the dimly lit sidewalk and trees behind them. If you want more separation than the backlight alone will provide, you can throw some broken light splotches on the shrubs to the left of the actors. If the light on the shrub is blue, it should come from the same height and angle as the moonlight. If you use white light, it should come from the same height and angle as the backlight. Do not just hit the bushes with some blue light from a convenient low angle off screen left. Such an approach has been used often, and the resulting shadows created by such a placement have ruined the illusion. Since there is a practical porch light, we can use it as a motivation for lighting the exterior of the house and as a motivation for backlighting actors as they stand in front of the door before their cross to the swing. An overhang at the roof line of the porch will serve to mask the placement of small Fresnels and broads or mini-strips to create the desired look.

Often a small pin spot is aimed directly at a practical wall sconce from directly in front to provide a circular wash on the wall behind it. This approach always looks phony because it casts a shadow of the light fixture on the wall and lights do not cast their own shadow. That is exactly what happens when practicals are lit by a single Fresnel from the front in an effort to simulate reality. It is better to light these practicals from an oblique angle with a carefully controlled inky so the light can wash the wall without casting a shadow of the practical. It is generally best to use two such spots, one from each side, to complete the effect without casting fixture shadows and spoiling the intended illusion.

A couple of broads, like the Lowel Tota lights or the new LE low-voltage mini striplights or Nooklites (see Chapter 11) can provide a general wash on the front of the house, scrimed to provide fall off on the ends of the porch away from the practical. Placing these well away from the area directly above the steps will prevent the actors from walking into a hot spot when they enter the porch.

As they stand in front of the door area, they are sidelit by the practical and backlit by light coming through the windowlight of the door. Blue moonlight can wash them from

screen right to maintain the evening illusion. If the moonlight was established as coming from a high angle, it should not fall on their faces because the porch roof overhang would prevent it from striking their upper bodies when they are up by the door.

As they cross and sit on the swing at the end of the porch, another interesting lighting situation occurs. Now actor A is backlit by the cool blue moonlight and is lit from the front by warm yellow light coming through the living room window. Actor B is backlit by that same warm windowlight and is lit from the front by the cool blue moonlight. Depending on the degree of texture the director wishes to introduce into the scene, several things can be done. One of the first things is to decide if the moonlight should be a continuous wash on the front wall of the house and the actors or should be broken up by cookies to provide splotches of light. Careful control of these areas of light and dark can serve to pull focus to an actor's eyes or lips in close-ups.

The next opportunity to introduce texture can be motivated by carefully planned scenic elements such as the type of windowlight in the front door and the use of lace curtains and/or shades on the living room windows. Stained glass and/or curtains on the windowlight in the front door can provide interesting background material for the two-shot of the actors in front of the door. Such elements can motivate texture and color in the backlight or key for that area. The same holds true for the treatment of the living room windows. If heavy lace curtains are used on the windows, you can project that pattern onto the face of actor A and the back of the actor B in the final shot of the sequence. Colored shades can also introduce motivation for a colored wash that can be projected on the acting areas. If the shades are partially closed, actors can move from areas of colored wash or darkness into areas of different color, with lace patterns adding light and texture to the scene.

From this one simple example you should be able to see how a variety of different looks can be achieved. Whatever combination of effects you desire, it is important to plan early with set designs and dressings to achieve maximal effect through lighting. Consistency and attention to detail will make the difference between creative, convincing results and conflicting, unbelievable attempts.

MAY THE FORCE BE WITH YOU

Adequate power is the force I am talking about, and let's face it, most of the time it is not with you. When you get into any situation that involves more than simple three-point lighting of a static head shot, chances are that the power available will not be adequate. When that is the case, you have one of three choices for interior shooting. You can rent a generator and its associated distribution equipment, a costly solution that may be necessary if the project is an ambitious one. You may be able to get by with installing a tie-in to the existing service entrance panel, or you can phone the new business division of your electric utility company and request the installation of a temporary service drop at the location site.

A request should be made one to two weeks before the scheduled shoot date, and you will have to install your own bull switch or breaker box, following local codes, at the site before they bring power to it. The cost for such a service ranges from about \$150 for locations that are fed by underground feeds to \$300 for sites requiring an aerial or overhead drop. For that fee they will provide you with 100 to 200 amps of current and a meter of your own. You will have to pay for the current used plus the initial installation fee. Though this method is technically not a tie-in, it uses the same basic hardware as a tie-in but provides more power than would otherwise be available and removes the possible hazard involved in connecting your leads to an existing service entrance. However, you do need the necessary lead time and the \$150 to \$300 for the installation fee.

A generator or temporary service drop will provide more power at the location than would be available from a tie-in. The tie-in does not make additional power available, it merely makes it possible for you to get maximum use of unused power in a very convenient manner. If the service entrance panel is rated at 200 amps, that is the maximum amperage available for the combined use of your needs and the normal, necessary power requirements of the location. If there are computers, air conditioning or refrigeration units, etc., that must remain on during your shooting schedule, you have to subtract their consumption from the 200 amp total in order to determine the remainder available for your use. Generator setups and temporary service drops bypass the normal power requirements of a site and allow you full use of whatever current capacity they provide.

Tie-Ins

If you determine that there is not enough current available at the outlets located in the vicinity of your set but that there is sufficient unused power available at the entrance panel for your needs, you should plan for a tie-in. That will make it possible for you to distribute all the power not required by the normal needs of the location directly to your area. You will bypass house wiring, eliminate voltage drops and give yourself more complete and readily accessible control of the circuits you are using.

Tie-In Equipment

You may not own the proper equipment necessary to complete a tie-in, but it is readily available from any major lighting rental facility. The cost for such equipment ranges anywhere from about \$100 to \$300 per day, depending on the extent of distribution required. This cost is less than that for renting a generator and will pay for itself in speedier setups and strikes and will eliminate delays caused by blown breakers or fuses during shooting.

The following information regarding tie-ins is not intended to encourage you to attempt making a tie-in if you do not have a basic knowledge of electricity or have a general fear of electricity. That fear could keep you out of serious trouble. It is best to leave tie-ins to a professional electrician if you have any doubt about the techniques or equipment involved.

Installing a Tie-In

Installing a tie-in is not difficult, but care should always be taken when you are working with electricity to avoid fire or personal injury. The greatest hazard exists at the time you connect the clips to the service entrance bus bars. Be sure to wear insulated rubber gloves and to stand on a dry, nonconductive surface. The gloves should be handled carefully to prevent any punctures from occurring. A pinhole in a set of rubber gloves will render them useless as insulators between your body and the current present in the service panel.

The equipment required for a tie-in is not expensive, and only the best should be used. A tie-in is no place to cut corners. Do not try to use ordinary alligator clips to fasten your cables to the buses of the service entrance panel. Use only approved clips that screw tightly to the current source and provide adequate insulation. After they are attached, be sure to secure them with dry ropes to some solid item to prevent their being pulled loose or being brought into contact with other legs or a ground by accident. Your first connection should always be to the ground bus of the service entrance. The other end of this connection should be securely fastened to a known earth ground such as a cold water pipe or a brass rod that you have driven into the ground to a depth of at least 3 feet.

The next connection should be made to the neutral wire of the entrance bus. Your final connections should be made to the hot bus, or buses, of the panel, taking great care not to short two hots together or short a hot to a neutral or ground. You can place a piece of heavy rubber or fiberboard between the two hot clips to prevent accidental shorting. The secured leads from the service entrance panel are then connected to your own breaker panel, commonly called a bull switch, taking care to keep the polarity straight throughout your distribution system.

It is important that your bull switch not only have a master breaker and disconnect switch for emergency shutoff of your entire distribution system, but each branch should have its own breaker for selective shutdown of circuits and to prevent a short on any one branch from taking your whole system down.

From the branch breakers of the bull switch, power can be distributed by two methods: (1) You can use 15-, 20-, 30- or 50-amp female twistlock connectors that are mounted in power strips on the same board as the bull switch. Distribution cables with the appropriate male twistlock plugs on one end and stage boxes on the other can be used for further distribution before being converted to Edison plugs using a 1900 box. (2) Distribution cables with twistlock plugs on one end can be terminated on the other end directly with 1900 boxes. This is really a matter of personal preference, tempered by the necessary cable lengths to get from the service entrance to the location site.

In most cases, if you need to bring large amounts of current from the bull switch to the location site over long distances, you will be better off using welder's cable for each leg and neutral rather than more expensive heavy-duty three- or four-conductor cable. Such multiconductor cable is extremely heavy and bulky to transport and is incapable of handling the large loads that can be readily handled by individual strands of welder's cable. Welder's cable is generally terminated on each end with a male or female mole-pin connector.

•		
•		

10 Studio Lighting: The Good Life

The studio environment offers many advantages over location work. It represents the good life because it has sufficient power, a rigging system of some type to hang instruments from and probably a power distribution arrangement with a dimming control package. In addition, air conditioning will keep you from melting during repeated takes. For all of its comforts the studio still poses a problem you do not face on location. How do you create the illusion that the background for an exterior scene has the expanse that occurs in nature? How do you create natural looking exteriors outside windows and doors of studio sets or create the illusion of infinite space?

There are two basic approaches to these problems. The first solution is to use a large neutral background known as a cyclorama, or cyc. The second method is to use electronic devices such as chroma key, Newsmatte or Ultimatte, which may be used in conjunction with a good cyc. Both approaches have special lighting requirements that must be taken into consideration. The degree of success you achieve with these methods is directly proportional to the care you take with the lighting. The better the lighting, the more convincing the end results will be.

CYCLORAMAS

One of the most versatile and valuable assets of any studio is a good cyc setup. However, it places high demands on power and air conditioning requirements and must be connected to a dimming system to be truly effective. There are two basic types of cycloramas, hard and soft.

When cycs are constructed using a variety of solid materials such as concrete, lath and plaster or plasterboard, they are referred to as hard "cycs." Usually, however, cycs are made of fabric stretched over a frame to form a smooth surface and are called "soft cycs." Each type has its own advantages and can be configured in any of the three basic shapes shown in Figure 10.1.

Figure 10.1: Basic Cyc Shapes

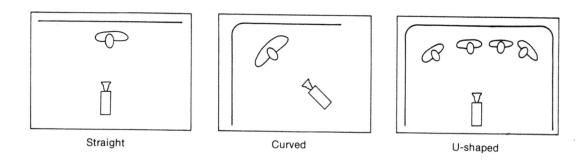

Hard Cycs

The simplest form of a hard cyc is illustrated on the left in Figure 10.2. It is a plain plaster wall with cyc strips mounted about 8 feet in front of its surface at the top. The simple straight wall arrangement with a separate, movable ground row sweep that is placed at the base to help create the illusion of infinity and make it more difficult to detect where the wall meets the floor. A sweep is a curved masking piece that sweeps up from the horizontal surface toward the cyc or back wall (see the illustration left of center in Figure 10.2.) However, such an arrangement will not equal the effectiveness of a cyc that has an integrated sweep like that shown right of center in Figure 10.2. It is the most expensive form of cyc and blends the wall with the floor in a gradual integrated sweep. These hard cycs, with a built-in sweep, create the most convincing illusion of infinity. If the cyc is higher than 12 feet, it will probably require light from below as well as above to be lit evenly. In such cases the ground row sweeps can be moved forward and lighting instruments can be placed behind them as illustrated on the far right in Figure 10.2.

In more expensive installations, if the cyc is more than 12 feet high and requires additional lighting from the bottom to achieve an even wash, a trench may be created in the floor to conceal the strips rather than using a ground row sweep (see Figure 10.3). As the contour of the cyc increases in complexity from a straight line design to a curve or U-shape, the costs rise accordingly, especially when an integrated curved sweep is formed to join the cyc with the floor.

Figure 10.2: Basic Cyc Designs

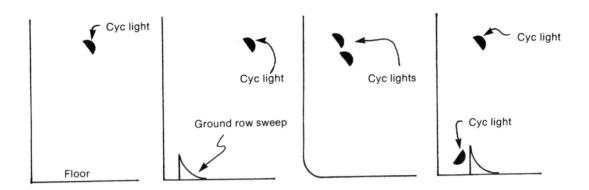

Soft Cycs

If the cyc is constructed of fabric, there are a number of ways to approach the situation, and some of them are quite sophisticated. In the simplest case, a large, seamless piece of muslin or canvas can be stretched with grommets and tie lines between an upper and lower batten and vertical battens on either end. Again, as with hard cycs, if the surface is over 12 feet high, it will be necessary to light it from the bottom as well as the top to obtain an even wash of sufficient intensity in deep colors. This can be accomplished by hiding the lower lighting instruments with a ground row or sweep or creating a trench in the studio floor to conceal the instruments. These methods of concealment will work with a straight, curved or U-shaped arrangement.

A great variety of effects can be created with multiple-layer fabric cycs using nothing more than close control of the light on each layer of fabric. Although multiple-layer cycs have traditionally called for a hefty investment in instrumentation, power and space and air conditioning requirements, newer instrumentation and cyc materials available today make the same effects possible with fewer layers and less consumption.

While a single layer of material is adequate in many situations, the multilayer approach is often used when many different effects have to be made on a real-time basis during performances of musical numbers or within a dramatic scene. Such effects might involve changing the background from a bright blue sky with white clouds to a stunning sunset and on to a star-filled evening sky.

The type of cyc you construct should be based on the needs of your productions. If they require nothing more than a plain neutral sky, install a single-layer blue cyc material that can be lit with white light only. This arrangement requires less expensive, single-circuit cyc lights that use fewer watts, since the light output is not cut by the use of gels, and puts less burden on the air conditioning system.

Figure 10.3.: Trench Cyc

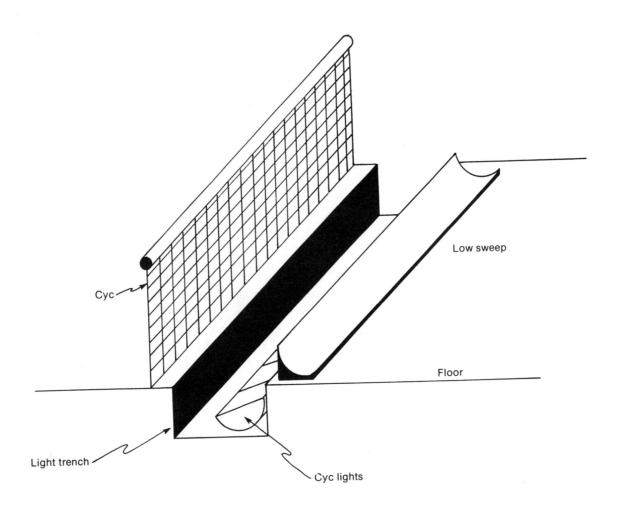

If you must produce minimal changes in your backgrounds during production, choose an off-white or gray muslin and light it with a two-circuit arrangement of cyc lights. White muslin or canvas should never be used as cyc material, even if you desire a white background, because once you start with a material that reflects more than 60% of the light that falls on it, you will create a situation in which the actors and scenery placed in front of the cyc will tend to be silhouetted against the bright background. Even if you do not put any light on such a cyc directly, spill from the other lights can create problems.

With a two-circuit cyc lighting system, you can gel the instruments with the two colors needed for the scene and then cross fade from one to the other, as required, to introduce a change during the scene.

For the greatest flexibility in the creation of effects, a two-layer cyc and a three- or four-circuit cyc light arrangement work best. A natural-color shark's tooth scrim is hung about 1 foot in front of the off-white muslin or canvas backing. This has a twofold advantage over the single layer cyc. As the light strikes the mesh scrim, it creates a much softer look that creates a more believable impression of infinity. You can also place small Italian lights on the front surface of the muslin layer. When these lights are turned on, they shine through the open mesh of the scrim and create very believable stars in the evening sky. Since there is bound to be some movement of the scrim in front of the lights, caused by natural drafts in the studio, this movement causes the stars to twinkle in a believable and random fashion as they are alternately exposed to the spaces and solid areas of the shark's tooth scrim.

Years ago, CBS used a three-layer cyc in which the third layer was used to create the illusion of clouds in the sky. An opaque black duvetyne layer backed up the entire cyc with random cloud-shaped holes cut out and lined with mesh or scrim to maintain their shape. When the scoops or skypans were lit, they projected a soft-edge, cloud-shaped pattern on the muslin, and the effect was further softened by the front layer of scrim. This arrangement of the back layer and its associated backlights required a great deal of backstage space and is not used today because of more efficient special effects projectors such as the Great American Scene Machine that is covered in Chapter 11. These effects machines achieve even better effects with no sacrifice in precious studio floor space.

Efforts to blend the ground row evenly with the floor and cyc can be handled effectively by using a series of Fresnels that are aimed directly down on the ground row and controlled by dimmer circuits. This is an effective way to control the intensity of the ground row and achieve the desired results. These Fresnels must be gelled with the same colors that are used in the main cyc strips. Placement of the cyc strips should be guided by the manufacturer's photometrics in order to achieve the greatest efficiency. You want an even wash with the greatest output per watt. Generally this will mean placing the cyc strips from 8 to 10 feet in front of the cyc.

CYC LIGHTING AND EQUIPMENT

For the past 20 years we have had to use pretty much the same type of material and lighting intruments to build functional cycs. Since this older material and equipment is more universally available, we will deal with it in this chapter as we discuss cyc lighting methods and equipment.

During the past couple of years some new items have been developed that reduce cyc construction costs, space, power and air conditioning requirements. These newer materials will be discussed in Chapter 11. The concepts and techniques remain pretty much the same

whether new or old technology is involved. Live theater makes frequent and extensive use of cycloramas. The lighting instruments used usually consist of relatively inexpensive striplights or borderlights that have three or four circuits of lamps that range in size from 100 to 300 watts. The lamps may be R-40s or as simple as conventional household lamps, each in its own separate compartment. This compartment may have a colored, round, glass lens, called a roundel, covering the opening, or it may be equipped to receive any color gel sandwiched in a gel frame.

A typical three-circuit arrangement may consist of alternate circuits of primary red, blue and green and use roundels or gels to color the light. A fourth circuit may add pure white light to the mixture to increase the versatility of effects. Because of the relatively low wattages and heat dispersion involved, permanent glass roundels or inexpensive gel material may be used in front of the lamps. Unfortunately, these instruments do not produce enough intensity to adequately light a television cyc. What looks great to the human eye in the theater will do little to produce an acceptable image for the television camera.

Television cyc lights range from 750 to 2000 watts each and require larger, more expensive instruments and more costly color media, but there has been little choice in these matters until some recent developments that will be covered in Chapter 11.

NEWSMATTE AND ULTIMATTE

Although chroma key has been improved technically since its introduction in the early 60s, it still has some drawbacks and telltale signs that limit its use when high-quality matting is required. A father and son team, Victor and Paul Vlahos, have invented more sophisticated matting systems. The least costly of the two is Newsmatte, designed to be used in live telecasts for such things as matting graphics for weather reports with live studio shots of the weather forecaster. The more costly and sophisticated unit is called Ultimatte. It is intended for critical use in post-production matting to combine live-action foreground material with prerecorded background information. Thanks to a major breakthrough in encoding and decoding techniques, it is even possible to achieve flawless Ultimatte composites using foreground material that has been recorded on 1-inch tape or on new Sony Beta or Panasonic MII formats.

Composite Lighting

Realistic lighting of the foreground is as important as anything else in making the composite look natural and realistic. Again, the key light must come from the same direction as the light in the background scene, but it is just as important that the contrast ratio of the foreground lighting match that of the background. If the background material has flat lighting, then so must the foreground elements.

The way to achieve the best matting is by using Stewart Ultimatte blue screen material for the background screen because it provides the greatest separation between the blue and green spectrums. If it is not available or your budget does not permit its use, there are two approved sources for Ultimatte blue paint. They are Rosco and Gothic Color. Of the two paints, the Gothic Ultimatte blue comes closest to the blue-green separation provided by the Stewart Ultimatte blue screen material (see the Appendix). If the background element was an exterior scene, the easiest method to achieve a convincing composite is to shoot the blue screen outside in the parking lot or up on the roof. The easiest way to match sunlight is to use sunlight. It is the best way to get a match between exterior background material and foreground subjects that are to look as though they were a part of the original background.

When planning a composite, shoot the background material first, and then light the foreground to match. If you light the foreground subject in the studio so that it looks good to the naked eye and then matte it over previously unseen background material, the end result will never be believable.

With the background in the can, the next step is to light the foreground subject to match it. When you go into the studio to complete the composite, light the blue screen after you light the foreground talent or scenic element, especially if you want it to cast a shadow on the background. If you want cast shadows to appear on the background, position your key light so it causes a shadow to fall on the blue screen. Such a setup will result in spill from the key on the blue screen background. If you had already lit the blue screen so that it was extremely evenly lit, you would create a problem for yourself. Even though you can see a shadow on the blue screen in the studio, it will not key in because it will be necessary to set the clips on the Ultimatte or Newsmatte to a lower setting to remove the excess light from the key that strikes the background. When you make this adjustment, it will bring the level of the cast shadow even with the normal background level of the blue screen, and the shadow will disappear from the final composite.

Convincing Matting

There are two crucial elements involved when you are lighting foregrounds for convincing matting. They are backlighting and sidelighting. Sidelighting is particularly crucial because often when you look at someone standing in front of a blue screen, you will notice light bouncing off the screen onto the talent. To the naked eye this looks like good backlight or sidelighting. However, when it is properly adjusted, the Ultimatte will remove that blue spill and produce a negative effect on the final composite. Without good white light directed at the subject from the back and the side, once the blue spill is removed, the foreground elements will be surrounded with what looks like a dark shadow in the final composite. You will naturally think the matte is bad. It is not. The electronics are doing precisely what they are designed to do. The problem is an absence of good white sidelight. This effect is bothersome when the background material is high key. If, however, the background material is low key or very dark, this absence of sidelight will work in your favor

to create a more natural composite. In such a case, sidelight would only cause an unnatural glow around the edge of the foreground elements. Sidelight sources can be soft or specular in nature, depending on the look you are trying to match. Fresnels might be used when matching the look of a background that was shot outside on a sunny day, but softlights might be appropriate if the background material was shot in a fluorescent-lit office environment or outside on an overcast day.

The use of an amber backlight, like that recommended in some chroma key situations, is not a good idea for Ultimatte. It will only give an amber cast to the foreground subject. It will not create a better matte. The design of the Ultimatte automatically takes care of blue spill without creating a ragged edge around the talent. (Light for Newsmatte or Ultimatte composites as though the foreground subject were situated in front of a black velvet drape. Any spill from the blue screen will not be seen in the final composite. Whatever light you want to see in the finished matte must be put there by you.)

The most important thing about lighting the blue background screen is consistency in terms of evenness and color temperature. If the color temperature of the background screen varies, it will cause a hue shift in the final background scene. For this reason, dimmers cannot be used to even out the illumination of the background screen. The instruments must be moved closer to the screen, or farther back, to adjust for intensity differences. Scrims might also be used, but they provide definite steps rather than gradual degrees of intensity correction. Cyc strips are the easiest instruments to use since they are designed to produce an even wash of light over large areas.

Even lighting is relatively easy to achieve over a limited blue screen area when you are only matting the upper body of talent in the foreground. If the foreground subject must be seen from head to foot, walking down a path for instance, the lighting task becomes far more complicated as you try to achieve even lighting where the blue back wall blends with the blue floor. When you light the floor, do not light it straight down from above because the light will kick back into the camera as specular white light and destroy the even wash you are trying to create. The use of a polarizing filter, because of its ability to remove glare, is highly recommended if you are going to shoot a floor. Like a hard cyc, the best way to achieve an undetectable blend between floor and back wall with blue screen matting is to sweep some of the Stewart blue screen material down the back wall and out onto the floor in one continuous piece. If you have to, you can use ground rows, but the issue of detection becomes more critical. If you already have a good hard cyc with sweeps, just paint it Ultimatte blue.

The polarizing filter is especially good if your background material suggests that the foreground subject is strongly backlit by the sun and you want to key the subject's shadow into the final matte as it comes forward from the feet. To do this you must use a strong backlight in the studio. By the very nature of its placement, it will put a bright glare on the floor. The only way to remove that glare is by using a polarizing filter. As with any filter, it will reduce the amount of light that reaches the camera's pickup device, tubes or CCDs. Do not boost the gain on your camera to compensate for this reduction. Add more light to the entire setup, or you will degrade the composite by adding more noise with the increased gain.

The ratio of light on the background screen to the foreground subject should be roughly 1 to 1 when measured with an incident light meter. If a gray card is placed directly in front of the blue screen, it should read the same as when that card is placed directly in front of the foreground subject.

Uneven lighting on the back wall will affect the way the background scene is reproduced in the composite. You can use this fact creatively to relight your background scene. If you wish your background scene did not have such a hot spot in the upper right corner, for instance, you can reduce the light level on the corresponding area of the blue screen and the Ultimatte will reduce the level of the background scene in that area of the final composite. It is a bit like dodging in the print process of still photography. When you reduce the light on a given area of the blue screen to tone down some element of the original background scene, be sure you do not dim the light electrically, thereby reducing its color temperature. If you do, you will change the color temperature of the prerecorded background material in that area, causing it to appear warmer.

By the same token, you can add colored light to the blue screen to paint the background scene if you have some area or object that did not photograph to your liking in the original scene. If you want the sky to be more orange in the final composite, you can wash the upper portion of the blue screen with an orange light, and it will transfer to the final composite.

You could use blue-colored gels to light the blue screen and increase the density of the blue, making the matting process easier. This can be done only when you are able to place the foreground subject far enough from the blue screen so that the blue light will not be cast on the subject and reduce the contrast of the foreground subject in the final composite. Blue light cannot be used in cases in which you need to shoot the floor, as this light would bathe the foreground subject and obscure the final composite.

	*		
	× *.		
•			

11 Future Directions: Watts New?

The majority of items that are new and different in the lighting field involve the application of modern technology to earlier approaches. The end result is generally a smaller, more efficient widget that takes the place of the earlier device. While the first product discussed here is certainly the application of modern technology, I am not aware of any previous device involving the same concept except in specialized medical applications.

HMI OFFSPRING

Fiber-Optic System

The rather odd-looking device shown in Figure 11.1 is a product of the LTM Corporation. It has an HMI light source and a variety of fiber-optic attachments and is called a Micro-Set Lighting system (MSL).

The MSL 250 system consists of two main units and as many as eight attachments that allow you to bend, distribute and focus the output in a variety of unique ways. Like any HMI source, the system starts with a ballast to convert the ac line current to high-voltage dc. This dc current is then fed to a separate light box that contains a 250-watt HMI daylight lamp and has a port for the attachment of various accessories. The ballast can also be powered by a 12-volt dc supply such as an auto battery.

The attachments include the CML 100 fiber-optic bundle containing one hundred 2.5-foot fiber-optic strands. Each strand is covered with a wear resistant black sheathing. These strands may be used separately or in bundles.

Figure 11.1: Micro-Set Lighting System

Photo courtesy LTM Corp. of America.

My initial reaction to this accessory was, "Big deal! What good is it?" Then I started thinking about the many times I was working with tabletop setups and needed a bit of light here or there and had to try to restrict the output of an inky enough so that it did the job without washing out everything else in the display. This product works well for that and other applications.

The CML 4 contains only four fiber-optic strands of much larger diameter and has two very useful accessories. One is the Microlite, which has a Fresnel and a barndoor. It makes an excellent fill inside cars, trucks and planes because it is extremely small and lightweight and can be mounted in very cramped locations. Since there is no heat at all at the end of the fiber-optic cables, you do not have to worry about scorching auto interiors or roasting the talent. Since the color temperature of the unit is 5600 °K, it does not require booster blue gel to match sunlight, and it is extremely powerful. It produces 1400 foot-candles for a 2-inch diameter beam at distance of 1 foot from the subject, more than enough to add fill in bright sunlight. Even if another type of instrument did produce such high output, no human could stand the heat that would be generated in close quarters. This handy Fresnel can be mounted outside the vehicle to shine through side or front windows, or it can be used for many other applications.

The six-light bar attached to a CML 4 fiber-optic shaft is also great for interior vehicle use, clipped to a sun visor for fill or to the dash to simulate instrument lighting for night-time scenes. Gels and NDs can be used, in the same way they are used with conventional instruments, to color correct or reduce the MSL's output.

If you are involved in commercial production and the soap company wants to show its product in the best possible light, this is the device for you. A fiber-optic strand can be placed in the bar of soap to make it shine from within, and because there is no heat, the bar will not melt after the first take. A model submerged in a tub of bubble bath will look very glamorous when the water and bubbles are lit from below. Since there is no current in the fiber-optic strands, they can be submerged in liquids without endangering talent. A fiber optic in a beverage will give it a punch like you have never seen before. Think about it for a minute. There are many times when you need lots of cold light in confined or dangerous locations. Shooting microchips for instance. Think about the manufacturing equipment you are called on to light and how difficult it is to do. The MSL system certainly has application for these and many other assignments. The designers at LTM even invite you to challenge them to design an accessory for this system that will solve some extremely difficult lighting situation you are facing.

Since the entire system costs about \$5000, it probably will not sell like hot cakes, but a daily rental rate of about \$120 puts it within reach of most production budgets.

This may be a glimpse at the future of studio and theater lighting. The time may come when a few large light sources are attached to multiple instruments with fiber-optic cables.

Softlights

The success of the first HMI instruments with Fresnel lens systems proved the technology and the ultimate economy of this power-saving form of illumination. (See Figure 11.2.) The soft, airy quality of the light was also appreciated by many cinematographers. This led to the development of the Single Soft "D" by the LTM Corp. of America. This compact HMI daylight softlight brings the same power and economy to the set as regular Fresnel instruments do, and it results in a far more efficient instrument than regular softlights. It is possible to light a 16.5-foot-wide area that is 13 feet high to an intensity of 195 foot-candles at a distance of 10 feet, an impressive coverage when compared with conventional softlights. This 1200-watt instrument draws only 12 amps and comes with a shock resistant ultraviolet filter. The Soft "D" is already beginning to change the look of many sets and product shots.

Hard Lights

Just as the HMI softlights have caught on in commercial circles and with lighting directors who are looking for powerful diffuse sources, the hard rock crowd has fallen in love with HMI PARs. (See Figure 11.3.) These rather harsh (specular) sources lend themselves

well to the strong shafts of light that are frequently swiveled around the smoke-filled rock stages. This type of PAR light is now being used by network news crews for interior and exterior lighting setups.

Figure 11.2: HMI Lamp with Attachments

Photo courtesy LTM Corp. of America.

Because they are extremely bright $5600\,^\circ K$ sources, they can be used as fill in exterior daylight setups or can be bounced off ceilings for interior news coverage to provide a

good soft fill for "talking head" interviews. A 575-watt PAR 46 can provide 45,000 foot-candles at 10 feet. The lamp life is rated at a minimum of 1000 hours. Like any HMI instrument, a ballast is required, and the Strand Century ballast unit for the 575-watt ParLite weighs 32 pounds.

Figure 11.3: Cinepar 575

Photo courtesy LTM Corp. of America.

THE MR-16 FAMILY

The First in a Long Line

In the beginning there were ordinary tungsten 35mm projection lamps. They were very hot and required heavy forced ventilation to prevent slide meltdown. Along came Emmet Wiley who designed the multi-mirrored MR-16 lamp. Its unique properties permit the infrared and ultraviolet rays to pass through the efficient reflector bowl rather than projecting them forward with the beam of light. The result is a much cooler beam and brighter slides.

This first MR-16 projection lamp was not suitable for general lighting purposes because of the nature of its secondary focal point. It produced a very uneven field of light when used as a source for open-faced lighting instruments. Then came George Panagiotou who reasoned that the secondary focal point of the MR-16 could be changed to adapt it to general lighting applications. He spent several years redesigning the lamp so it would produce a more even light field and started marketing his new version of the MR-16 in a portable fixture called the Mini-Cool. (See Figure 11.4.) Photometrics show the newly designed 250-watt MR-16 lamp produces a higher light output than an ordinary 600-watt lamp. The

Mini-Cool led to the development of other similar instruments such as the Anton Bauer single and dual lamp UltraLight.

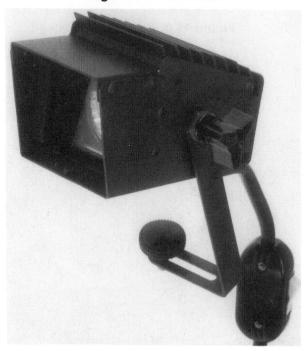

Figure 11.4: Mini-Cool

Photo courtesy Cool-Lux.

Micro Brutes

Realization of the potential of such an efficient, compact 3200 °K source led to the development of other instrument types. The idea is now being used in miniature versions of a nine-light unit, such as the Micro Brute by The Great American Market or L & E's Mighty-Lite. (See Figure 11.5.) These instruments are designed to use either 120-volt lamps in the same manner as their larger counterparts or 12-volt lamps in series, much like the ministrips described below. A nine-lamp unit like the Micro Brute LV9 will deliver 238 footcandles of light at a distance of 10 feet, which is quite impressive, and you do not need a generator to power it. It draws a mere 750 watts using nine 75-watt lamps.

Ministrips

When Jules Fisher decided to take one of his shows on the road a couple years ago, a problem arose when the wagons were redesigned with with a lower profile than those used in the Broadway production. Those higher wagons had concealed conventional theatrical striplights that washed a cyc. The new wagons would not hide the necessary strips. Mr. Fisher called on Victor En Yu Tan to work out a solution. What resulted was the low-voltage Mini-Striplight that uses 10 MR-16 lamps per circuit, wired in series. (See Figure

11.6.) A neon indicator was designed to indicate which lamp has blown since the series arrangment caused all lamps in the circuit to go out. These remarkably compact striplights, manufactured by Strand Lighting and Lighting & Electronics, Inc., are extremely powerful and offer a viable alternative to conventional cyc lights on location. Theatrical striplights will not do the job, and legitimate cyc lights are very difficult to rent. These charmers will get the job done, and they are beginning to appear at rental houses around the country. They are also good for providing floods and washes in hallways and other confined locations. They can be easily fastened to a ceiling or concealed behind a small false beam.

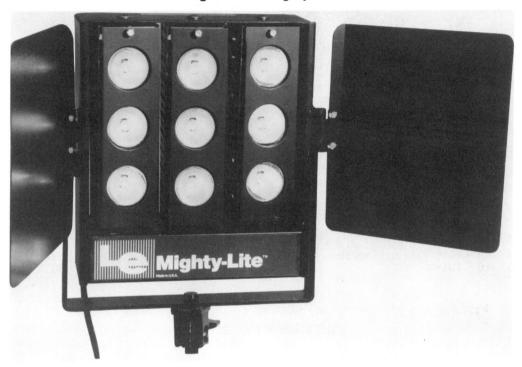

Figure 11.5: Mighty-Lite

Photo courtesy Lighting & Electronics, Inc.

Mini-Fresnels

The first application of the MR-16 lamp to a line of compact Fresnel instruments has been undertaken by Lighting & Electronics, Inc. (See Figure 11.7.) The 4.5-inch 250-watt ENH MR-16 lamp Mini-Fresnel provides light output equal to a standard 6-inch 750-watt Fresnel. At the moment the manufacturer does not recommend using this lamp under conditions in which it might be bumped during operation because it blows out rather easily when vibrated. Designers are working to produce a more hardy version of the lamp. With the exception of this problem, it is a great little instrument. These Fresnels also come in 150-, 250- and 300-watt sizes.

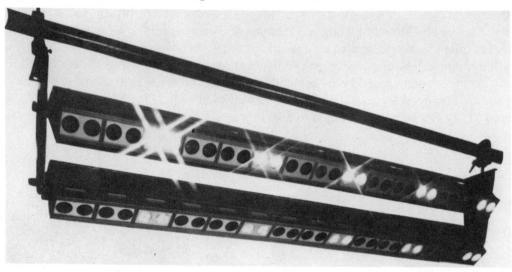

Figure 11.6: Ministrips

Photo courtesy Lighting & Electronics, Inc.

Research is under way by the people at Cool-Lux to manufacture a MR-16-type lamp with a replaceable lamp capsule. This would substantially reduce the cost of lamp replacement since the most costly part of the current lamp is the specially coated multifaceted reflector bowl.

The MR-16 lamp, like the earlier quartz halogen lamp, makes possible the design of even more efficient and compact instruments to help you place shadows more precisely in your scenes. Like modern electronic gear, lighting tools are being improved and miniaturized.

NIFTY NEW PRODUCTS

These next few items are not as innovative as the previous ones, but they are examples of manufacturers recognizing the needs of professionals and packaging products that meet those needs.

I call them duck feet, but the Matthews people who invented them call them Griff Clips. These interlocking wedge-shaped pieces are designed to allow the hanging of any fabric or diffusion material without damage to the material or the need for tools. One section of the wedge is placed on one side of the material to be hung, and the other section is placed on the opposite side of the fabric and inserted into the wide end of the first section. A ring in the first section can then be attached to suspension ropes. As tension is applied to the ropes, the interlocking wedges tighten and hold the fabric securely without ripping it. Originally intended to hang Griffolyn and other Matthews diffusion textiles used in butterflys or overheads, the Griff Clip can be used for many other fabric or diffusion hanging applications.

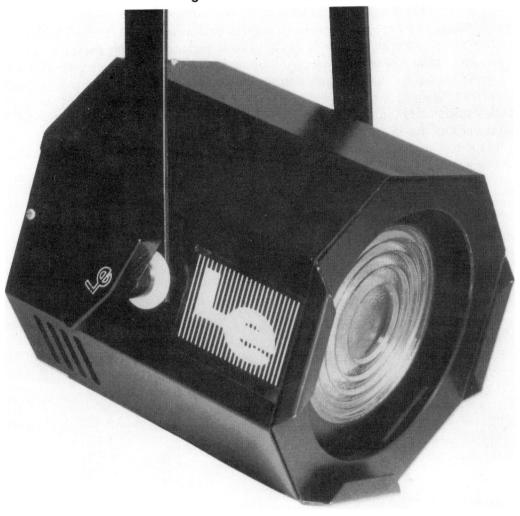

Figure 11.7: Mini-Fresnel

Photo courtesy Lighting & Electronics, Inc.

If you have done much lighting at all, there has probably been more than one occasion on which you used household aluminum foil to mask spill from an instrument or create a snoot or a flag. The problem with ordinary aluminum foil is that it chars under the extremely high heat of an instrument and reflects objectional spill in a variety of places around the set. While heavy-duty roasting foil does not char under high heat, it does produce unwanted reflections. The Great American Market has produced a product called Blackwrap that has a matte black finish and will stand up to the heat of lighting instruments. It is packaged like ordinary household foil. A similar product called Cinefoil is manufactured by Rosco. Cinefoil also comes in a Satin Silver version, which reflects light softly and evenly.

The need to adjust intensity on some instruments, such as backlights, effect lights and background lights, for which exact color temperature is not important, can be easily

accomplished with a dimmer. Usually you would not carry a dimming system around on location but would resort to the use of scrims, which diffuse the light, or ND material, which maintains the specular nature of a source. That means that intensity adjustments require moving the instrument farther away or replacing or exchanging the scrim or ND. The use of scrims will only permit corrections in half- or full-stop increments. The first convenient solution I found for such intensity correction was the Photo Dimmer by Cool-Lux. (See Figure 11.8.) This extremely small in-line dimmer can be used to dim their FOS-1 lamp in the Mini-Cool instrument. An interesting thing about it is the scale printed on the control that indicates the color temperature of the lamp at any given setting and tells you how much the lamp life will be extended if the lamp is operated at that setting throughout its life.

Since the Mini-Cool lamp is only 250 watts but produces the output equivalent to conventional 600-watt tungsten lamps, the Photo Dimmer is really limited to use with inkys or the Cool-Lux Mini-Cool.

Figure 11.8: Photo Dimmer

Photo courtesy Cool-Lux.

For control of higher wattages, the LTM Pepper Pot is the solution. This physically larger in-line dimmer control is rated at 1000 watts. Measuring 5 (l) by 2.75 (w) by 3.25 (d) inches, it is a rugged, practical dimming device.

A new material called Cycscreen may soon add to the list of effects achieved by studios with cycs and may reduce the candle power required to achieve satisfactory results. Instead of using a dual-layered fabric arrangement consisting of an outer layer of scrim and a backing layer of muslin or canvas, the Rosco people have invented a rear-screen-type plastic film that can be welded together to form a seamless cyc of any shape or size. When lighted, these welds are invisible in normal operation from either the front or the back.

The front surface of Cycscreen offers a reflectance that is approximately 10% higher than that of cloth surfaces used today. This can reduce air conditioning and power requirements.

What makes Cycscreen truly different is that it allows you to paint scenes or designs on the surface with "Sign-Stick," which can be removed later by simply peeling off the film coating. You can also project images on it from the rear. It has excellent off-axis reflectance characteristics and permits closer placement of lights, which reduces wasted studio floor space. Unlike conventional cyc materials, if a puncture occurs, an invisible repair can be made. Costs are said to be comparable to conventional two-layer fabric installations.

A CLOSING SHOT

Remember the phrase "Lights, camera, action"? Lights come first for good reason. Without them the camera and the action are useless. So are some of the tips in this text if they are not put into practice.

This is not the end of a text. It is the beginning of your on-going effort to light your subjects more effectively. It is a point at which you begin to apply a new understanding of light and technology to the realities of your profession. It is your opportunity to experience the control you hold over the viewer's perception of every scene—to conceal and reveal selectively, to place shadows and light creatively. So, let there be light, but not too much light. Remember, God's job was to illuminate, yours is to light. To apply...The Art of Lighting. Enjoy!

			*

Appendix: Resources for the Lighting Professional

The firms listed in this section represent a cross-section of companies that manufacture, rent or sell products that are used by lighting professionals. Some may have branch offices nearer to you than those listed. You will find them very helpful when you need solutions to the various lighting problems you encounter. Don't hesitate to give them a call to discuss a product you want more information about, or to seek advice for a specific problem.

Alan Gordon Enterprises 1430 Cahuenga Blvd. Hollywood, CA 90028 213/466-3561

Altman Stage Lighting Co. 57 Alexander St. Yonkers, NY 10701 914/476-7987

Anton Bauer 1 Controls Dr. Shelton, CT 06484 203/929-1100

Arben Design 600 W. Roosevelt Rd. West Chicago, IL 60185 312/231-5077

Arriflex Corp. 500 Rte. 303 Blauvelt, NY 10913 914/353-1400 Barbizon 426 W. 55th St. New York, NY 10019 212/258-1620

Bardwell & McAllister 7051 Santa Monica Blvd. Hollywood, CA 90038 213/466-9361

Batib 443 S. Victory Blvd. Burbank, CA 91502 818/846-7480

Belden Communications, Inc. 534 W. 25th St.
New York, NY 10001 212/691-1910

Bogen Photo Corp. 17-20 Willow St. Fairlawn, NJ 07014 201/794-6500 B-W Lighting Systems PO Box 470162 Tulsa, OK 74147 918/664-1111

Cinema Products Corp. 2037 Granville Ave. Los Angeles, CA 90023 213/478-0711

Cinemills Corp. 3500 Magnolida Blvd. Burbank, CA 91505 818/843-4560

Cine 60 630 9th Ave. New York, NY 10036 212/586-8782

Colortran 1015 Chestnut St. Burbank, CA 90506 818/843-1200

Comprehensive Video Supply 148 Veterans Dr. Northvale, NJ 07647 201/767-7990

Cool-Lux Lighting Industries 5723 Auckland Ave. North Hollywood, CA 91601 818/761-6166

DeSisti Americas 328 Adams St. Hoboken, NJ 07030 201/792-4980

Dyna-Might Sound & Lighting 3119-A S. Senic Rd. Springfield, MO 65807 417/883-4549 Frezzolini Electronics 5/7 Valley St. Hawthorne, NJ 07506 201/427-1106

General Electric Nela Park Cleveland, OH 44112 216/266-2122

Gothic Color Co., Inc. 727 Washington St. New York, NY 10014 212/929-7493

Grand Stage Lighting Co. 630 W. Lake St. Chicago, IL 60606 312/332-5611

Great American Market 826 N. Cole Ave. Hollywood, CA 90038 213/461-0200

ILC Technology 399 Java Dr. Sunnyvale, CA 94806 408/745-7900

Imero Fiorentino Assoc. 6430 Sunset Blvd., No. 618 Los Angeles, CA 90028 213/467-4020

Imero Fiorentino Assoc. 44 W. 63rd St. New York, NY 10023 212/246-0600

Keylite Psi Group 333 S. Front St. Burbank, CA 90502 818/841-5483 Kliegl Brothers Lighting 31-31 48th Ave. Long Island City, NY 11101 718/786-7474

Lee America 534 W. 25th St. New York, NY 10001 212/691-1910

Lighting & Electronics, Inc. Market St. Industrial Park Wappingers Falls, NY 12590 914/297-1244

Lighting Methods 691 St. Paul St. Rochester, NY 14605 716/546-8710

Lowel-Light Manufacturing 175 10th Ave. New York, NY 10018 212/947-0950

LTM Corp. of America 1160 N. Las Palmas Ave. Hollywood, CA 90038 213/460-6166

Luxor Lighting Products 1050 Wall St. Lyndhurst, NJ 07071 201/933-9400

Matthews New York 143 W. 20th St. New York, NY 10011 212/691-4720

Matthews Studio Equipment 2405 Empire Ave. Burbank, CA 91504 818/843-6715 Mole-Richardson 937 N. Sycamore Ave. Hollywood, CA 90038 213/851-0111

Olesen Co. 1535 Ivar Ave. Hollywood, CA 90028 213/461-4631

Osram Sales Corp. PO Box 7062 Newburgh, NY 12550 914/564-6300

Photo Research 3000 N. Hollywood Way Burbank, CA 91505 213/849-6017

Rosco Laboratories 1135 N. Highland Ave. Hollywood, CA 90038 213/462-2233

Rosco Laboratories 36 Bush Ave. Port Chester, NY 10573 914/937-1300

Sanders Lighting Templates 5830 W. Patterson Ave. Chicago, IL 60634-2680 312/736-9551

Stage Lighting Distributors 346 W. 44th St. New York, NY 10036 212/489-1370

Stewart Filmscreen Corp. 1161 W. Spulveda Blvd. Torrance, CA 90502 213/326-1422 Strand-Century 18111 S. Sante Fe Ave. Rancho Dominguez, CA 90224 213/367-7500

Sylvania Lighting Center 100 Endicott St. Danvers, MA 01923 617/777-1900

Sylvania Lighting Center 630 5th Ave., Suite. 2670 New York, NY 10111 212/603-0700

Sylvania Lighting Center 800 Devon Ave. Elk Grove Village, IL 60007 312/593-3400

Sylvania Lighting Center 6505 E. Gayhart St. PO Box 2795 Los Angeles, CA 90051 213/726-1666

Teatronics 3100 McMillan Rd. San Luis Obispo, CA 93401 805/544-3555

Tiffen 90 Oser Ave. Hauppauge, NY 11788 516/273-2500 Ultimatte Corp. 18607 Topham St. Reseda, CA 91335 818/345-5525

Ultra Light 7270 Bellaire Ave. North Hollywood, CA 91605 818/765-2200

Victor Duncan, Inc. 661 N. LaSalle St. Chicago, IL 60610 312/943-7300

Victor Duncan, Inc. 6305 N. O'Connor, Suite. 100 Irving, TX 75039 214/869-0200

Victor Duncan, Inc. 32380 Howard Madison Heights, MI 48071 313/589-1900

Visual Departures, Ltd. 1601 3rd Ave. New York, NY 10128 212/534-1718

Recommended Readings

BOOKS

- Burrows, Thomas D. and Wood, Donald N. *Television Production: Disciplines and Techniques*. 3rd ed. Dubuque, IA: William C. Brown Co., 1985.
- Carlson, Verne and Sylvia. *Professional Lighting Handbook*. Stoneham, MA: Focal Press, 1985.
- Carroll, James K. *The TV Lighting Handbook*. Blue Ridge Summit, PA: TAB Books, Inc., 1977.
- Fuller, Barry J. et al. Single-Camera Video Production. Englewood Cliffs, NJ: Prentice-Hall, 1982
- Grob, Bernard. Basic Television and Video Systems. New York: McGraw-Hill Book Co.,
- Iazzi, Frank. Understanding Television Production. Englewood Cliffs, NJ: Prentice-Hall, 1984.
- Ingram, Dave. Video Electronics Technology. Blue Ridge Summit, PA: TAB Books, Inc., 1983.
- Kybell, Harry. *Videotape Recording*. Indianapolis, IN: Howard W. Sams and Co. Inc., Publishers, 1978.
- Lazendorf, Peter. The Videotaping Handbook. New York: Harmony Press, 1983.

- Mathias, Harry and Petterson, Richard. *Electronic Cinematography: Achieving Photographic Control Over the Video Image*. Belmont, CA: Wadsworth Publishing Co., 1985.
- McQuillin, Lon B. *The Video Pruduction Guide*. (Edited by Charles Bensinger). Indianapolis, IN: Howard W. Sams and Co. Inc., Publishers, 1983.
- Medoff, Norman and Tanquary, Tom. *Portable Video: ENG and EFP*. White Plains, NY: Knowledge Industry Publications, Inc., 1986.
- Millerson, Gerald. *The Technique of Television Production*. 11th ed. Stoneham, MA: Focal Press, 1985.
- Millerson, Gerald. The Technique of Lighting for Television and Motion Pictures. 2nd ed. Stoneham, MA: Focal Press, 1982.
- Millerson, Gerald. TV Lighting Methods. 2nd ed. Stoneham, MA: Focal Press, 1982.
- Oringel, Robert. The Television Operations Handbook. Boston, MA: Butterworth, 1984.
- Quick, John and Wolff, Herbert. Small Studio Video Tape Production. Reading, MA: Addison-Wesley, 1976.
- Ritsko, Alan J. *Lighting for Location Motion Pictures*. New York: Van Nostrand Reinhold Co., 1985.
- Robinson, Richard. The Video Primer. New York: Perigee Books. 1983.
- Sambul, Nathan J., ed. *The Handbook of Private Television*. New York: McGraw-Hill Book Co., 1982.
- Samuelson, David W. Motion Picture Camera and Lighting Equipment. Stoneham, MA: Focal Press, 1986.
- Smith, Welby A. Video Fundamentals. Englewood Cliffs, NJ: Prentice-Hall, Inc., 1983.
- Utz, Peter. The Video User's Handbook, 2nd ed. Englewood Cliffs, NJ: Prentice-Hall, 1982.
- Wardell, Douglas O. *Television Production Handbook*. Blue Ridge Summit, PA: TAB Books, Inc., 1981.
- Westmoreland, Bob. Teleproduction Shortcuts: A Manual for Low-Budget Television Production in a Small Studio. Norman, OK: University of Oklahoma Press, 1974.
- White, Gordon. Video Techniques. Boston, MA: Butterworth, 1982.
- White, Hooper. How to Produce Effective TV Commercials. Chicago: Crain Books, 1986.

Wiegand, Ingrid. *Professional Video Production*. White Plains, NY: Knowledge Industry Publications, Inc., 1985.

Wurtzel, Alan. Television Production. New York: McGraw-Hill, 1983.

Zettl, Herbert. *Television Production Handbook*. 4th ed. Belmont, CA: Wadsworth Publishing Co., 1984.

PERIODICALS

Here is a list of publications that deal with up-to-date information about lighting techniques and equipment. Many are available without charge and others have an annual subscription rate. All are excellent sources for a broad spectrum of professional tips and techniques.

AV/Video 25550 Hawthorne Blvd., Suite. 314 Torrance, CA 90505

BM/E (Broadcast Managment/Engineering) 295 Madison Ave. New York, NY 10017

E-ITV (Education-Industrial Television) PO Box 6018 Duluth, MN 55806

Lighting Dimensions PO Box 425 Mt. Morris, IL 61054-9907

Light News Lowel-Light Manufacturing, Inc. 475 10th Ave. New York, NY 10018-1197

The Matthnews Quarterly 2405 Empire Ave. Burbank, CA 91504

Millimeter 12 E. 46th St. New York, NY 10017 Rosconews 36 Bush Ave. Port Chester, NY 10573

Strandlight
Rank Strand Ltd.
PO Box 51, Great West Rd.
Brentford, Middlesex TW8 9HR, United Kingdom

Theatre Crafts
33 E. Minor St.
Emmaus, PA 18049

Theatre Crafts
PO Box 630
Holmes, PA 19043-9930

Videography 475 Park Ave. S. New York, NY 10016

Video Magazine 460 W. 34th St. New York, NY 10001

Video Manager Knowledge Industry Publications, Inc. 701 Westchester Ave. White Plains, NY 10604

Video Systems Box 12901 Overland Park, KS 66212

Index

American Institute of Electrical Engineers (AIEE). See Institute of Electrical and Electronics Engineers American National Standards Institute (ANSI), 89

Belden Communications, Inc., 10

Camera operation
auto white balance, 7-8
black balance, 8-9
filter wheels, 9-10
CBS, 143
Century Lighting, 69
Chroma key. See Studio lighting
Cinefoil, 157
Color monitor, 33-39
Color temperature meters, 30-32
Colortran, 71
Cool-lux Lighting Industries, 84, 85, 156
Mini-cool, 22, 84, 158
Cyclorama. See Studio lighting

Electronic Industries Assoc. (EIA), 34

Ellipsoidal, 93. See also Lekos

Fisher, Jules, 154 Flexfills, 128. See also Visual Departures, Ltd. Fluorofilter, 16 Fome-Cor, 128 Fresnel, Augustin Jean, 66 Fresnels, 46, 66-68, 75, 84, 87, 89, 90, 92, 104, 143, 146 Frezzolini, 94 Future directions, 149-159 HMI products, 149-153 fiber-optic system, 149-151 hard lights, 151-153 softlights, 153 MR-16 products, 153-156 micro-brutes, 154 mini-fresnels, 155-156 ministrips, 154-155

Gatorfoam, 128 Gothic Ultimatte, 145 Great American Market, 90, 154, 157 Great American Scene Machine, 143

n 151,
51,
51,
51,
51,
51,
51,
51,
49-
ns,
m-
on,

Reflection, 52-56 and surfaces, 73-76 Rosco, 18, 31, 32, 127, 128, 145, 157, 158 Booster Blue, 18 Daylight Control Media, 18 Diffusion Material, 18 Light Control Media, 18 Reflection Media, 18

Society of Motion Picture and Television Engineers (SMPTE), 34, 35, 38

Sony Beta tape, 144

Spectra, 17, 32

Stewart Ultimatte, 145, 146

Strand, 71, 153, 155

Studio lighting, 139-147

chroma key, 139, 144

cyc lighting and equipment, 143-144

cycloramas, 139-143

hard, 139, 140

soft, 139, 141-143 Newsmatte and Ultimatte, 139, 144-147 composite lighting, 144-145 convincing matting, 145-146

Tan, Victor En Yu, 154 Tiffen, 10 Tough Blue, 32, 52

Ultimatte. See Studio lighting

Vectorscope, 40-41 Visual Departures, Ltd., 128 Flexfills, 128 Vlahos, Paul, 144 Vlahos, Victor, 144

Waveform monitor, 39-40 Wiley, Emmet, 153

About the Author

As Ted Baxter was fond of saying, "It all began at a 5000-watt radio station in Fargo, ND."

For Tom LeTourneau it began at a 1000-watt radio station in northern Wisconsin. And what does a radio announcer know about lighting? For one thing, he knows that when pranksters turn the lights out in the studio while you are reading a live newscast, you had better be prepared to tap dance or come up with some creative lighting.

His solution to that all-too-frequent lighting problem was to hold the copy against the glass faceplate of the VU meter so that its small lamps acted as a backlight to the paper...and keep on reading. It took the puzzled pranksters several weeks to figure out how a sighted person could read UPI wire copy in the dark. When they learned his secret they also learned a valuable lesson. No aspect of lighting is too small to be ignored, a fact LeTourneau has been espousing ever since. (They also learned how to remove the small lamps from a VU meter and to laugh at the sound of tap dancing.)

From those early days of solving lighting problems in radio and learning to read ahead of flaming scripts, LeTourneau moved on to television as an audio man, director, producer and lighting designer. After more than 25 years in the business he has opened his own production company and provides a full range of production services for his commercial and industrial clients in Chicago. He also conducts lighting and directing seminars around the country.